WALL STREET

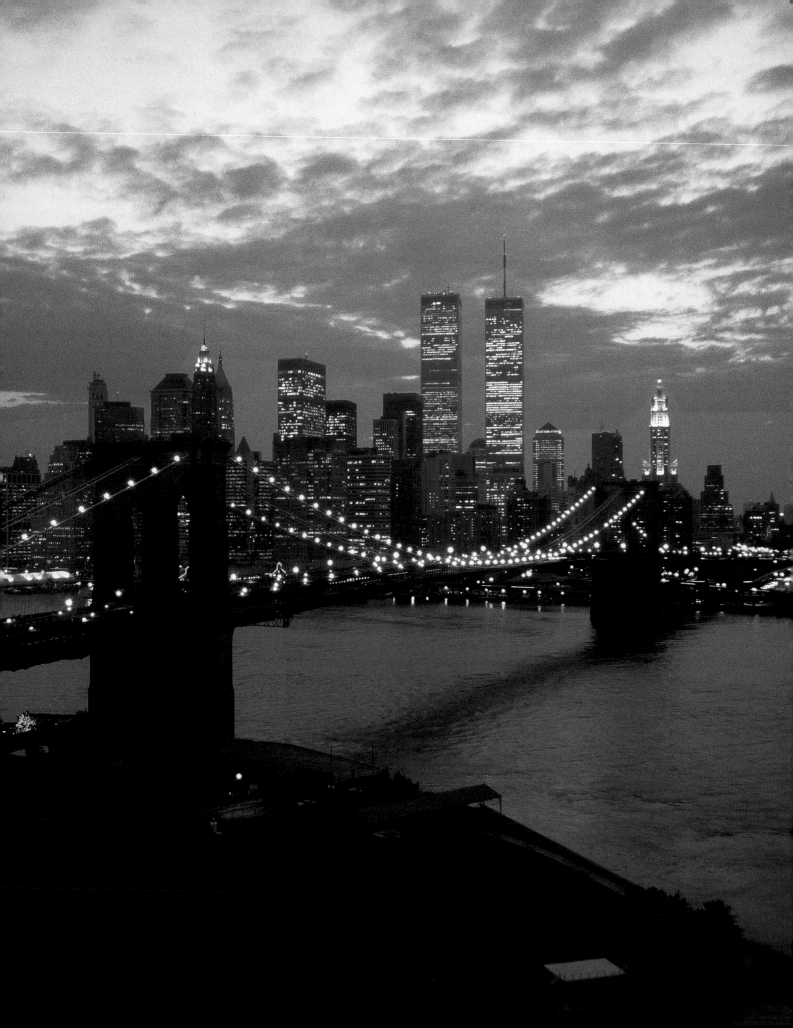

WALL STREET
FINANCIAL CAPITAL

ROBERT GAMBEE

W.W. NORTON & COMPANY
NEW YORK · LONDON

For Sumner Gambee

Library of Congress Cataloging in Publication Data

Gambee, Robert.
 Wall Street : financial capital / Robert Gambee
 p. cm.
 Includes index.
 ISBN 0-393-04767-9
 1. Wall Street (New York, N.Y.)—History—Pictorial works.
 2. Wall Street (New York, N.Y.)—History. 3. New York, (N.Y.)—
 History—Pictorial works. 4. New York, (N.Y.)—Buildings, struc-
 tures, etc.—Pictorial works. 5. Business enterprises—New York
 (State)—New York—History—Pictorial works. I. Title.
 F128.67.W2G35 1999
 974.711—DC21 98-4116
 CIP

Printed in Japan by Dai Nippon Printing Company Ltd.
Designed by Jacqueline Schuman
Production supervised by Tsuguo Tada

Excerpts from the following works have been reprinted by permission.
Here Is New York ©1949 by E.B. White, reprinted by permission of
Harper & Row, Publishers, Inc.
Manhattan Transfer by John Dos Passos ©1953 by Elizabeth H. Dos
Passos (Executrix)
Leaves of Grass by Walt Whitman ©1900 by David McKay
American Notes by Charles Dickens ©1891 by Dodd Mead & Co.

Frontispiece

Framed by the hundred-year-old Brooklyn Bridge, here
is the greatest financial community in the world.

CONTENTS

Photographic Books by Robert Gambee

Nantucket Island in Black & White (*Introduction by Nathaniel Benchley*)
Manhattan Seascape: Waterside Views Around New York
Exeter Impressions (*Introduction by Nathaniel Benchley*)
Nantucket Island in Color
Princeton in Color (*Introduction by Robert Goheen*)
Wall Street Christmas
Nantucket
Wall Street—Financial Capital

INTRODUCTION

Wall Street is as much a state of mind as a street. It is an industry and a financial capital whose boundaries extend far beyond its origins. It encompasses in two words the greatest financial center in the world, whose stock and bond markets exceed all others. It is a short street that begins at the steps of a church and ends in a river, and yet it is a street where more fortunes have been made (and lost) than any other. Wall Street is the most famous address in America. Main Street and State Street may be more common; there is only one Wall Street.

This book is about the institutions that make up the Street. Most are still downtown and are actually on Wall Street or its tributaries. Others are midtown (or uptown as the location used to be called.) But they are all part of the financial industry wherever they might be domiciled.

Leading the industry is the venerable New York Stock Exchange that traces its origins to 1792. Its majestic columned Greek temple has set the tone of stability and strength since it was first constructed in 1903. J.P. Morgan, one of the greatest financiers, chose to locate his firm opposite the Exchange at Wall and Broad Streets. He could have designed the largest structure in New York, with a grand entrance and a multitude of leading brokerage and law firms as his tenants. But he chose the opposite. Barely four stories in height, it was the epitome of understated elegance on one of the most expensive parcels of land in the country.

The rich architecture of the past as well as the present indicates this is an industry that takes itself very seriously. The classical design that is reflected along Wall and Broad Streets has been replaced with a design of similar majesty but greater massiveness as illustrated by the World Financial Center —Wall Street's own version of Rockefeller Center. It is dominated by Merrill Lynch but also includes Lehman Brothers, Oppenheimer and Dow Jones. As recently as 1970, Goldman Sachs and Smith Barney had only three floors apiece in the modest building at 20 Broad Street. Now, they each have grand structures with the latter dominating the TriBeca skyline. Morgan Stanley has its own skyscraper, this one on Broadway with a moving band of stock trades around the outside. It too has expanded from modest Wall Street quarters in 1970 where it had 110 employees and linoleum floors for its associates.

There were seventeen investment banking firms identified by the Securities & Exchange Commission in 1948 as allegedly forming a conspiracy to restrain and monopolize the new issues market. The government lost its case. Judge Harold Medina of the Southern District Court of New York summarized the histories and present-day activities of these firms in his famous opinion, written in 1953. The order in which he selected them is as

follows, and it is interesting to note that out of seventeen, only the names of six exist today, two in their original form:

<div align="center">

Morgan, Stanley & Co.

Kuhn, Loeb & Co. Smith, Barney & Co. Lehman Brothers

Glore, Forgan & Co. Kidder, Peabody & Co. Goldman, Sachs & Co.

White, Weld & Co. Eastman, Dillon & Co. Drexel & Co.

The First Boston Corporation Dillon, Read & Co.

Blyth & Co. Inc. Harriman Ripley & Co. Incorporated

Stone & Webster Securities Corporation

Harris Hall & Company Incorporated Union Securities Corporation

</div>

An unfortunate discovery in researching this book was not the degree of change, for without change the industry would atrophy, but the amount of focus only on today's transactions. There is little regard for the future and almost no recall of the past. Driven by the high volume of present events, we often forget some of the great institutions and developments that have played an integral part in making Wall Street the financial center that it is. One of the purposes of this book is to record some of these stories.

The views, the images, the ideas and the facts assembled in this book were all presented to me as the project unfolded. Throughout this journey, I did not always know where I was going. I simply followed the thoughts as they came. The results must speak for themselves. I am grateful for the valuable help provided by so many.

Wall Street Acropolis

Reflected in a glass table top in the conference room of Deutsche Bank Capital Corp. is the pyramid atop the Bankers Trust Company Building at 14-16 Wall Street and the bold classic superstructure of the Equitable Building at 120 Broadway. They form Wall Street's own Acropolis.

Bankers Trust Company commissioned its new building in 1912 from Trowbridge and Livingston who also designed 23 Wall Street for J.P. Morgan. In fact the pyramid, for many years Bankers Trust's logo, was J.P. Morgan's office.

Wall Street Downtown

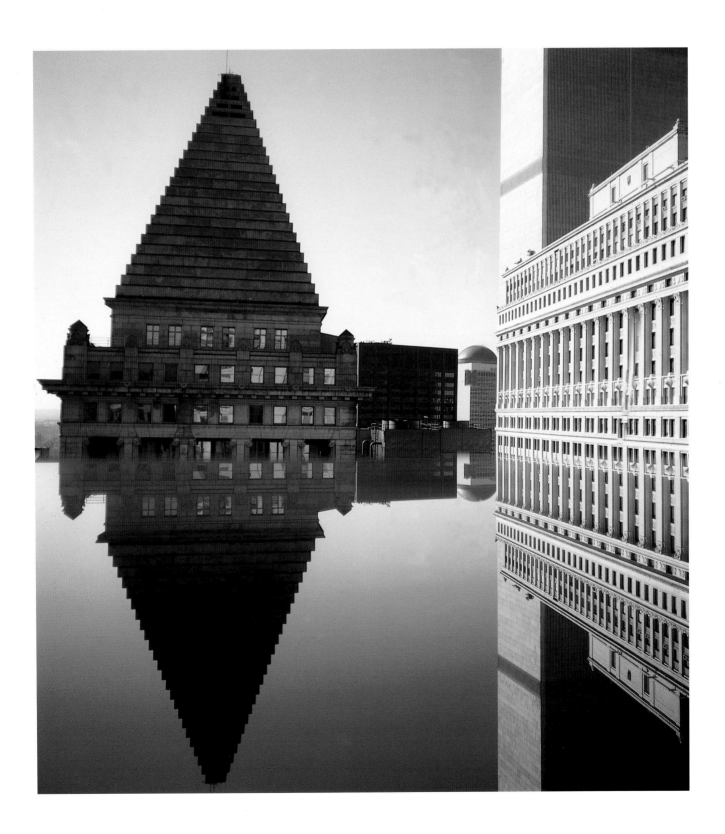

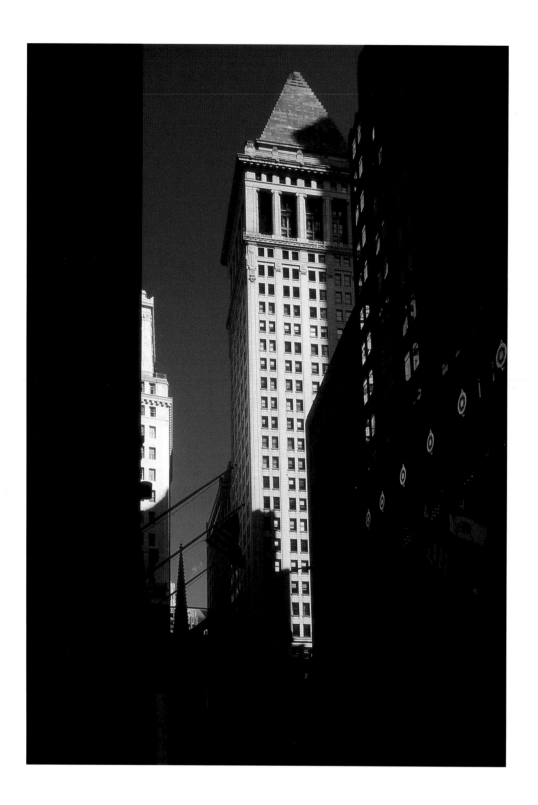

The City

Shown in these two photographs are views of the intersection of Wall Street and Broad Street. "Wall Street" is not just a street. It is an area as well as a state of mind. It is the financial district of New York, a city within a city, and thus may be considered the same way as the finan-cial district in London—simply "the City."

This famous intersection is dominated by the New York Stock Exchange, J.P. Morgan & Co.'s 23 Wall Street, the Federal Hall National Memorial and the old Bankers Trust building.

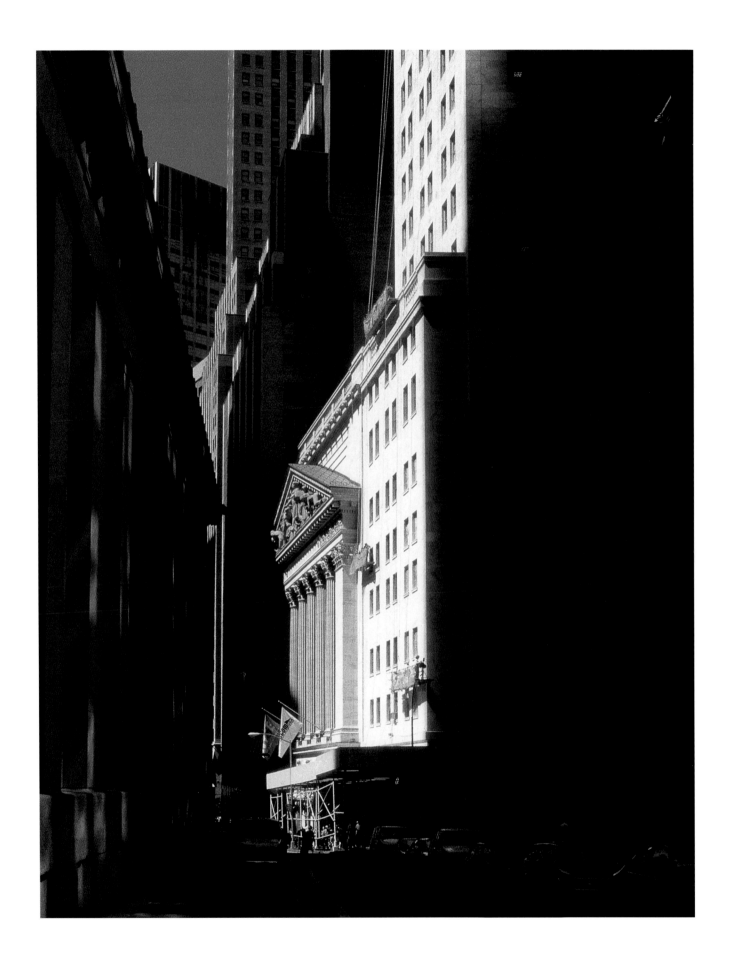

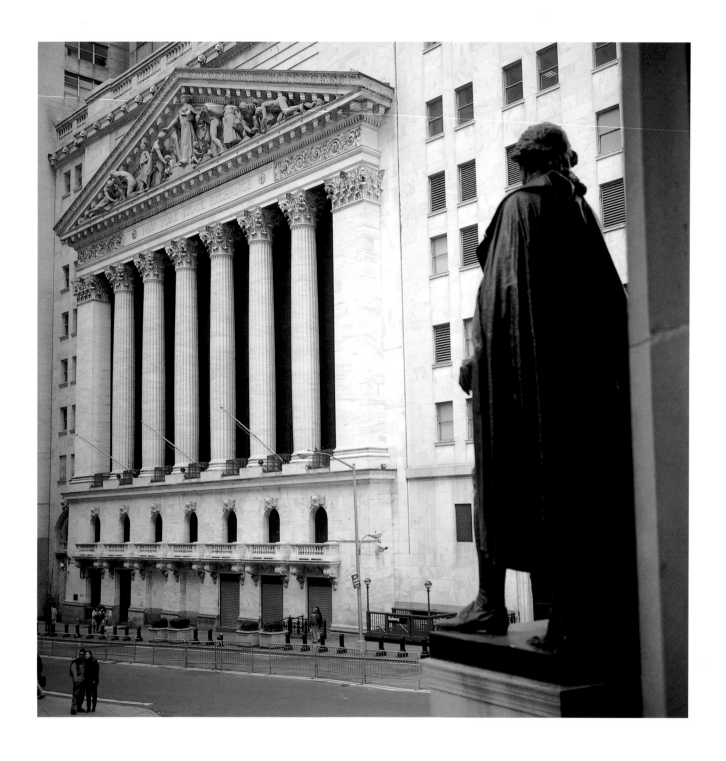

The New York Stock Exchange

Completed in 1903, this building was originally going to have tenants on the upper floors. But the governors felt such a move was unseemly because it placed the Exchange in the role of a dowager of reduced circumstances forced to rent rooms. J.P. Morgan had the same attitude when he built 23 Wall Street. There was to be no space available for other tenants.

Architect George Post was asked to design a commercial palace in keeping with the prestige of the organization. He accomplished this with a facade of 52-foot-high marble columns whose height gave the building a stately appearance.

Three of Wall Street's best addresses

A view of 120 Broadway, 100 Broadway, and Two Wall Street. These are buildings known as much for their current tenants—such as Doremus & Co. at 120, Bank of Tokyo at 100, and Banco Portugues at Two Wall—as for their previous tenants: Equitable Life, American Surety, First Boston, and Morgan Stanley. The last occupied the same offices at Two Wall Street from the inception of the firm in 1935 until 1967. It also might be said that Morgan Stanley ruled the corporate bond market from this location. It was the only firm to print "red herrings" with the complete syndicate already listed, and the only firm to send its own associates to Washington to file offerings with the Securities and Exchange Commission— such a sacred mission not being trusted to outside counsel. Well into the 1960s, the associates were instructed to travel by overnight train as it was more reliable than the air shuttle.

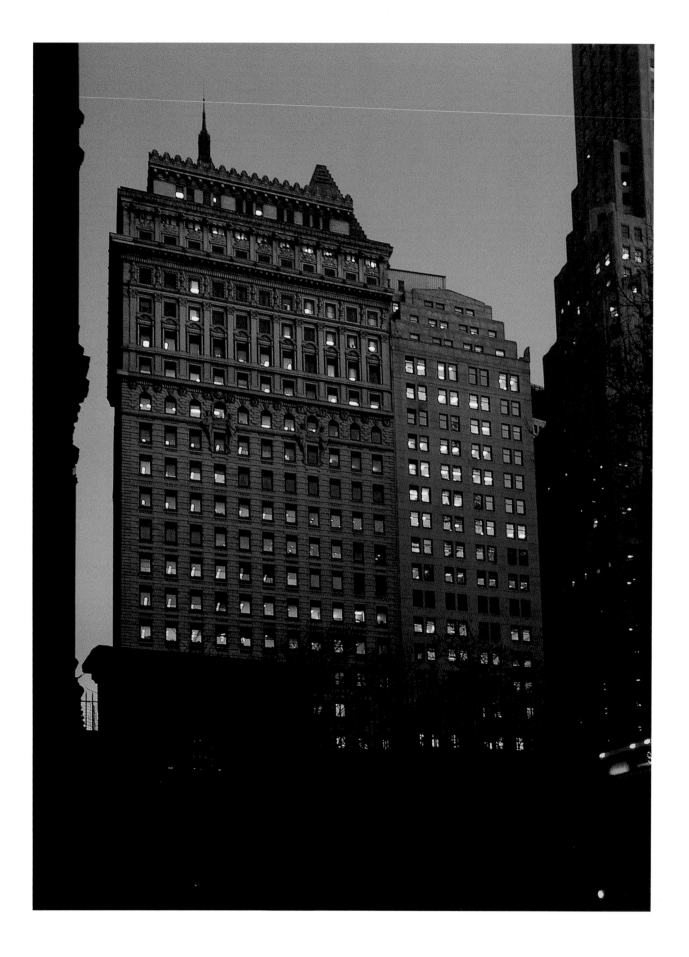

The American Surety Company Building

(Opposite) Clearly, one of the loveliest buildings downtown is 100 Broadway, built in 1895 and extended in 1921. It is presently the home of the Bank of Tokyo. This was one of the first structures in New York to use non-supporting walls. Upon its completion, it was the tallest building in the world, such that the National Weather Bureau located its office here.

The United States Custom House at Bowling Green

(Above) This magnificent palace at the edge of Bowling Green was designed by Cass Gilbert and completed in 1907. It served as the center of New York's customs activities until 1973 when they relocated to the World Trade Center. Presently, the building is home to the National Museum of the American Indian.

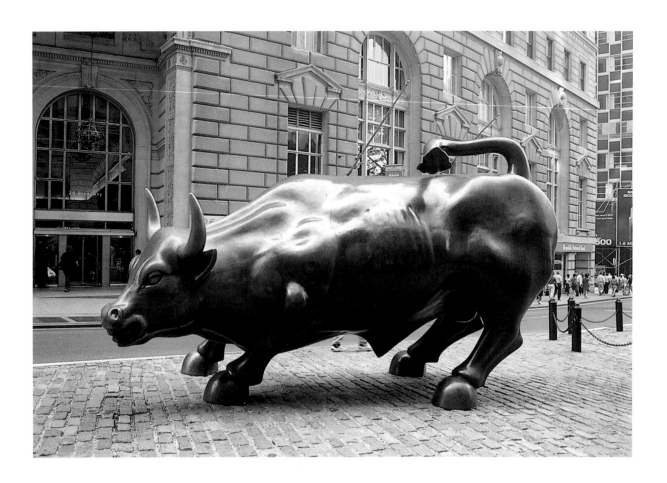

Bowling Green

(Above) This familiar landmark bull was sculpted in 1989 by Arturo Di Modica. *(Opposite)* The site of the Custom House is Fort Amsterdam, the original defense center of the Dutch colony. It was built from 1638 to 1646 and renamed Fort James when the British claimed New Amsterdam in 1664. King Charles II wanted to unite his colonies in New England and the Mid-Atlantic by taking New Netherlands. Peter Stuyvesant was unable to muster the barest semblance of a fighting force and surrendered without a single shot being fired. The new city was named in honor of King Charles' brother James, Duke of York. But in 1673, the Dutch forces marched back into the city and reclaimed it, calling it New Orange; the fort was called Fort Willem Hendrick. The following year the Dutch withdrew and New Orange became New York, once and for all.

In the foreground of the photograph opposite is Bowling Green, the site where Peter Minuet negotiated the purchase of Manhattan for twenty-four dollars. He later built a residence where the United States Lines Building is today.

The green has been maintained as an open area since the earliest days. In fact, the fence around it was built in 1771-72 to protect a statue of King George and preserve the area. This fence is thus one of the oldest landmarks in lower Manhattan. During construction of a new subway line in 1914, the fence was removed to Central Park, where it was forgotten and actually lost. It was finally discovered and returned, a marvel of urban survival.

The photograph shows the Cunard Line Building, 25 Broadway, designed by Benjamin Morris (1921) and the Standard Oil Company Building, 26 Broadway, designed by Carrère and Hastings and Shreve, Lamb & Blake (1922).

These two neighbors, facing each other across Broadway, form a complementary balance. Both are quiet, dignified and grand classical office buildings. The main attraction of the Cunard Line Building is its booking hall where, under ornate groin and domical vaults, people booked passage on the *Mauretania*, the *Queens* and other ships.

The Standard Oil Company Building is one of New York's great unappreciated structures. The base of the building follows the gentle curve of Bowling Green Park. The 480-foot high pyramidal tower, however, is set at an angle, aligning with the uptown grid of streets. Thus the building relates to two separate elements—the street level and the skyline. The total composition never appears disjointed. It is an interesting blend of two different environments in one building design.

The House of Morgan

When J. Pierpont Morgan purchased the site at 23 Wall Street—perhaps the most highly coveted in the Wall Street area—it was assumed that he would commission a monolith to justify the price he paid, which, at the time, was the highest price per square foot ever recorded for real estate. But, true to his own ways, he wanted only four stories, and the upper two recessed so as to be invisible from the street. The resulting design was understated, even austere, but a most extravagant use of space. There was no towering stack of offices with rental income to provide maintenance. There was only a large banking hall with a few offices; there was not even a nameplate on the door.

Pierpont Morgan established J.P. Morgan & Co. in 1860 as the New York correspondent of J.S. Morgan & Co., the London merchant bank led by his father. When he succeeded to this business in 1890, he consolidated the firm's European and American interests. His son, Jack, inherited the financial empire in 1913 and led the firm through three tumultuous decades that spanned two world wars as well of periods of international economic prosperity and depression.

Establishing the roots of its long-standing role as financial advisor to national governments, Morgan extended a £10 million loan in 1870 to the besieged government of France during the Franco-Prussian War; the prospectus for the issue was transmitted from London to Paris by a fleet of carrier pigeons, the tissue-paper pages rolled into capsules. The firm also served as a financial representative for the French and British governments during the wars and provided major financing for reconstruction after both.

During the late 19th and early 20th centuries, the firm played a critical role in creating enterprises that later became symbols of American industrial power, including General Electric Company, U.S. Steel Corporation, and American Telephone and Telegraph. J.P. Morgan's name also became inextricably linked with the railroad industry. In 1909 President Taft asked Morgan to head a group of banks to assist China in the construction of an overland railway. But it was in the United States, during a time of wild and cutthroat competition, that Morgan played a central role in the reorganization of most major railroads —in many cases, issuing groundbreaking 100-year bonds.

In 1940, the firm incorporated, established its trust operation, and began building its investment department. At first, its business consisted primarily of the pension fund of Carnegie Corporation and the endowments of Phillips Exeter Academy, St. Paul's School, and Amherst College. Trust accounts soon followed from George Whitney and others, including the extensive estate of J.P. Morgan.

The firm's first public stock offering was issued in 1942. In 1959, to boost its capital base and lending limits, the firm merged with the much bigger Guaranty Trust Company, an old New York institution, to form Morgan Guaranty Trust Company, the principal subsidiary of J.P. Morgan & Co. Incorporated.

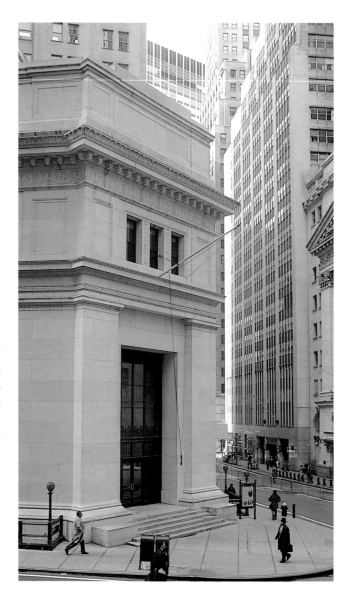

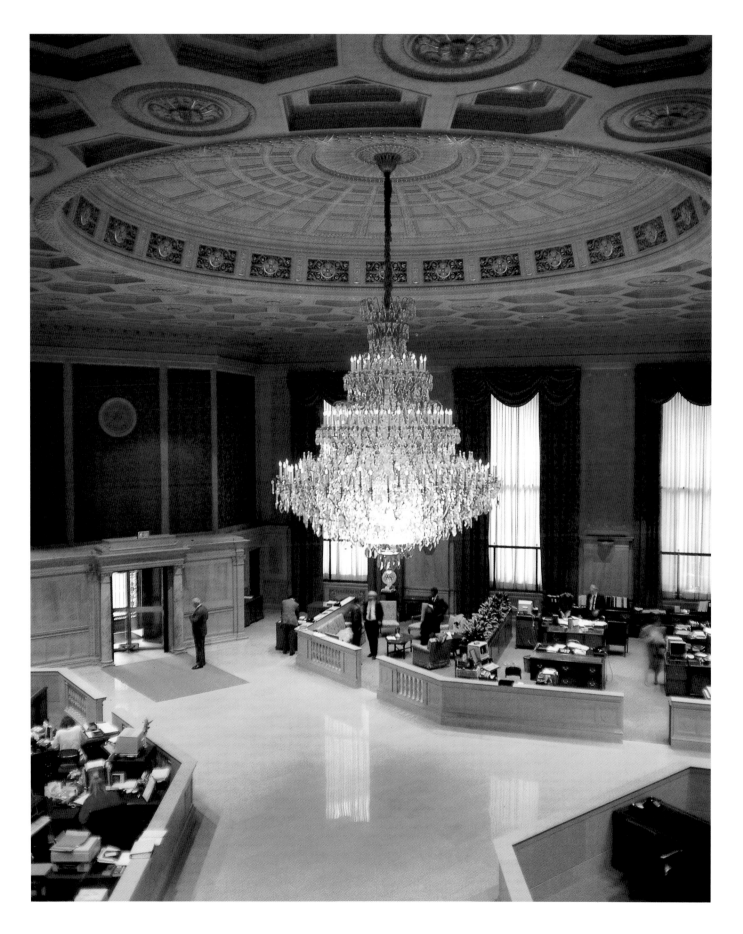

J. P. Morgan & Co.

The firm's new headquarters at 60 Wall Street was erected in 1989, designed by Kevin Roche, John Dinkeloo & Associates. The 47-story structure replicates the elements of a classical column.

In that same year, Morgan won back the right to underwrite corporate debt securities in the United States, powers that had been suspended by the passage of the Glass-Steagall Act of 1933. Equity underwriting permission followed in 1990. The firm's July 13, 1989 offering of 9.20% notes for the Xerox Corporation marked the first corporate debt securities offering underwritten by a commercial bank affiliate in the United States since the enactment of Glass-Steagall. In 1997, just eight years later, the firm managed more than $104 billion in combined debt and equity issues in the United States—a figure that made Morgan the fourth largest securities underwriter in the world.

Innovation remains a Morgan hallmark. As more and more borrowers and investors have turned to the securities markets to either raise or provide capital, Morgan has established market-making prowess across all asset classes in both emerging and developed markets. (The fixed income trading floor is shown here.) The firm trades the securities of more than 50 countries, and is the largest trader in emerging markets.

Few institutions have played as prominent a role as J.P. Morgan in the development of modern global finance. Many of the clients that the firm first served during the 19th and early 20th centuries maintain relationships with Morgan today, as do a wide and growing variety of individuals, governments, and business enterprises for which the firm provides access to debt and equity capital, advice on strategy and capital structure, research, risk management, and a complete range of trading capabilities.

J.P. Morgan's core values, defined years ago by the Morgans themselves, are described today as ethics, teamwork, respect, merit, excellence, and development. The last illustrates Morgan's commitment to drawing out the potential of every employee at the firm.

A sign of Morgan's dedication to the development of its people is the conversion of the firm's historic headquarters at 23 Wall Street into the most advanced conference and training center in the financial district. The center, which opened in early 1997, hosts Morgan's entry-level, mid-career, and project-specific training programs.

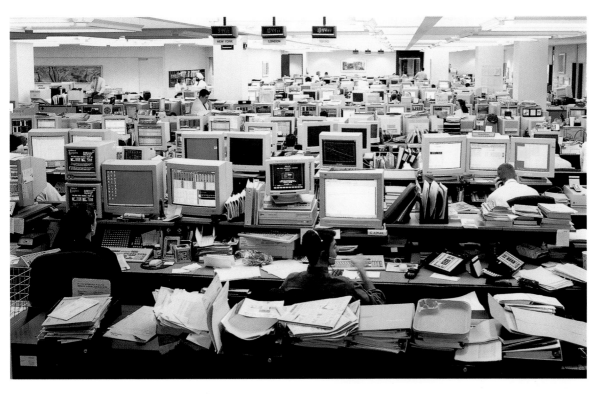

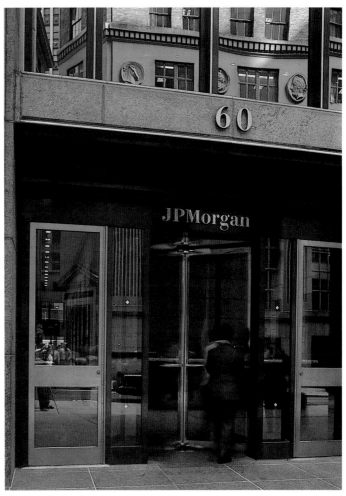

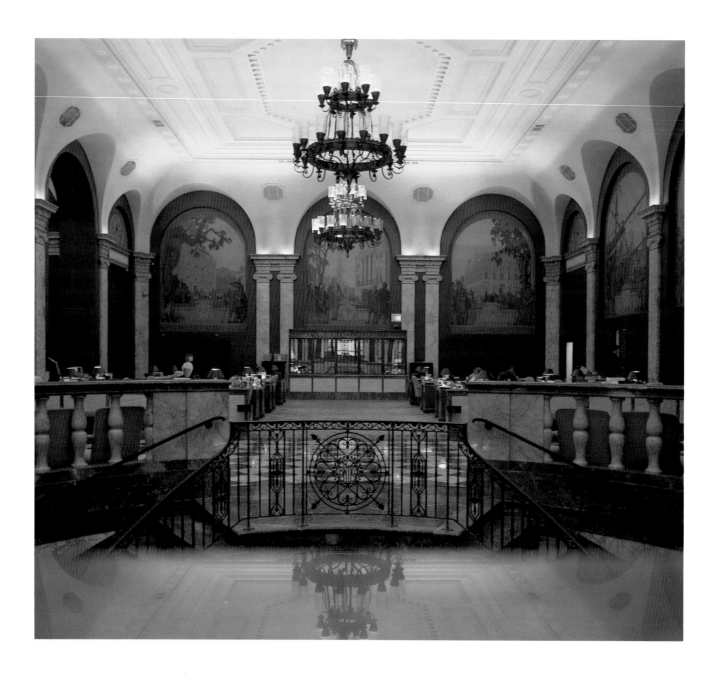

The Bank of New York at 48 Wall Street

Established by Alexander Hamilton in 1784, this is New York's oldest bank and one of only a handful of U.S. Corporations that have existed for over 200 years. The bank was organized at the end of the Revolutionary War, when the population of New York had been depleted by half and the Continental currencies were worthless. The bank was capitalized with specia, precious metal coinage of foreign governments (Bavaria, Venice, France, and Spain, for example). There was no federal coinage until 1792. In New York the unit of exchange was the Spanish silver doll. Thus, the need to establish a bank, to accept deposits and issue notes, was apparent.

Banks were not universally favored, however,. In fact, many voiced them as inherently evil because they ban-

ished gold and silver and substituted paper. Their fees were questioned, as was the interference with the rapport between known creditors and debtors. However, The Bank of New York continued to sail its course and gradually proved the need for a central credit institution to enable the city's economy not only to recover to pre-war levels but expand beyond.

In 1797 The Bank of New York moved to a new two-story Georgian building at the corner of Wall and William Streets. It has been located here ever since, except for a brief period in 1799 when it moved to Greenwich Village after an outbreak of yellow fever that took 10 percent of the city's population.

A new building for the Bank was built in 1857-58 at 48

Wall, designed by Calvert Vaux, an English architect who collaborated with Frederick Law Olmstead in the design of Central Park. The building was expanded through the addition of two upper floors in 1879. This permitted an innovation—a luncheon room for officers and clerks. Until well into the twentieth century precise rules of conduct were observed. Each employee ate at a prescribed time and sat at an assigned seat under the watchful eyes of supervisors; female employees sat at separate tables. But the savings to the staff through lunches purchased on the premises, and the savings of time otherwise lost by workers going out, convinced the bank that this was a wise program.

The Bank of New York merged with the New York Life Insurance and Trust Company (established in 1830) in 1922; with the Fifth Avenue Bank in 1948; the Empire Trust Company in 1966; the County Trust Company in 1969; and with Irving Trust Company in 1988. Today the Bank's parent, the Bank of New York Company Inc., ranks as one of the largest bank holding companies in the United States.

The magnificent Renaissance Revival building at 48 Wall Street shown in these photographs was designed by Benjamin Morris and completed in 1928. Morris also designed the Cunard Line Building at 25 Broadway. In 1998 the bank consolidated its Wall Street operations in a much larger building at One Wall Street.

The Bank of New York at One Wall Street

This extraordinary Art Deco-inspired interior was created for the Irving Trust Company, which merged with Bank of New York in 1988. The Irving headquarters, previously located in the Woolworth Building (a major client), moved to One Wall Street in 1932. Its building, including a lofty fifty-story limestone tower, was designed by Voorhees, Gmelin & Walker.

The main banking hall is believed to be the only room in the world entirely covered with mosaic tiles. Its ceiling is 37 feet high, and the interior was adapted from the *Stadshuser* (city hall) in Stockholm. The mosaic tiles are gold, orange, and red. They were manufactured in Berlin and account for approximately 9,200 square feet. This is the largest installation of mosaics in modern times.

On the 49th floor the bank built its equally unique board of directors' room and observatory. The ceiling is covered with iridescent kappa shells from the Philippines.

The Irving Trust Company was founded in 1851. Since there was not yet a federal currency, each bank issued its own paper and those institutions with the most appealing names found their certificates more widely accepted. Some banks, such as the Bank of the Metropolis, tried the imposing image. Irving selected another route and named the bank after Washington Irving, an author, diplomat, and lawyer who had gained an international reputation as America's first man of letters. His portrait appeared on the bank's notes and contributed to their wide appeal.

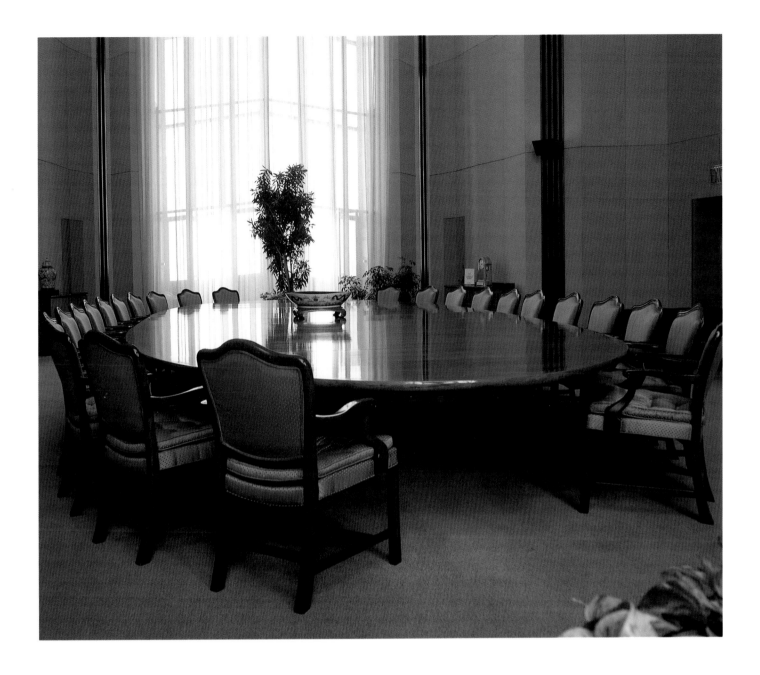

By the turn of the century, Irving began to acquire nine of the city's many banking institutions such as the New York Exchange Bank in 1912 and the Mercantile National Bank in 1913. Also in that year, it relocated to new quarters in the Woolworth Building, which it occupied until moving to One Wall Street in 1931. Only two other structures are known to have occupied the site at Wall Street and Broadway, one of which by coincidence housed the law offices of Washington Irving.

Today, The Bank of New York is the principal subsidiary of The Bank of New York Company, Inc., one of the largest bank holding companies in the United States. With over $4.4 trillion in assets under custody, the bank is one of the largest custodians for institutional and personal assets in the world. It is the leading issuer of American and global depositary receipts with more than a 60% market share and is also the leader in corporate trust, representing over 60,000 issues and more than $600 billion in principal. The bank is a leading stock transfer agent, handling this function for more than 1,200 corporations and 11 million shareholders. The Bank of New York has the largest retail branch network in suburban New York, New Jersey and Connecticut, and it is the largest asset-based lender in Canada, the United Kingdom and the second largest in the United States. It is one of the largest lenders to major American corporations and has a long and distinguished history in the area of private banking, personal trust and investment management.

55 Wall Street

This is one of Wall Street's grandest interiors. Originally designed for the Merchant's Exchange by Isaiah Rogers and completed in 1842, it represents a unique blend of monumental engineering. It was built on the site of an earlier exchange destroyed by the Great Fire in 1835 and has a fireproof insulated floor (adopted from the English Mills.)

From 1863 to 1899 this was the United States Custom House and after that, the headquarters of the First National Bank, which was founded in 1865. The National City Bank, which was known in 1929 as the City Bank Farmers Trust Company, was located at 20 Exchange Place. When First National Bank merged with the latter

in 1955, they simply joined their offices with an overhead bridge across Exchange Place.

Presently, 55 Wall Street is owned by a group of private investors and is operated by the Cipriani family. The interior space, which includes the largest display of Wedgewood in the world around the central chandelier, serves as one of New York's grandest meeting places. This family is best known for Harry's Bar and Hotel Cipriani in Venice. They also operate the famous Rainbow Room in Rockefeller Center. A new European-style hotel with one hundred and forty-two guest suits will occupy the upper floors of 55 Wall Street.

Brown Brothers Harriman & Co.

The painting in the partners' room shows four brothers, George, John, William and James, circa 1860. The statue in the entrance rotunda is of Alexander Brown, father of the four.

Brown Brothers Harriman & Co. is America's oldest and largest private bank. The firm traces its origins to December 1800, when Alexander Brown emigrated from Ireland and established an "Irish Linen Warehouse" in Baltimore, where he would eventually be joined by his four sons. John A. Brown & Co. was established by the third son in Philadelphia in 1818 and it is from this firm that the present-day Brown Brothers Harriman & Co. descends.

The early years as a merchant bank in 1818 provided Brown Brothers Harriman & Co. with access to a growing global financial network. These international activities forged profitable financial alliances around the world, many of which still exist today. They also led the firm into related areas such as foreign exchange, corporate advice and personal banking.

Today, Brown Brothers Harriman & Co. remains an owner-managed partnership that provides financial ser-

vices in six key areas: commercial banking, corporate finance, investment management, securities brokerage and research, foreign exchange and global custody. With offices in major financial centers both domestically and abroad, the firm's clients range from financial and multinational institutions to family-owned businesses and individuals.

Recognized worldwide for its strong client-oriented service, Brown Brothers Harriman & Co. is identified for its substantial global reach, high credit ranking and ability to provide personalized financial expertise to a select group of institutional and individual clients.

Brown Brothers Harriman & Co. maintains a unique position in the financial community as one of Wall Street's most enduring partnerships. The partners manage the firm on a daily basis, participate extensively in client relationships and hold unlimited liability for its obligations. It is through this structure that Brown Brothers Harriman has been able to successfully anticipate and respond to changing economic and financial environments for over 180 years.

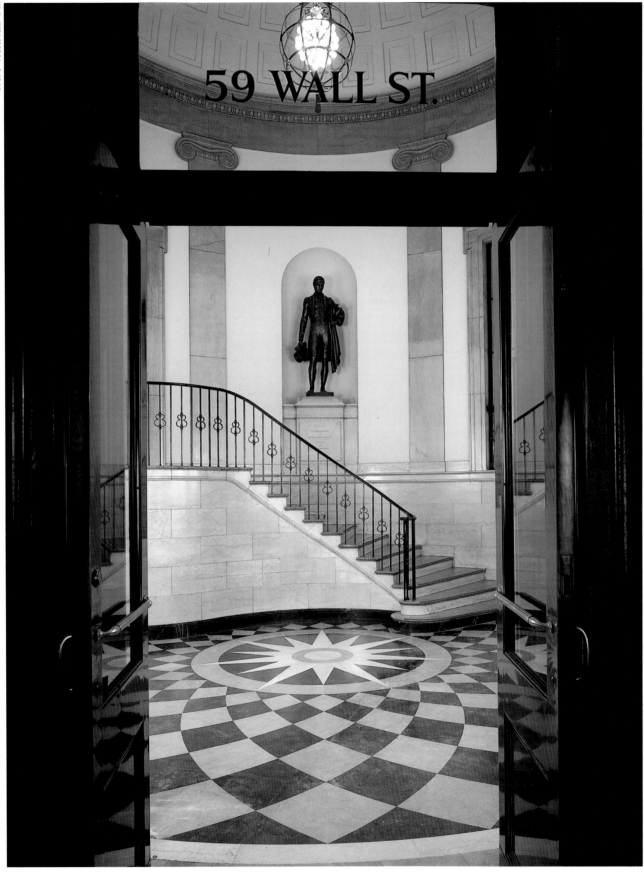

59 WALL ST.

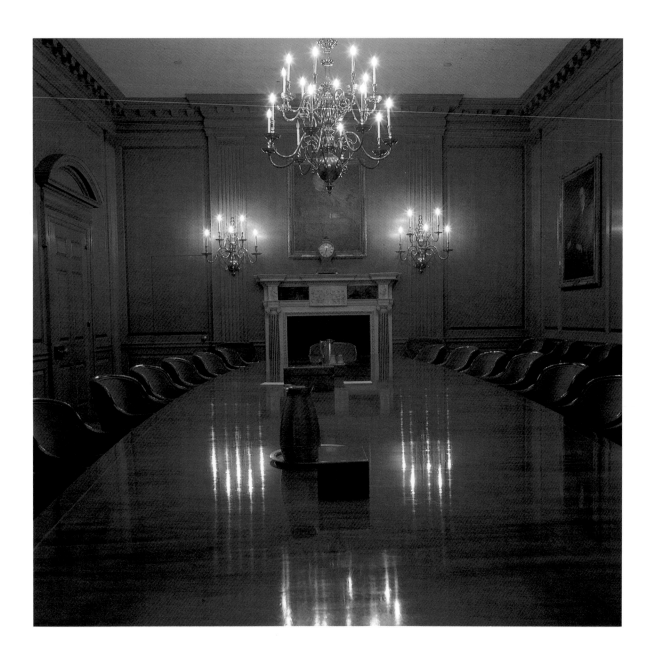

U.S. Trust Corporation

Organized in 1853, this is the nation's oldest trust company. One of the founders was a young actuary with the United States Life Insurance Company in New York, John Stewart, whose idea was to start a company to act as executor and trustee for the funds of individuals and corporations. By June 10, 1853, the Trust Company had organized a board of trustees of thirty prominent New York merchants, bankers, industrialists, and civic leaders (including the mayor of New York). The offices were in rented space at 40 Wall Street—The Bank of The Manhattan Company.

In those days the variety of investments was limited at best. Fixed-income securities were available only from the federal government, three states and three railroads. On the New York Stock Exchange, shares of just twenty-four companies were traded in 1853: eleven railroads, three banks, three insurance companies, three coal companies, two mining companies, one canal company, and two other enterprises.

The first corporate trust account came in 1855, when the United States Trust Company of New York was named registrar for the New York Central Railroad. But banking business via commercial and personal loans was the mainstay of the Trust Company's operations. In 1868 the trans-continental railway link was completed, opening up the West Coast to the commerce and industry of the East. U.S. Trust participated in this growth, but then there were setbacks—financial panics in 1874 and again in 1884. The

Trust Company's conservative management enabled it to ride out the storms, and by 1886 it led all other New York banks in deposit rankings with a total of just over $30 million.

In 1889, prompted by an increase in its business. U.S. Trust moved to a new nine-story edifice at 45 Wall Street. It occupied the same site for over 100 years, a remarkable accomplishment for any organization, few of which have survived such a long time. Additional offices were opened, in 1979 on 54th Street next door to the University Club, in 1981 at 770 Broadway—the old Wanamaker Building—and in 1988 at 100 Park Avenue near Grand Central Terminal. Its headquarters were relocated to a newly constructed building on 47th Street in 1989. During

the 1980s U.S. Trust began a selective national expansion strategy and now has offices in California, Connecticut, Florida, New Jersey, New York, Oregon, Texas and Washington, D.C.

Today, U.S. Trust provides a wide variety of trust, investment, and banking services to clients throughout the country. Its family of Excelsior Funds is well known in the industry, and several are leaders in their respective categories. Clients include individuals, corporations, institutions, governments, and fiduciaries. It is one of the largest managers of personal wealth in the country.

Bankers Trust Corporation

This company was founded in 1903 as a trust company for commercial banks which were precluded from engaging in trust business at the time. Therefore, in fact as well as in name, it was a trust company for banks. The banks were not allowed to perform any fiduciary services, and it is for this principal reason that J.P. Morgan and other colleagues were instrumental in the forming of Bankers Trust Company.

With the passage of the Federal Reserve Act of 1914, which granted trust privileges to national banks for the first time, Bankers Trust decided, for competitive reasons, that it should enter commercial banking on a full scale. It acquired the Astor Trust Co. in 1917 and, in 1922, was one of the first American banks to open an office in London. Its trust activities flourished during the 1930s as the bank was called upon to act as trustee in the safekeeping of collateral and in reorganizations.

World War II brought many changes in the way Americans lived and did business. The bond campaigns made investors of many people who never before had owned securities of any kind. Checks were being used by many people whose only banking contact in past years had been a savings account.

Beginning in 1951, the bank entered the retail market and expanded its operations in the state as well as worldwide. It saw the need of additional capital and offered $100 million of 25-year, 4½% capital notes in 1963, the first issue of its kind by a major bank. With the annual volume of customer checks reaching 120 million by 1962 and growing at the rate of 65,000 a day, the bank pioneered in check processing systems and was the first in New York to provide checks with magnetic ink code numbers.

New facilities were built at 280 Park Avenue in 1962 and at One Bankers Trust Plaza, 130 Liberty Street in 1974. Expansion continued overseas with the opening of offices in 35 countries. Its non-banking activities have reached the point where Bankers Trust is a major participant in private placements, mergers and acquisitions, currency transactions, and securities underwriting. Bankers Trust sold nearly all of its retail branches in 1979 and 1980, concentrating more on wholesale banking and trust activities.

Recent years have seen Bankers Trust establish itself as a truly global organization, with half of its revenue derived from activities overseas. By the mid-1990s, it ranked among the world's leading high yield securities underwriters and began a series of strategic acquisitions to

strengthen its global merger & acquisition, and equities capabilities.

In 1996 it acquired the mergers and acquisition firm, Wolfensohn & Co. and the next year it acquired the nation's oldest investment bank, Alex, Brown & Sons. In 1998 it added NatWest Capital Market's European cash equities business, a leading European research house. It has thus become a fully integrated global investment bank. Bankers Trust Corporation is the seventh largest US bank holding company with over $157 billion in assets, 18,000 employees, and offices in over 55 countries. It has over $335 billion in assets under management, making it one of the largest investment managers in the world. It is also a leading provider of securities processing services, with $2 trillion in global assets under custody.

Sixty and Forty Wall Street

(Opposite) J.P. Morgan & Co.'s new office tower at 60 Wall Street was completed in 1989, designed by Kevin Roche, John Dinkeloo & Associates. This fifty-five-story building replicates, in contemporary terms, the elements of a classical column (base shaft and capital). Its height was made possible through the transfer of air rights from 55 Wall Street.

(Above) Forty Wall Street was built in 1929 by Craig Severance and Yasuo Matsui as the headquarters of the Bank of the Manhattan Company, which had originally been organized in 1799 at this same location.

For many years, some of Wall Street's greatest firms were located at 40 Wall Street including Loeb, Rhodes & Co. and Bache & Co.,each with their private entrances, and Kuhn, Loeb & Co. and White, Weld & Co. In more recent years, Manufacturers Hanover Trust Company and foreign affiliates such as Deutsche Bank Capital Corporation and The Toronto-Dominion Bank were headquartered here. Today, the building has been entirely renovated by the Trump Organization as a first class residential structure.

The Chase Manhattan Bank

This is the largest banking firm in the United States with assets of $388 billion. It is among only a handful of truly global financial institutions, with operations in fifty-two countries around the world. *(Above)* Two hundred years of banking history is housed in The Chase Manhattan Corporation's world headquarters at 270 Park Avenue. The building, originally the home of Union Carbide, was later bought by the Manufacturers Hanover Corporation. With the latter's merger with the Chemical Banking Corporation in 1991, the building became the headquarters for the new entity which took the Chemical name. And with the historic 1996 Chase-Chemical merger, creating the nation's largest banking company, Chase's name went up on the entrance lobby's red wall. *(Opposite)* Jean Dubuffet's sculpture, "Group of Four Trees" still stands at the original One Chase Manhattan Plaza. It was commissioned in 1972 by the bank's chairman at the time, David Rockefeller.

Today's Chase can be traced to four New York-based institutions, only one of which was initially chartered as a bank. The earliest predecessor was The Manhattan

Company, formed in 1799 to supply water to New York City. Aaron Burr, one of its founders, had the state legislature include a provision in the company's charter that served to allow the formation of The Bank of The Manhattan Company. Banking operations soon superseded the water business, which was phased out in the 1840s. Two manufacturing companies also figure prominently in Chase's past. In 1812, the New York Manufacturing Company was formed. In addition to its primary business of "perfecting brass wire, copper wire, cotton cards and wool cards," the company was allowed a banking operation, which, over a number of years, evolved into the Manufacturers Hanover Corporation.

Chemical Bank's history began in early 1823 as the New York Chemical Manufacturing Company which produced chemicals, medicines, paints and dyes. As with The Manhattan Company and the New York Manufacturing Company, banking soon became more attractive than industrial production.

Chase's fourth predecessor institution and its namesake, the Chase National Bank, was founded in 1877

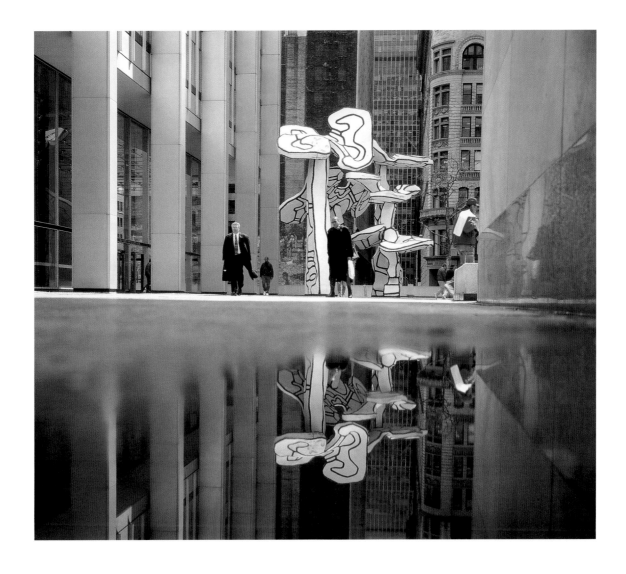

when John Thompson, his son Samuel and three other New York businessmen pooled $300,000 and opened a bank on lower Broadway. It was named for Salmon P. Chase, who, as President Abraham Lincoln's Treasury Secretary, had led the fight for passage of the National Bank Acts of 1863 and 1864. Each of the four early banks played an important role as the United States of the nineteenth century saw geographic and industrial expansion at home, and became increasingly involved in commercial and political activities overseas.

Over the years, the banks also established a tradition of growing through mergers and acquisitions. The Bank of The Manhattan Company joined forces with the Chase National Bank in 1955 to become The Chase Manhattan Bank. In 1961, the Manufacturers Trust Company-Hanover Bank merged, creating a bank strong with New York's medium-sized businesses. Chemical was equally strong in this area, and their 1991 merger created a powerful institution. Chemical was the port of entry for many women executives into the male-dominated industry by way of its management training program. Chase, under the leadership of David Rockefeller, was a preeminent international bank. The combination of Chemical with Chase has created a global institution, with over 70,000 employees worldwide.

Today, Chase concentrates on three basic areas; 1) Chase Global Banking—one of the world's largest and most profitable wholesale banking franchises, serving over 5,000 corporations in 180 countries; 2) Chase Technology Solutions—a custody, cash management and global trust operation with over $4 trillion in assets in global custody and processing over $3 trillion in average daily funds flows; and 3) National Consumer Services—mortgages, credit cards, consumer loans, mutual funds and p.c. banking. It operates the largest branch system in the metropolitan New York area and is the leading bank to small and medium-size firms. Chase is the largest employer in New York City with over 25,000 employees. It is indeed a dominant fixture in the landscape.

The Federal Reserve Bank of New York

Headquartered at 33 Liberty Street, this is the most important of twelve Federal Reserve Banks throughout the country. Completed in 1924, the structure was designed by York & Sawyer to resemble a fifteenth-century Florentine palace such as were built for only the wealthiest merchants. The architects here have used oversized limestone blocks to emphasize the fact that this is a banker's bank. It contains more gold than Fort Knox. In fact, the gold reserves of approximately eighty foreign nations are stored in its vaults, five levels below the street, possibly the largest accumulation of gold in the world. It moves from one account to another, almost never leaving the building.

Inside the New York Fed

(Above) Weighing gold in the Fed's gold vault is a daunting task. Gold from nations around the world is stored in a massive vault in the bedrock of Manhattan—one of the few foundations considered adequate to support the weight of both the vault and the gold inside. It is eighty feet below the street and fifty feet below sea level. Approximately $85 billion worth of gold is stored in 122 compartments assigned to depositing countries. The vault is actually the bottom floor of a three-story bunker of vaults arranged like strongboxes stacked on top of one another. The massive walls surrounding the vault are made of steel-reinforced structural concrete.

There are no doors into the gold vault. Entry is through a narrow ten-foot passageway through a 90-ton steel cylinder that revolves vertically in a 140-ton steel and concrete frame. The vault is opened by rotating the cylinder 90 degrees. An airtight seal is achieved by lowering the slightly tapered cylinder into the frame, like pushing a cork into a bottle. The series of time and combination locks are under multiple control—no one individual has all the combinations necessary to open the vault.

(Opposite) An interactive lobby exhibition shows how the Federal Reserve System works. The Fed, as the system is called, is composed of twelve regional Reserve Banks. It is responsible for monetary policy, maintaining the liquidity, safety and soundness of the nation's banking system, and assisting the government's financial operations.

Each Federal Reserve Bank plays an important role in operating the nation's payment system. Monetary tools are: open market operations, discount window lending and reserve requirements. The principal goal of monetary policy is to encourage non-inflationary economic expansion.

The New York Fed is responsible for open market operations, for intervening in foreign exchange markets and for the safeguarding of gold reserves of foreign countries.

The Federal Reserve Bank of New York

The West Lobby of the New York Fed leads to its U.S. Treasury securities sale and redemption center. Here, the Fed handles some of the work necessary to allow the U.S. Government to borrow from the public. Although most transactions take place electronically, thousands of people visit the New York Fed each year to obtain information or buy U.S. Treasury securities.

High above the gold bars and trading activity is the bank's loggia, which offers a magnificent private space from which to oversee Liberty Street and the East and Hudson Rivers beyond. This is one of the many Florentine touches that were successfully incorporated by chief architect, Philip Sawyer.

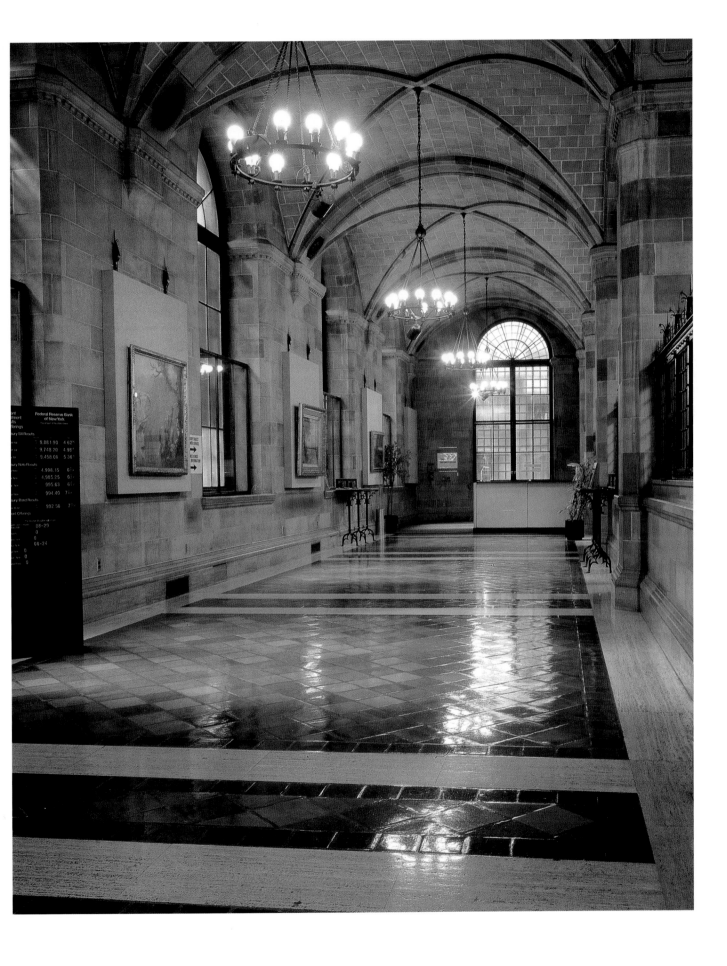

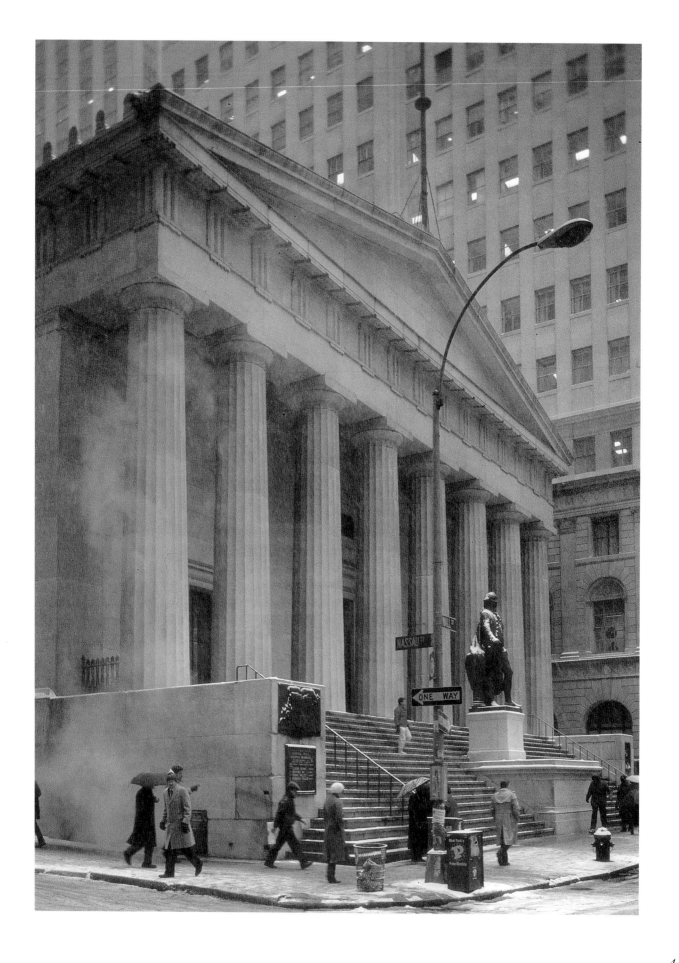

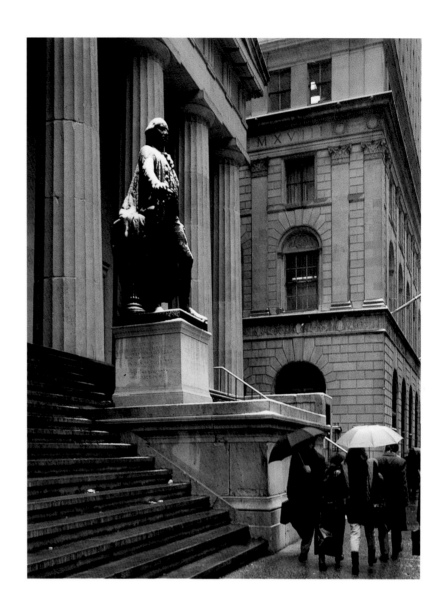

Federal Hall National Memorial

Located at 26 Wall Street, this is the finest example of a Greek Revival temple in New York. The design by Ithiel Town and Alexander Davis is inspired by the Parthenon, but the original dome was modified into a rotunda with a deep entablature and a two-story colonnade.

The building was completed in 1842, replacing the original Federal Hall where George Washington was sworn in as the country's first president in 1789. It served as the nation's Custom House until 1862 and then as the United States Subtreasury until 1920. It has been a Federal monument since then.

President George Washington

The statue of George Washington in front of the Federal Hall National Memorial is where he was sworn in as the nation's first president in 1789. New York City was then the capital, and, although the war had ended six years earlier, the nation still had some disagreements among the states.

Just to the right is the former Seamen's Bank for Savings at 30 Wall Street, also home for many years to Kuhn, Loeb & Co. This building was designed by York & Sawyer in 1919 as the United States Assay Office. Seamen's Bank, which was organized in 1829 as one of the first savings banks in the country, moved here in 1955.

One Wall Street

This has been headquarters of the Irving Trust Company prior to its 1989 acquisition by the Bank of New York. This Art Deco structure was built in 1932 and designed by Voorhees, Gmelin & Walker. On the side of the entrance to One Wall Street is a plaque commemorating the history of the street. In 1653 a wall of planks and rails was erected to protect Nieu Amsterdam from invasion by both Indians and the British. It extended across the island to Pearl Street and was called *de Waal*. The attack did not come until eleven years later, by sea, and the wall never served its purpose. The British tore it down in 1699.

Lee Higginson & *Co.*

The Greek temple at 37 Broad Street was built in 1932, designed by Cross & Cross as the headquarters of Lee Higginson & Co., one of the greatest names in investment banking during the first quarter of this century.

While many firms survived the stock market collapse of 1929, Ivar Kreugar, the "Swedish Match King," dealt a near-fatal blow to venerable Lee Higginson and a handful of other firms, including J.P. Morgan, duping them out of over a quarter of a billion dollars and then committing suicide in his Paris apartment in March of 1932. Lee Higg, as it was known, eventually disappeared into Hayden Stone in 1966. Its building was long ago taken over by Bank of America's International operations who have now, in turn, let this magnificent temple be occupied by a dress shop.

Fraunces Tavern

This tavern at 54 Pearl Street is largely a reconstruction of the original Georgian-style residence and tavern. Its reconstruction, completed in 1907 by William Mersereau, was based on a house originally built in 1719 as a residence for Etienne de Lancey, who sold it in 1762 to Samuel Fraunces, an innkeeper. The New York State Chamber of Commerce was founded here in 1768 during a meeting called to protest British trade policies. And six years later American patriots met here to plan New York's version of the Boston Tea Party. George Washington made his farewell address to his troops here on December 4, 1783. Six years later and a few blocks away he was inaugurated as first president of the United States, at Federal Hall. Samuel Fraunces was there as his steward.

This site was the entrance to Nieu Amsterdam. Pearl Street ringed the edge of the city and Broad Street was originally a canal extending up to where the Dow Jones Building was, just short of Exchange Place. In 1614, Captain Adriaen Block launched the *Onrust* at this intersection, the first ship built on Manhattan. His previous ship had burned the year before, forcing him and his crew to construct what were to be the first Dutch dwellings here and spend the winter. Captain Block returned to the Netherlands in 1614, sailing up the coast of America and discovering Block Island, for whom he is best remembered, on his way home.

Coenties Slip and Pearl Street

Pearl Street is named for the oyster shells that once lined the shores of the city and were used to pave this street. Its neighbor, Stone Street, was the first to be paved with cobblestones. Coenties Slip was named for a Dutch family who once lived here. The slip was filled in around 1835.

The first City Hall originally stood at this intersection on Pearl Street. It was built in 1642 originally as an inn for the many traders and settlers who were crowding into the city. In 1653 Peter Stuyvesant turned the inn into the *Stadt Huys*. In the photograph are nineteenth-century warehouses of the Fraunces Tavern Block Historic District, built primarily from 1829 to 1858 on the city's first landfill, which dates back to 1689.

The expansion of new buildings in the Wall Street area was enhanced by the demolition of the Pearl Street Elevated in 1950-51. Fifty-five Water Street was built in 1971 by Emery Roth & Sons—the largest privately financed office building in the world at the time.

The Coenties Slip buildings were threatened by a plan for a parking lot but were granted national landmark status in 1977 (and local status the following year). They are now referred to as the Fraunces Tavern Block Historic District.

One of the casualties, however, was the old Seamen's Church Institute Building (1909-1969) which resembled more of a downtown "Y" than anything else. But its vast cafeteria steam tables provided affordable lunches. During my first summer at Glore, Forgan & Co., I had colleagues in similar underpaid management apprenticeships at Kuhn Loeb; F.I. du Pont; and Goodbody. We would meet regularly at the Seamen's Institute for cheap lunches; we always referred to it as "the Yacht Club."

When Goldman Sachs began construction of its new facilities at 85 Broad Street, it unearthed remains of seventeenth-century dwellings, which are now carefully preserved in glass-topped sidewalk displays.

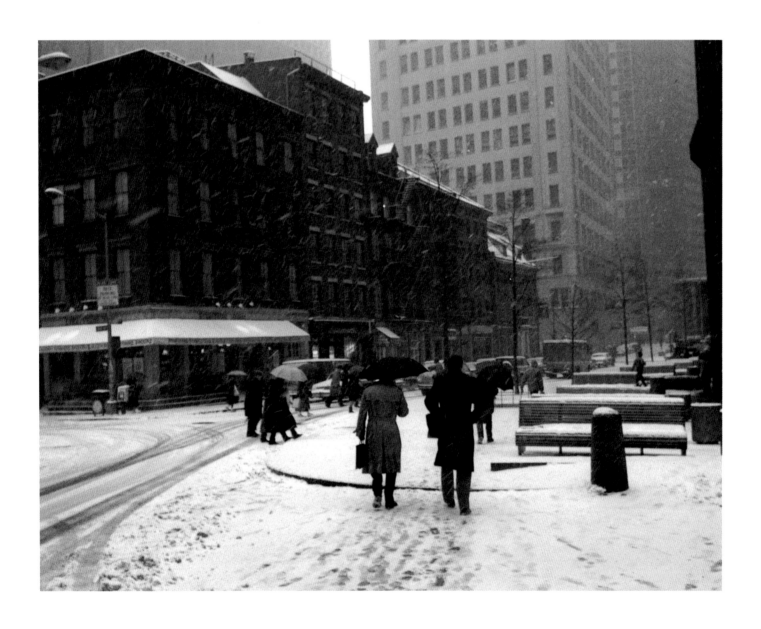

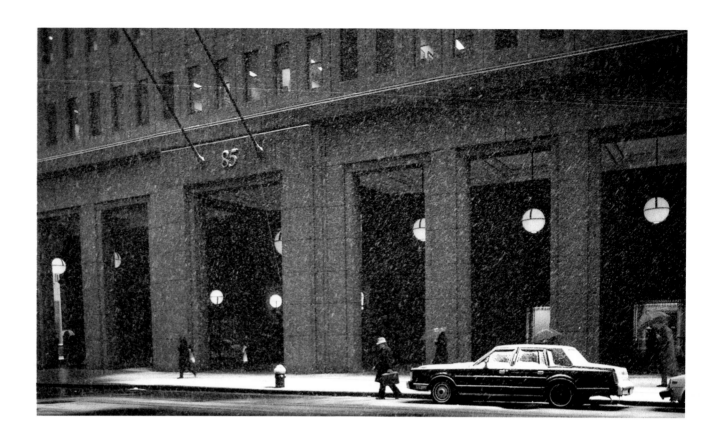

Goldman, Sachs & Co.

The headquarters building of this firm at 85 Broad Street, designed by Skidmore, Owings & Merrill was completed in 1983. Its lobby curves to conform to the shape of Stone Street over which it was built. Originally this site was purchased by Lehman Brothers, who were going to build their own new headquarters to replace the cramped One William Street offices. But the economic downturn of 1973-75 changed all that, and now Goldman Sachs, its friendly competitor for many years, occupies the spot instead.

In 1882 Marcus Goldman and Samuel Sachs formed a partnership to continue a commercial paper business which had been started by Goldman in 1869. It has operated under the name Goldman, Sachs & Co. since 1885.

From the early days when Marcus Goldman would walk the streets of Manhattan negotiating trade receivables among merchants and banks, stuffing the receipts in the lining of his top hat, the firm has maintained a unique, close-knit entrepreneurial spirit. When asked some years ago if Goldman Sachs had a new business department, Walter Sachs replied that "Goldman Sachs & Co. is a new business department."

The firm joined the New York Stock Exchange in 1896 and entered the field of investment banking in 1906, when it co-managed its first public offering for United Cigars Manufacturers which is still one of the firm's clients. Goldman Sachs was a pioneer in underwriting public offerings and brought many issues to market for well-known names in retailing and consumer goods manufacturing. In the 1930s, the firm began making markets in securities, and it developed institutional and individual sales departments.

In 1956, Goldman Sachs was co-manager of the first public offering of Ford Motor Company common stock, the largest equity offering ever undertaken and a major event in corporate finance history The syndicate contained an unprecedented number of underwriters—seven hundred twenty-two—clearly the greatest assemblage of firms ever. Partners of firms competing to manage the offering all began driving Fords that year.

Today, Goldman Sachs is a leading, full-service investment banking firm. There is practically no financial activity they are not involved with. The difference is that Goldman does its business with a degree of professionalism that has been admired by many, and envied by some, for decades. Its culture fosters the team approach which derives from its long heritage as a partnership. There are few individual stars at Goldman, and everyone is rewarded handsomely. The firm has approximately 11,500 employees in thirty-eight offices. It has occupied various Broad Street sites, primarily nos. 20, 55, and 85 for almost fifty years.

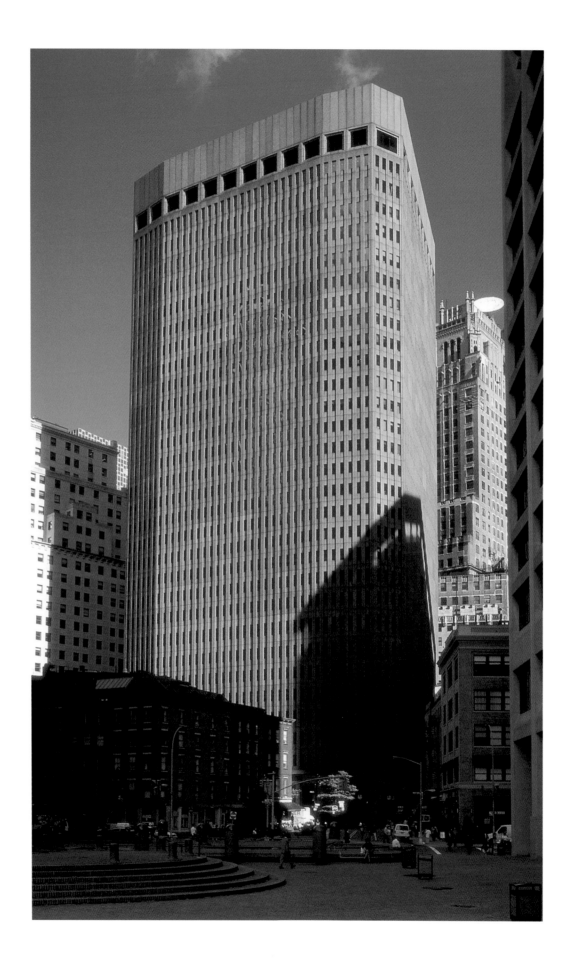

Bloomberg L.P.

This is one of the great success stories in finance. Founded in 1981 by the son of a Boston bookkeeper, this company has grown to become one of the world's leading information services organizations serving customers in 100 countries around the world. It employs over 4500 people in nine sales offices, two data centers and 80 news bureaus worldwide.

Michael Bloomberg began his career in the "cage" of Salomon Brothers & Hutzler. His first job was counting bond certificates and registering them in the firm's inventory. He then moved on to the equities department and eventually the fixed-income department, trading stocks and bonds in bulk. At that time on Wall Street, the back office and the salesmen worked on computer terminals but they did not interact.

If a salesman needed a bond yield there was no information in the computer, so they had to look it up in a book or use a calculator. Mr. Bloomberg convinced management that all salesmen should have a computer at their desks connected to a mainframe computer. His reason-

ing was simple, if the Salomon salesmen had the best information they would make the best trades. As a result, the salesmen were liberated by having ready access to necessary information. Being a trader, he understood the needs of his salesmen and their customers. And being an engineer by background, he understood the necessary technology.

When Salomon announced its merger with Phibro Corp. in 1981, Michael Bloomberg was one of many who left the firm. He took his severance, formed a partnership with three former colleagues and set about convincing Merrill Lynch Pierce Fenner & Smith that his black information box could offer its traders and salesmen a variety of information including yield curve analyses, the ability to track every transaction, marking to market all inventory instantaneously, with a secure e-mail system to communicate with customers, suppliers and co-workers. No one else offered these features. A Merrill Lynch executive said the company could build the same system. Bloomberg offered to do the job in six months with

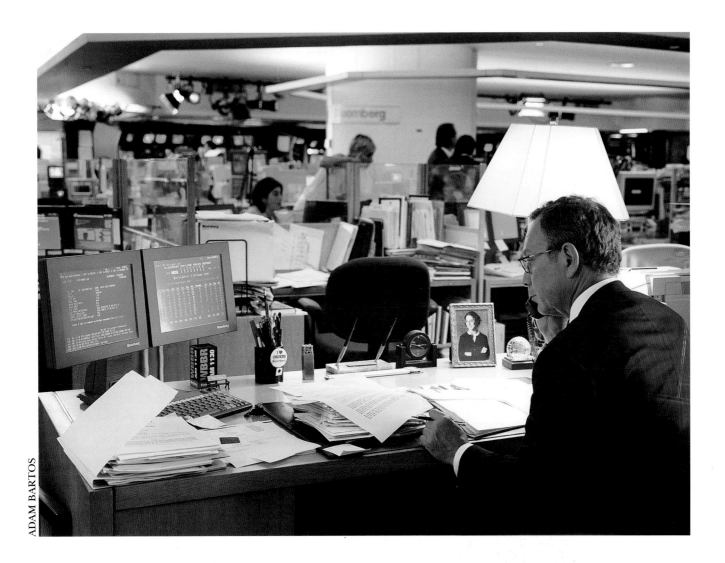

Merrill being under no obligation to buy it. The offer was accepted. Merrill ordered 1,000 terminals and took a thirty percent interest in the new company. The partnership still continues although Merrill recently sold a third of its interest back to Bloomberg.

Today there are about one hundred thousand computer terminals around the world built on the basic premise of serving the customer all information necessary. The system generates real-time worldwide pricing of bonds, stocks, commodities, currencies, money market instruments and mortgages. It has news of corporations and filings with the Securities & Exchange Commission stretching back over ten years. Its data library includes information on sixty-five thousand companies using eight hundred categories of information. It allows clients to buy or sell stocks, bonds, and even airline tickets.

The company has expanded into radio and television news, beginning in 1992 with the purchase of WNEW-AM in New York. Television stations provide twenty-four hour news service in French, German, Italian, Japanese and Spanish (as well as English) around the world. Bloomberg News has over seven hundred reporters and editors in eighty of the world's major cities. News stories are syndicated without charge in over eight hundred newspapers. Bloomberg simply asks for a byline for the article. Name recognition is one of the cornerstones of the company. With the black boxes, radio, television and the new magazine, it seems to appear everywhere.

Subscribers pay a fixed price for everything the classic Bloomberg box can offer. It has two monitors, one keyboard and over four thousand functions. The key to its real-time capabilities—instantaneous quotes, functions and analytical communications—is a high speed network using dedicated digital phone lines allowing for interactive communication. It is regarded by most as simply the best in the industry.

There are no private offices or corporate titles at Bloomberg L.P. Everyone is on a first-name basis, casually attired and motivated from being on a remarkable, winning team.

Steamship Row Lobbies

(Above) The facilities at the Cunard Line Building, 25 Broadway, are now occupied by Standard & Poor's Corporation, and those at One Broadway by Citibank. This area was once known as "Steamship Row" from the large number of steamship companies maintaining their offices here. Even today, clients of Citibank may elect to enter through either the First Class or Cabin Class entrances. The Tourist Class entrance sign has been removed. Once inside, however, the service is all First Class.

(Opposite) One Broadway was home for many years to the United States Lines, best known for its flagship of the same name. On her maiden voyage in 1952, the *S.S. United States* established a world's record for crossing time between New York and Southhampton: three days and eighteen hours, which still stands today, almost forty years later. Her secret was classified until recently, and then the government decided to let us in on the deal: she had four engines. She also was the only ship built with duplicate machinery, wiring and fittings in case of any mechanical failure.

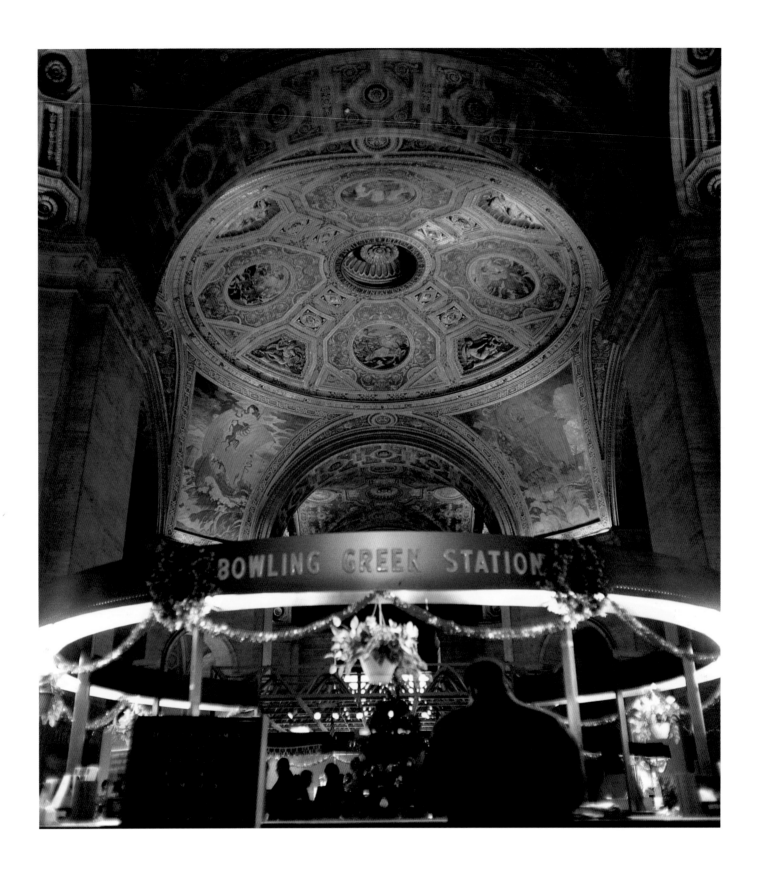

Cunard Line Building

The main attraction of the Cunard Line Building is its booking hall. The dome is sixty-five feet high and the entire space is covered with murals by Ezra Winter and maps by Barry Faulkner. It was a fitting statement for the most prestigious steamship company of a nation that claimed to rule the seas.

Cunard was one of the greatest transportation companies in the world when this building, designed by Benjamin Morris, opened in 1921. Cunard was founded in 1840 and merged with the White Star Line (1871) in 1934. The names of Cunard's ships always ended in "*ia*" such as *Lusitania, Mauretania,* and *Aquitania*. The White Star ships ended in "*ic*" such as *Olympic, Britannic,* and *Titanic*. In 1934, the chairman of Cunard Line, Sir Peter Bates, informed King George that the largest steamship company in the world would build the largest passenger ship and name it for England's greatest queen. King George acknowledged the disclosure and said he was pleased that it would be named for his wife. And thus, in an interesting turn of events, the new ship was christened the *Queen Mary* and not the *Queen Victoria* as Cunard Line had planned, in keeping with its *-ia* nomenclature tradition.

In 1977 the United States Postal Service moved its Bowling Green Station to this location from the Custom House.

The United States Custom House

This distinguished palace is a monumental statement to New York's role as a great seaport. It was designed by Cass Gilbert and completed in 1907. Gilbert also designed the Woolworth Building. If the latter, with its elaborate Gothic interior and mosaic icons, is referred to as the "Cathedral of Commerce," then the U.S. Custom House is certainly the "Temple of Commerce."

Because of the preeminence of the port of New York, this was the largest custom house in the country, and, prior to the creation of a federal income tax in 1913, it was the largest collector of funds for the government. Therefore, its grand structure seems fitting. Together with Grand Central Terminal, it is one of the greatest Beaux Arts buildings in New York. It was built using the latest technology but is wrapped in the exuberant decoration and expansive forms characteristic of the 1860s and 1870s—a rich display to convey the image of power and wealth and called Beaux Arts style after the Ecole des Beaux-Arts in Paris.

For many years the Customs Service was located in the

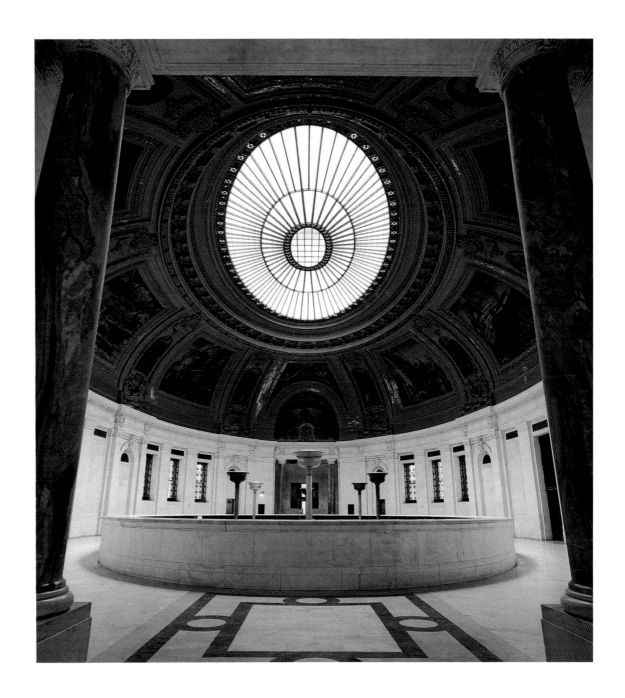

Merchants' Exchange building at 55 Wall Street. But it had outgrown its space at the turn of the century, a time when the United States had become a significant world power with a strong navy and manufacturing capacity. The government therefore wanted a structure that would reflect its new building.

The building is basically a modern steel skeleton clad in the fashionable Beaux Arts style. The rotunda employs a new vaulting system and contains an elliptical 140-ton skylight matching the shape of the large counter below.

The rotunda is covered with a flat timbrel vault whose technical design traces its origins to Byzantium that was imported to the United States in 1881. The system uses thin clay tiles laid in several layers bound by mortar. The eggshell-thin laminated structure is sturdy, light, and fireproof. Timbrel vaults have also been used at the Cathedral of St. John the Divine and St. Thomas' Church on Fifth Avenue.

Presently, this is the home to the National Museum of the American Indian.

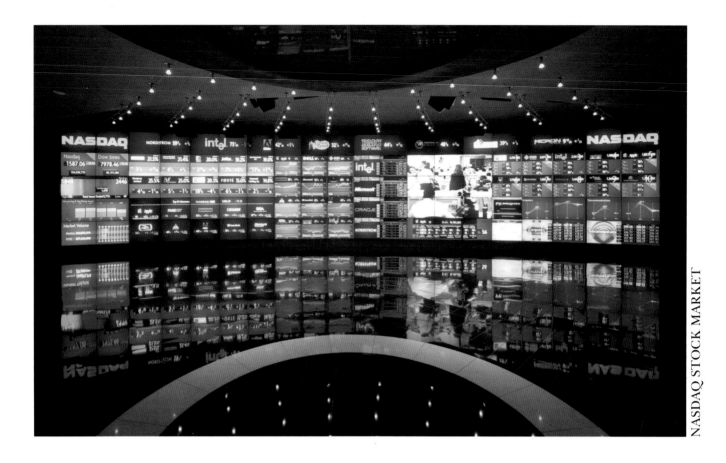

The National Association of Securities Dealers

This is the New York headquarters of the National Association of Securities Dealers. The photograph above shows MarketSite located in the company's offices at 33 Whitehall Street, a building designed by Fox & Fowle and completed in 1986.

Opened in April, 1997, MarketSite is an unusual display of 100 video monitors pieced together on a 55-foot-long installation. It is a digital information system providing price quote updates (often using corporate logos as well as ticker symbols), performance graphs and news reports. MarketSite provides an ever-changing real-time visual panorama of all levels of market activity, clearly the most sophisticated digital display system of its kind. It is used by the broadcast media for news exposure as well as a backdrop to corporate news reports. Recently, it has opened to the general public.

The NASD was organized in 1938 by the securities industry which recognized the need for self-regulation. Presently, all securities firms in the United States that transact business with the public are required by law to be members of the NASD. Its founding mandate was to standardize all principles and practices of trade, to adopt and enforce rules of fair practice, and to foster observance by its members of federal and state securities laws.

In 1963 the NASD began the development and operation of a screen-based securities market, which by 1971 evolved into The Nasdaq Stock Market. In 1997 its dollar volume of almost 4.5 trillion was equal to the combined dollar volume of the London, Paris and Tokyo stock exchanges. It averaged 648 million shares a day, making it the most active stock market in the United States for the third year in a row.

Nasdaq is the first and largest Internet-like electronic network for securities trading, transcending all borders. Its listed securities represent 28 countries worldwide. The regulatory process is facilitated within Nasdaq by on-line, real-time market surveillance conducted by the MarketWatch unit.

In 1998 the NASD established a regulation college, The NASD Academy at New York University. This is a self-funded institution serving industry regulators, compliance officers and legal counsel of securities firms. Investors benefit from increased professionalism and more uniform compliance knowledge.

Also in 1998 the NASD announced its merger with the American Stock Exchange and the Philadelphia Stock Exchange.

Lower Broadway

(Above) The United States Lines Building, One Broadway, originally built as the Washington Building by Edward Kendall in 1884 and *(opposite)* the Standard Oil Company Building, 26 Broadway, designed by Carrère & Hastings and Shreve, Lamb & Blake in 1922.

Just to the right is Eleven Broadway, built in 1893 as the headquarters for Spencer Trask & Co. He and J.P.

Morgan were the original backers of Thomas Edison and were among the first subscribers to electric lights in 1882. Spencer Trask also had his own private branch wire system in 1881, thanks to Edison, and in the area of research, the firm established the first statistical securities department in 1894. Its director, John Moody, eventually branched out on his own with his Moody's Manual.

The Standard Oil Company Building is one of New York's great unappreciated structures. The base of the building follows the gentle curve of Bowling Green Park. The 480-foot high pyramidal tower, however, is set at an angle, aligning with the uptown grid of streets. Thus the building relates to two separate elements—the street level and the skyline. The total composition never appears disjointed. It is an interesting blend of two different environments in one building design.

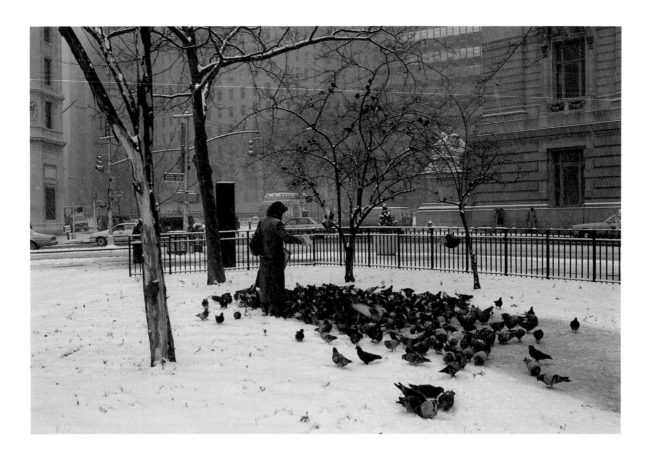

Blessed are the Meek

(Above) A Wall Streeter takes time out during her lunch hour to tend to her flock in Battery Park. A light snow is falling around them.

Blessed are the poor in spirit,
* for theirs is the kingdom of heaven.*
Blessed are those who mourn,
* for they will be comforted.*
Blessed are the meek,
* for they will inherit the earth.*
Blessed are those who hunger and thirst for righteousness,
* for they will be filled.*
Blessed are the merciful,
* for they will be shown mercy.*
Blessed are the pure in heart,
* for they will see God.*
Blessed are the peacemakers,
* for they will be called sons of God.*
Blessed are those who are persecuted because of righteousness,
* for theirs is the kingdom of heaven.*

Matthew 5: 3-10

The Immigrants

(Opposite) This bronze sculpture by Luis Sanguino was installed in Battery Park in 1973. Between 1855 and 1890 an estimated 7.8 million immigrants passed through the Immigrant Landing Depot—now Castle Clinton. The structure was originally a fort and later a concert hall. But as an immigrant station it was overcrowded and ill equipped, forcing the government to relocate to spacious new facilities on Ellis Island in 1892.

In the background of the photograph are three buildings built by Emery Roth & Sons: One Battery Park Plaza (1971), 17 State Street (1989) and One State Street behind it (1969).

Herman Melville was born in 1819 in a house where 17 State Street now stands. The old Seamen's Church Institute, which began in 1834 with a Gothic chapel on a barge to provide pastoral care to sailors away from home, moved here from Coenties Slip in 1969; it lasted less than twenty years at this site. Its previous location, where it had been since 1909, was destroyed to make room for 55 Water Street. This section is known as Battery Park or simply the Battery.

The Battery was the name given to a row of cannons along the waterfront, where State Street is today, from Bowling Green to Whitehall. During the War of 1812, on a pile of rocks offshore was erected West Battery which became known later as Castle Clinton. The landfill in later years connected West Battery to the shore and transformed the area into Battery Park.

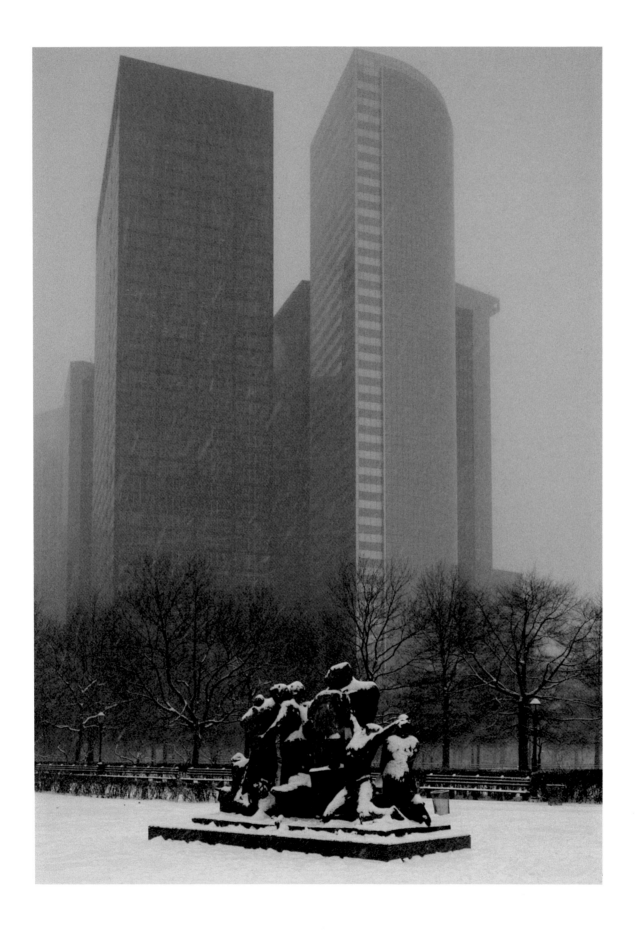

The New York Vietnam Veterans Memorial

(Above) This memorial was designed by Peter Wormser and William Fellows and completed in 1985. The memorial is a translucent wall of glass blocks upon which the letters of New Yorkers who died in Vietnam have been engraved. In a letter to his mother simply signed "Howie," one soldier writes:

"I worry more about the war back home than I do about my own life over here. What good is the peace we accomplish here if we don't have peace in our own back yards?"

This park was originally named Jeannette Park after the luckless ship of the same name that was lost, together with her entire crew, on an Arctic expedition in 1881. The expedition was sponsored by James Gordon Bennett, Jr., of the *New York Herald*, who had named the ship after his daughter. A memorial service to the lost seamen was held here in 1884 when the park was created. It sits on the bed of Coenties Slip.

Wall Street and Trinity Church

(Opposite) At the head of Wall Street, past the Doric columns of Federal Hall, J.P. Morgan's pyramid, and the Art Deco lobby of Irving Trust, is Trinity Church. Sitting astride the nation's most important street. Trinity still commands a presence even surrounded by taller structures. When completed in 1846, its tower made it the Empire State Building of its time—the tallest structure in New York, symbolizing the entire city. Even today it is powerful, making a strong Gothic Revival statement as it stands boldly at the front of the church.

The Street's name derives from the Dutch *de Waal*, a wall of planks and beams erected in 1653 across the island to protect the community from surprise attacks by Indians and the British. However, the attack did not come until 1664 and it was by sea; the wall never really served its purpose.

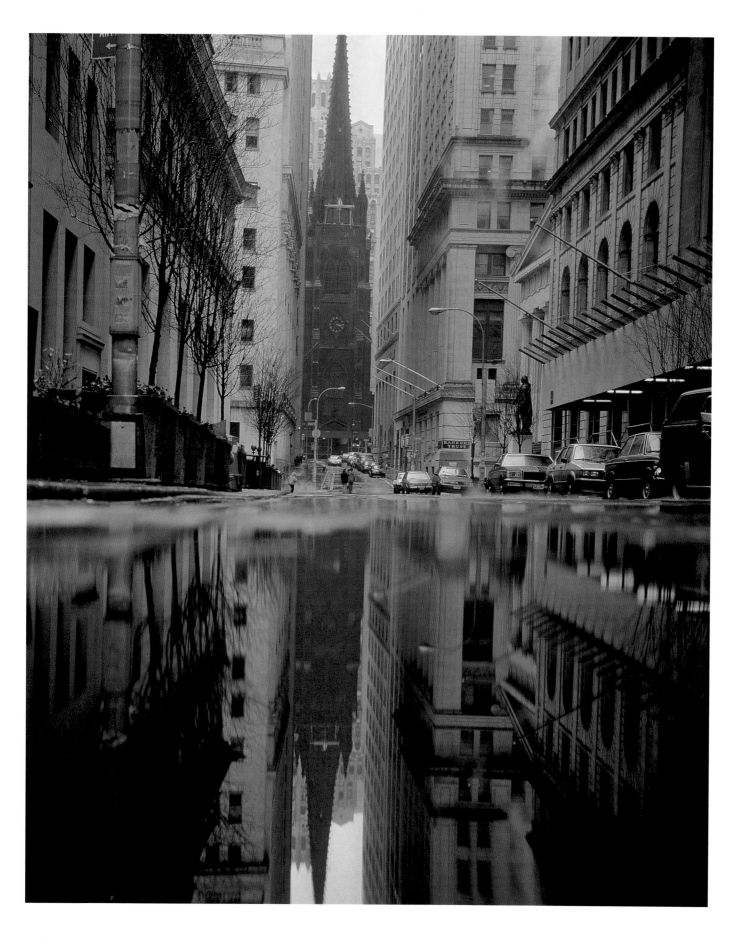

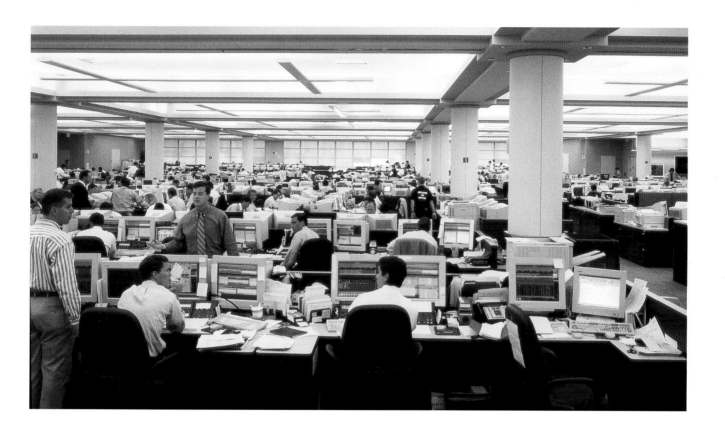

Salomon Smith Barney, Inc.

The November 1997 merger of Salomon Brothers and Smith Barney created a firm with approximately $9 billion in capital and a balance sheet of $276 billion. It was the latest example of growth-through-merger by Sanford I. Weill, chairman of the firm's holding company, the Travelers Group. Sandy Weill's legacy is the corporate family tree that appears on page 73. From modest beginnings with Carter, Berlind, Potoma & Weill, a mammoth organization has been created. The next stage is unfolding as the merger of Travelers Group with Citicorp NA is being planned.

The combined firm of Salomon Smith Barney, Inc. is a leader in all aspects of equity and fixed income underwriting, global debt underwriting, market making (1,554 domestic stocks and 381 foreign stocks), as well as equity and fixed income research. Its quantitative research group is the oldest and most respected in the industry.

Each of Salomon Brothers and Smith Barney was well known for some these activities, and the combination of the firms provides the synergy. The firm's private client group serves as an advisor to one of every six affluent US investors. Client assets held in accounts are approximately $600 billion.

New systems include Smith Barney Access, an Internet site allowing clients to view their account activity, the NextGen system connecting 5,800 financial consultants in 172 offices and AssetOne, a non-discretionary, fee-based securities investment program.

The parent company, Travelers Group offers a wide range of investment and asset management services through 68,000 employees around the globe including property and casualty insurance as well as asset-based financing through Commercial Credit Company.

Salomon Smith Barney's History

The history of this organization is one of the most fascinating stories of modern finance. Twice, from modest beginnings, the chief architect, Sanford Weill, has constructed vast organizations. The son of a Polish dressmaker, Mr. Weill started his Wall Street career as a messenger for Bear Stearns in 1955. In 1960 he joined with three friends to start a small brokerage firm called Carter, Berlind, Potoma and Weill. In the 1970s, this firm expanded by purchasing prestigious but floundering firms such as Hayden Stone, Shearson Hammill and Loeb Rhoades.

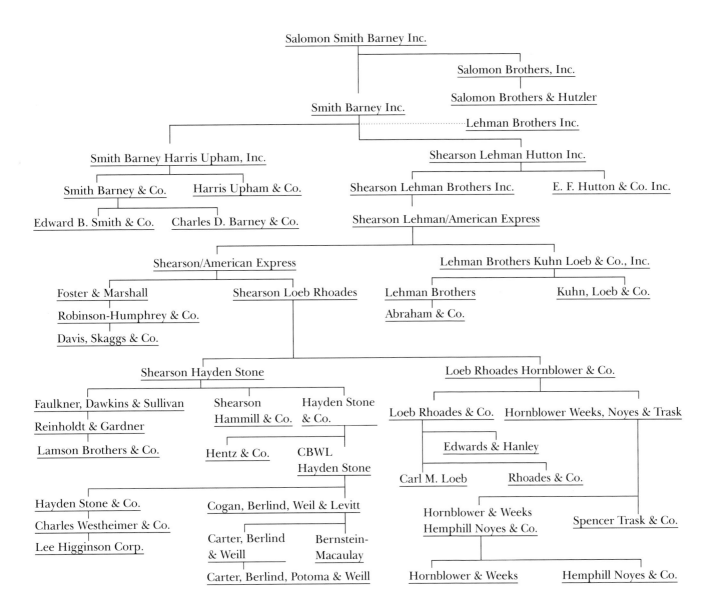

The firm was sold to American Express in 1981. In l985 Mr. Weill left American Express and took control of Commercial Credit Corporation, the Baltimore-based factoring and finance company that had been previously acquired by Control Data Corp. In 1988 Commercial Credit acquired Primerica Corp. which had already picked up Smith Barney, Harris Upham, Inc.—an old-line firm tracing its origins to 1873. The acquisition of Travelers Insurance in 1992 and 1993 came next, followed by Aetna Life & Casualty Corp.

The moment of true accomplishment came in 1993. This is when Sandy Weill re-purchased Shearson's bro-kerage and asset management business from American Express. (The Lehman Brothers operation was spun off to American Express shareholders in 1994). In 1997 Travelers Group merged with Salomon Brothers Inc. bringing the Salomon and Smith Barney organizations together. (For a history of Salomon Brothers see pages 148-149). Smith Barney has been traditionally a retail-oriented, domestic firm. Salomon Brothers' strength has been in bond trading and it has a solid overseas presence. It is largely a wholesale operation.

The l998 merger with Citicorp is the beginning of not just a new chapter but a whole new venture.

The Battery Maritime Building

Originally, this was called the Municipal Ferry Piers and it has remained in continuous operation since opening in 1909. Presently the Coast Guard operates ferry service to Governors Island from here. By the turn of the last century, at the peak of ferry service, there were seventeen lines operating between terminals in Manhattan and Brooklyn. Now the only one with regularly-scheduled passenger service is the Staten Island ferry, although new service from New Jersey and Brooklyn appears from time to time, especially during the summer months.

CROSSING BROOKLYN FERRY

Flood-tide below me! I watch you face to face;
Clouds of the west! sun there half an hour high! I see you also face to face.

Crowds of men and women attired in the usual costumes! how curious you are to me!
On the ferry-boats, the hundreds and hundreds that cross, returning home, are more
 curious to me than you suppose;
And you that shall cross from shore to shore years hence, are more to me, and more in my
 meditations, than you might suppose...
It avails not, neither time or place—distance avails not;
I am with you, you men and women of a generation, or ever so many generations hence;
I project myself—also I return—I am with you, and know how it is.

Just as you feel when you look on the river and sky, so I felt;
Just as any of you is one of a living crowd, I was one of a crowd;
Just as you are refresh'd by the gladness of the river and the bright flow, I was refresh'd;
Just as you stand and lean on the rail, yet hurry with the swift current, I stood, yet was
 hurried;
Just as you look on the numberless masts of ships, and the thick-stem'd pipes of steamboats,
 I look'd...

These, and all else, were to me the same as they are to you;
I project myself a moment to tell you—also I return.

Walt Whitman
Leaves of Grass, (1881)

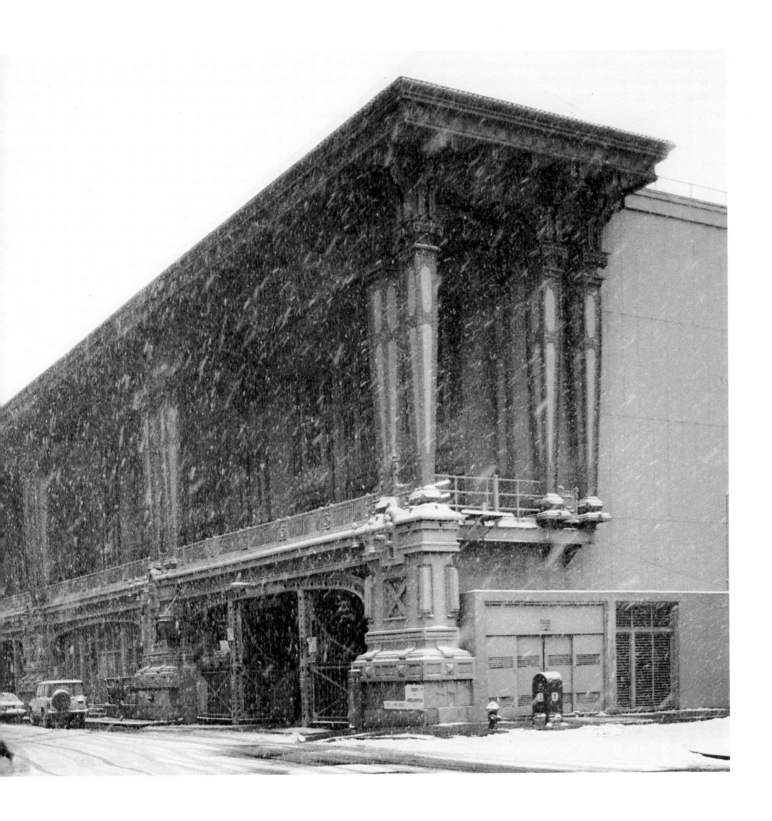

Stone Street

(Above) This view of Stone Street is taken from Goldman Sachs' plaza. Stone Street was the first to be paved with cobblestones. Pearl Street came next, with oyster shells.

Nassau Street

(Opposite) The financial district has its own *altstadt* ("old city"), in this case Nassau Street, which is so busily commercial that it can only be photographed at dusk and preferably during a snow storm. Nassau Street is named for King William III of the House of Orange-Nassau (for whom Princeton University's Nassau Hall is also named).

Many of the buildings in this area are richly decorated structures dating from the 1870s and 1880s. The original Keuffel & Essen Building (1893) is at 127 Fulton Street and an elaborate Bennett Building, built by James Bennett of the *New York Herald* (1889), is at 99 Nassau Street (at the right in the photograph). It has a deeply three-dimensional cast iron front that has been painted in creams and pastels. The *New York Herald* was one of the first subscribers to electricity in 1882, along with the *Evening Telegram*, which was started by Bennett's son. The power came from a private Edison plant built to service only these newspapers.

Wall Street Snowstorm

(*Left*) Pearl Street and Gerardi's in the snow. This has been a familiar landmark since 1932, as seasoned as Sweet's, Sloppy Louie's, and Harry's. Other less fortunate institutions exist only in memory, such as Masoletti's, which, until its demise in 1975, took personal checks but no plastic, and Eberlin's, whose captains owned territories and guaranteed to have you in and out in under twelve minutes so that the next customers could be seated. A second cup of coffee might easily wind up on one's shoulder as a warning salvo not to linger.

(*Above, left*) The old City Midday Club at 23 South Wil-

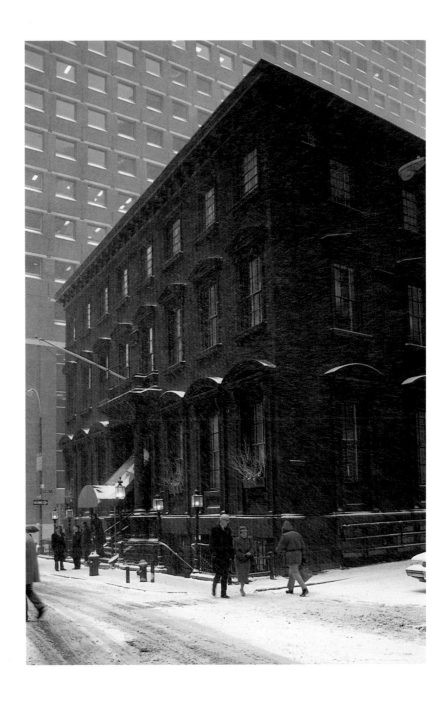

liam Street. (William Street was not named for King William III but rather for Willem Beeckman who served as mayor of Nieu Amsterdam for nine terms.) For many years this famous Wall Street luncheon club was located in this old Tudor-style building. It relocated to the top floors of 140 Broadway in 1967 and this structure became a public restaurant.

(Above, right) The India House at One Hanover Square. This structure, originally the headquarters of the Hanover Bank, was designed by Richard Carman and built between 1851 and 1854. It resembles a Florentine palazzo in New York brownstone, a material more commonly associated with uptown residences but once typical downtown as well. Handsome Corinthian columns and a fine balustrade create a distinguished doorway entrance. In addition to its role as headquarters of the Hanover Bank, India House served as the New York Cotton Exchange until 1886 and then as the headquarters of W.R. Grace & Co.

Two familiar Wall Street institutions share this landmark—the India House Broad Street Club upstairs and Harry's downstairs.

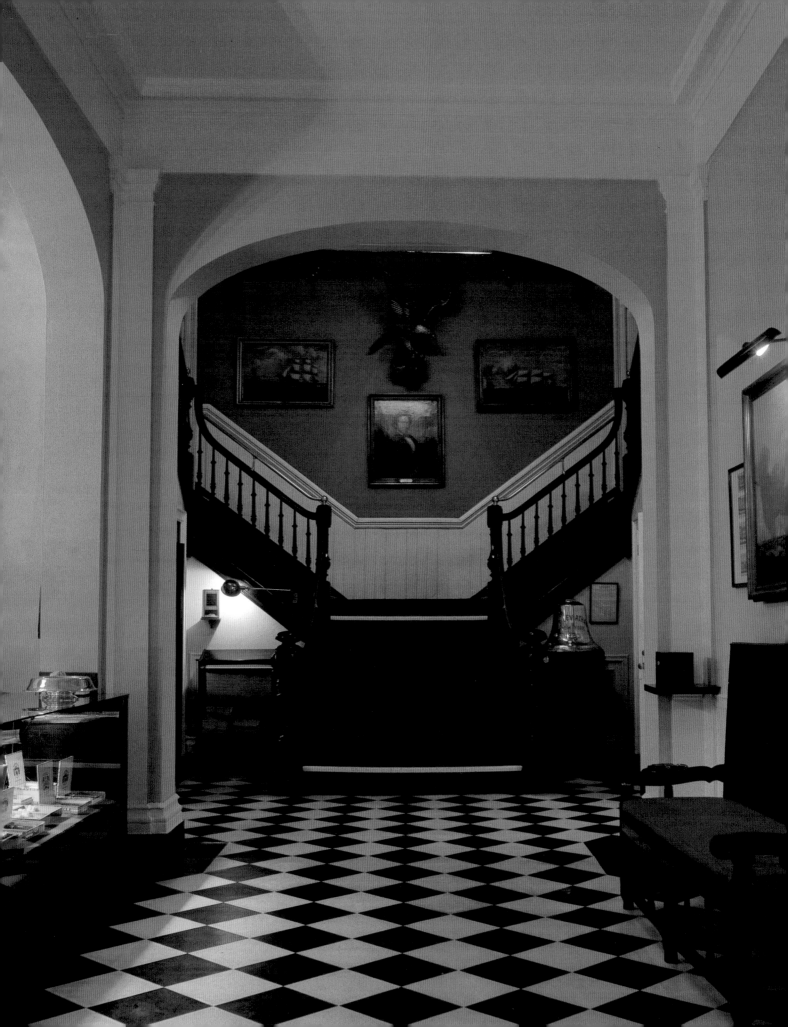

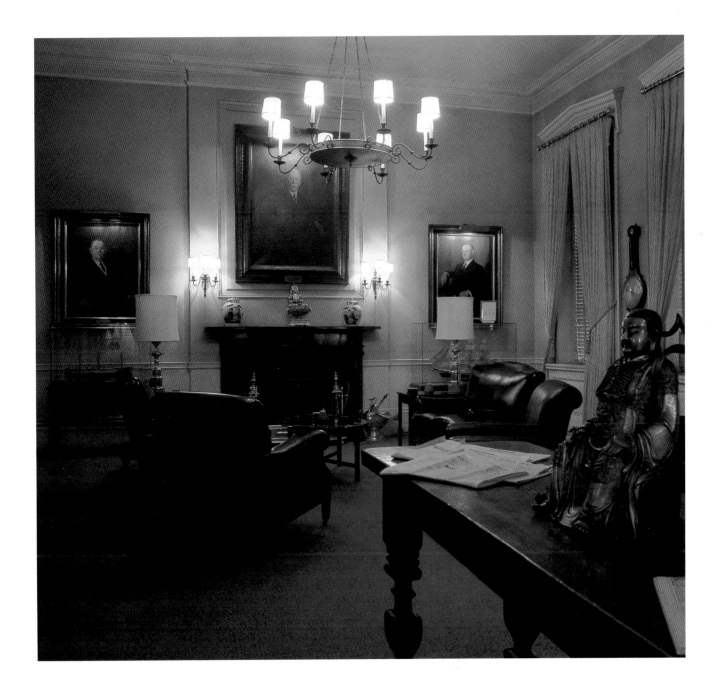

The India House

This 135-year-old house has been a private luncheon club since 1914. It was founded by James A. Farrell and others who had maritime as opposed to banking and securities interests. Its very name derives from the wealth of excitement, challenge and often prosperity from long voyages to the Indies, East and West, and to India. Throughout its spacious, residential-like facilities, the visitor is constantly reminded of its heritage by nautical paintings, ship models and several large Buddhas.

The rare ship models, engravings and paintings donated by James Farrell and Willard Straight, as well as the decorations of paintings by the American Asiatic Institute, constitute one of the greatest collections of maritime art in the country.

In the main reading room *(above)* of the India House, members catch up with the latest shipping news in the *Journal of Commerce* under the watchful eyes of former directors (on the left) or Buddha himself (on the right).

On a Clear Day You Can See the Singer Building

Pause for a minute and reflect on this rare photo mural of New York in the 1940s. It was taken from a member's ship and is mounted on the walls of the India House bar room. The photograph could have been taken anytime between 1931 (the Cities Service Building) and 1960 (when Chase Manhattan Plaza was going up). The distinctive rounded profile of the Singer Building is approximately equidistant between the Woolworth and Irving Bank towers. Note the solid, classical motifs of many of these buildings, virtually all of which are there today but ringed with an outer layer of modern boxes.

The evolution of the financial district's architecture had been slow up until the 1960s. Along the waterfront were many three- and four-storied commercial structures, like those of Schermerhorn Row on Fulton Street. The larger buildings of the banks and brokerage houses were clustered around Wall and Broad Streets— the inland blocks. The solid dignity of this center was ringed by a collection of older buildings. As the *New York Times* architecture critic Paul Goldberger has said, the world of Louis Auchincloss and that of Horatio Alger kept each other in check.

With the need for expansion, all of this changed. The Chase Manhattan bank was the first major office building downtown since the 1930s. But the available land at the center was soon absorbed and the expansion moved to the water's edge: Fifty-Five Water Street, the New York Plaza collection, the Schroder Building, and the World Trade Center and World Financial Center. The area has its own skyline—a larger group of waterfront skyscrapers than anywhere else.

There was Babylon and Nineveh, they were built of brick. Athens was goldmarble columns. Rome was held up on broad arches of rubble. In Constantinople the minarets flame like great candles round the Golden Horn...

Steel, glass, tile, concrete will be the materials of the skyscrapers. Crammed on the narrow island the millionwindowed buildings will jut, glittering pyramid on pyramid, white cloudsheads piled above a thunderstorm.

John Dos Passos
Manhattan Transfer, (1925)

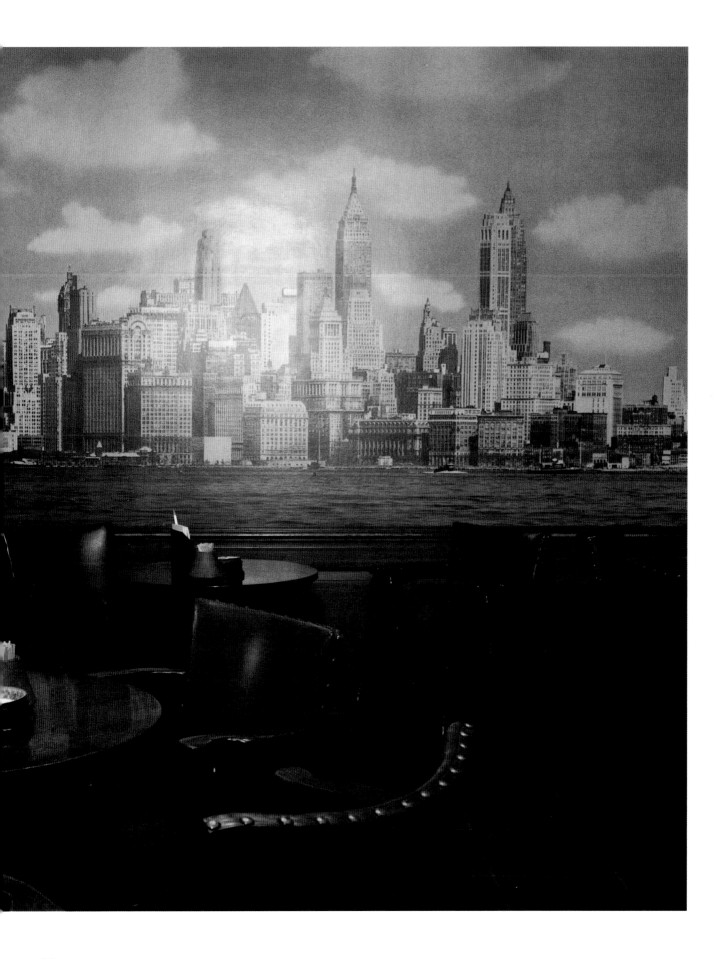

Upstairs at the India House

This is the main dining room of the India House; its Indian curried dishes are renowned. The main dining room can accommodate two hundred members and guests plus an additional two hundred thirty in the club's ten private rooms upstairs. Presently India House has approximately eleven hundred members from all sectors of the maritime and financial communities.

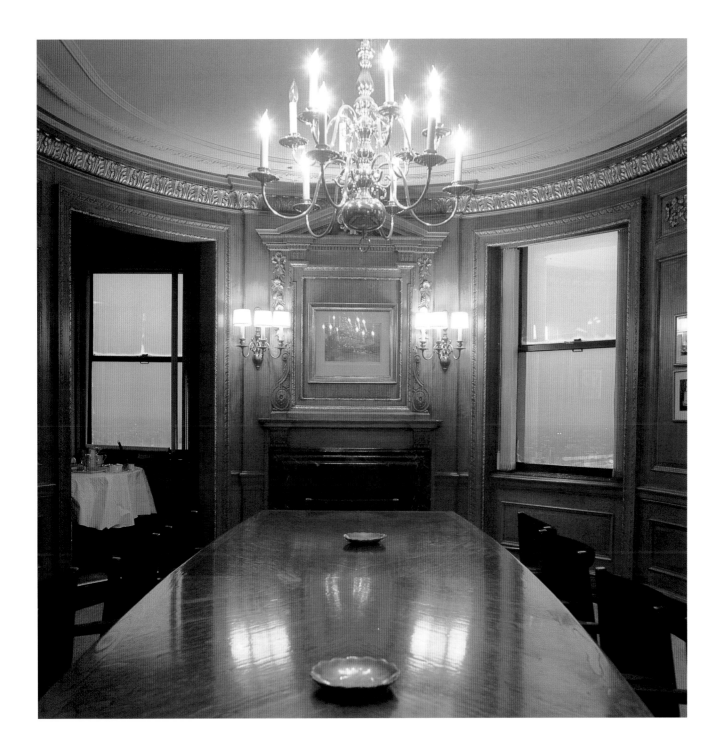

City Bank Farmers Trust Company

This is the executive dining room of the City Bank Farmers Trust Company at 20 Exchange Place. The Farmers Loan & Trust Company (1822) merged with the National City Bank (1812) in 1929. They moved into this magnificent fifty-seven story building in 1931. The unusual Art Deco lobby employs forty-five different marbles and a new combination of nickel and copper in its decorative motifs. The dining room shown here has its own fireplace and cherry wood paneling to remind its executives of an English manor house.

When the bank merged with the First National Bank, whose headquarters were at 55 Wall Street, they built a bridge across Exchange Place to join the two buildings. The street derives its name from the 55 Wall Street structure: the Merchants' Exchange.

Banca Commerciale Italiana

"BCI" was founded in Milan in 1894 and, in a short space of time, became an important member of the Italian banking system, while at the same time extending its presence abroad. BCI Group's international business activities began before World War I, and today are carried out through a widespread network of operating units. (These consist of 15 direct branches and 20 overseas representative offices, 321 branches and 5 representative offices of its five foreign subsidiary banks plus numerous associated and affiliated companies). BCI holds a leading position in Italy in the syndication market, as well as in corporate finance and merchant banking services. In 1994 the Italian government sold its interests and BCI is now held by over 200,000 shareholders. Approximately twenty-five percent of its capital is held by overseas investors and the stock is listed on the Milan Stock Exchange and in London.

J. & W. Seligman & Co. Incorporated

This investment firm was founded in 1864 by Joseph Seligman and his seven brothers. Originally the brothers ran a dry goods business. In New York, the Seligmans were located for a time at One William Street, on whose site they built the Seligman building in 1907. In its early years, the firm helped finance the U.S. Government's Civil War by placing $200 million of its bonds in Europe —an undertaking as difficult as stopping Lee at Gettysburg. The $500-denominated bonds were engraved with the statement that they bore interest at 10 cents per day. But the Europeans were not impressed with the credit. Later, J.&W. Seligman & Co. was appointed the U.S. Navy's Fiscal Agent by President Grant, joined the New York Stock Exchange in 1869 (and thus was one of its oldest members), and helped finance a broad spectrum of industrial America, from railroads to motor cars and talking machines. It also helped finance the Panama Canal and raised billions of dollars for Great Britain, France, and Italy during World War I. Today, it is an investment advisory firm, managing portfolios for pension funds, and a large family of mutual funds. The firm manages the family of Seligman Funds, many of which are known as industry leaders in their respective categories, especially the Seligman Communications and Information Fund. Tri-Continental Corp. is one of the oldest and is certainly the largest closed-end fund in the country. Seligman has a rare investment perspective of over 135 years that spans bull and bear markets, panics, wars, depressions and prosperity.

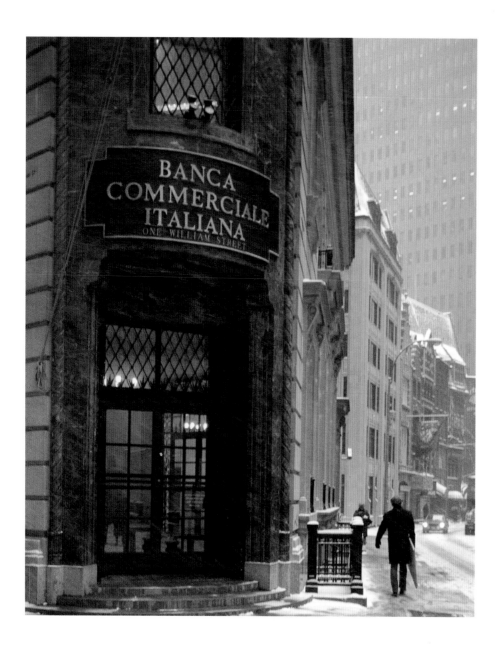

One William Street

This is one of the Wall Street area's most famous addresses. The Italian Renaissance building was originally built for J. & W. Seligman & Co. in 1907 by Francis Kimball and Julian Levi. Kimball also designed the Trinity and U.S. Realty buildings at 111-115 Broadway. From 1928 to 1980 it was home to Lehman Brothers. There is some irony in this because the Seligmans were always in a league above the Lehmans in spite of the fact that both the Seligmans and the Lehmans came from Bavaria in the 1840s and both set up trading operations in the South. But the Seligmans grew to be one of the most important American banking institutions by the late 1800s and certainly ranked far above Lehman Brothers and Goldman Sachs. After World War I the Lehman firm pushed ahead in all aspects of banking. Their turn came to rule, and they grew to such an extent that they purchased the land at 85 Broad Street for their new quarters—land that remained vacant, however, during the downturn of the 1970s and was ultimately sold to their competitors, Goldman Sachs.

In 1984 One William Street was substantially renovated and expanded by Gino Valle for its new owner, Banca Commerciale Italiana, for which it received the City Club of New York's Bard Award for Excellence in Architecture and Urban Design in 1988.

The view in the photograph looking down South William's narrow, curving street shows how European many of Wall Street's older buildings seem.

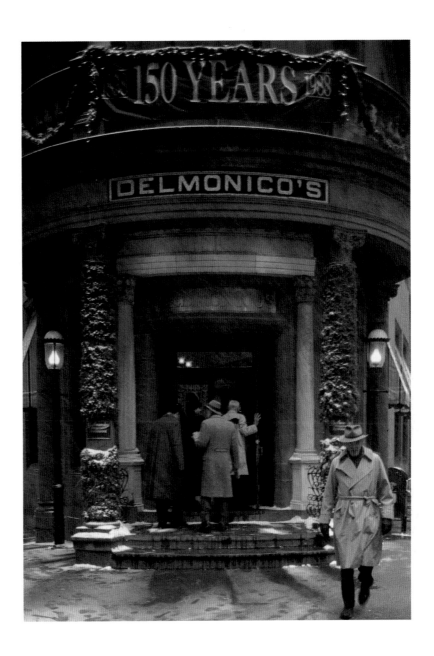

Delmonico's Restaurant

Delmonico's has survived several homes and incarnations; most others, including Luchow's, have succumbed. The original Delmonico's was established in 1827 and offered New Yorkers their first experience in haute cuisine.

Delmonico's building at 56 Beaver Street was designed by James Lord and completed in 1891. It is similar in plan to the famous Flatiron Building, filling an awkward triangular plot formed by two converging streets (Beaver and South William). It is said that the portal behind the porch was brought back from Pompeii by the Delmonico brothers themselves.

At the intersection of William, South William and Beaver Streets, the power and aura of the old financial district prevails. The streets are narrow and curved, and the buildings are solid. One William Street and Delmonico's offer graceful corner entrances. Twenty Exchange Place, a slender limestone tower built by Cross & Cross in 1931, offers a rear entrance to this intersection. For many years this building was headquarters to the First Boston Corporation, Kidder Peabody & Co., Shearman & Sterling and Debevoise & Plimpton among others.

Like the private entrances of Dillon Read, Loeb Rhoades and Bache around the corner, these structures remind us, as few other places in the financial district do, how self-assured a world this was and how closed to those who did not meet it on its own terms.

Warburg Dillon Read

Here are the old and new entrances of Dillon, Read & Co. Inc, one of Wall Street's most distinguished old-line investment banking firms. Clarence Dillon had joined the firm of William A. Read & Co. as a bond salesman in 1913 and became head of its New York office in 1920. The firm became known as Dillon, Read & Co. the following year. In addition to New York and Chicago, the firm had small offices in Boston, Philadelphia and Paris. Like Morgan Stanley and Kuhn Loeb, the firm concentrated on managerships of underwritten offerings rather than participations. During the 1950s, it ranked first in the dollar volume of agency private placements.

The photograph above shows Dillon Read's private entrance at 46 William Street which it maintained from 1949 until 1983—almost forty years. When it moved to midtown, it employed the same understated elegance in designing a contemporary but still very private entrance plaza.

The new firm of Warburg Dillon Read results from the joining together of two distinguished investment banking houses: Dillon Read and SBC Warburg. The latter was the result of the merger of Swiss Bank Corporation and S.G. Warburg. Known for its strong investment banking relationships and capital market activities, S.G. Warburg was founded in London in 1946. Warburg was acquired by Swiss Bank Corporation in 1995 along with the well-regarded investment management firm, Brinson Partners Inc. In 1997 Swiss Bank Corp. and Union Bank of Switzerland merged to become one of the leading banks in the world. Capital markets activities are now housed in one firm, Warburg Dillon Read. Its strengths are: relationship investment banking, equity research and trading, asset-backed securities, Eurobond trading and mergers and acquisitions. The firm employs about 15,000 full-time staff in more than forty countries around the world.

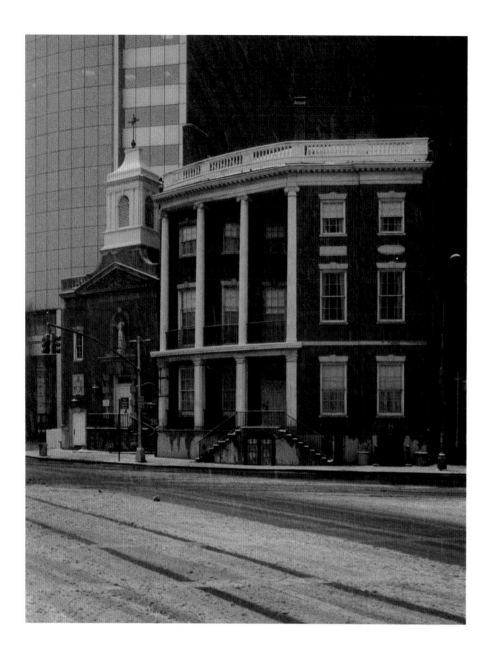

The Shrine of Elizabeth Seton

Located at Seven State Street, this was designed by John McComb and built as a residence for James Watson between 1793 and 1806. Its design is Federal, conforming to the popular style of Washington's early presidency. This is the last of a series of houses that once faced the Battery along State Street, one of the city's most desirable addresses. Built as a gentleman's home, this building demonstrates that even when pressed together in rows, such houses retained elegance and individuality. The unusually slender, elegant Doric columns were actually ship masts. During the Civil War the house was used by the Union Army, which also had an encampment in Battery Park. After the war, it was purchased by Charlotte Grace O'Brien, who upon arriving from Ireland had become disturbed at the treatment of immigrants. She raised $70,000 to purchase the Watson House where she established the Mission of Our Lady of the Rosary to look after the needs of Irish immigrant girls. The Mission still owns the house and maintains it as a shrine to St. Elizabeth Seton.

Mother Seton, born on Staten Island in 1774, was an Episcopalian who converted to Catholicism after her husband's death in 1805. She established the first American congregation of Sisters of Charity, and when canonized in 1971 became America's first saint.

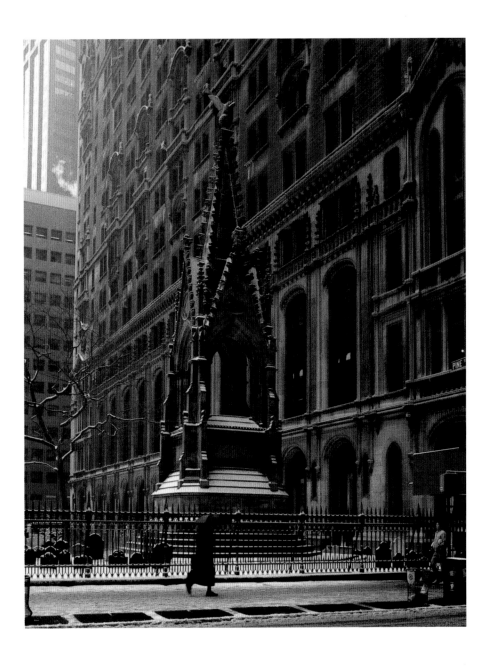

The Trinity Building and Soldiers' Monument

The extraordinary rich Gothic curtain of this building at 111 Broadway serves as a backdrop to the Trinity Churchyard and the Soldiers' Monument. The building was designed in 1905 by Francis Kimball, who was also responsible for the old United States Trust Co. at 37 Wall Street and the Seligman Building at One William Street.

The Soldiers' Monument was erected in 1852 in memory of the men who were killed during the Revolutionary War and are interred in the Churchyard. They died mostly in British prisons in New York, which remained in British control during most of the war. The internment of the soldiers prevented Trinity Churchyard from being bisected by Albany Street, whose merchants had fought for over forty years, until 1850, to have their street push through and link up with Wall Street. The driving force was the owners of the New York-Albany packets. Four times the extension of Albany Street won municipal approval, but it was never carried out.

At this point, Broadway begins to manifest its main characteristic, which continues up to Columbia Heights. It is the highest ridge on Manhattan—a backbone from which side streets often gently slope. Broadway was originally called *de Heere Straat* by the Dutch—"the Gentlemen's Street." The British renamed its lower section Great George Street and the section by Trinity Church, Church Walk. Sections further north had various names, including the Boulevard or Boulevard LaFayette. It was not until February 14, 1899 that the entire 15.5 mile street was given a single name.

Trinity Church

An oasis of Gothic splendor in the midst of a fast-paced environment, this is the oldest Anglican parish in New York and the third Trinity Church. The first one was built in 1698 and burned in 1776. The second was completed in 1790 with a 200-foot steeple and large Gothic windows. It was deemed structurally unsound and replaced with a new church designed by Richard Upjohn and completed in 1846. The new steeple of 280 feet was the tallest structure in the city for many years.

Trinity marks the beginning of mature Gothic Revival in the United States. The Gothic ribs of late fourteenth century influence, the lancet windows, and the nave arcade all combine to create an uplifting experience. The Christmas poinsettias are among the most magnificent seasonal displays anywhere in New York.

The great chancel window was made on the spot during the construction of the church. It represents some of the oldest stained glass in America and in itself is an innovation, since most of the previous churches had been content with plain glass.

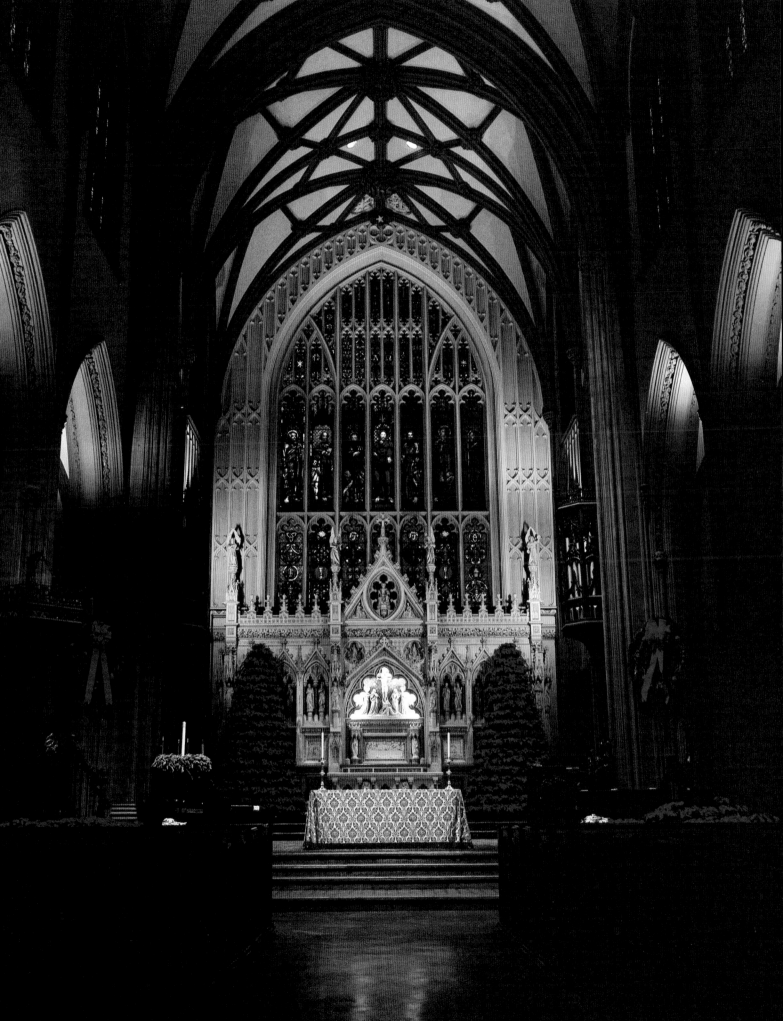

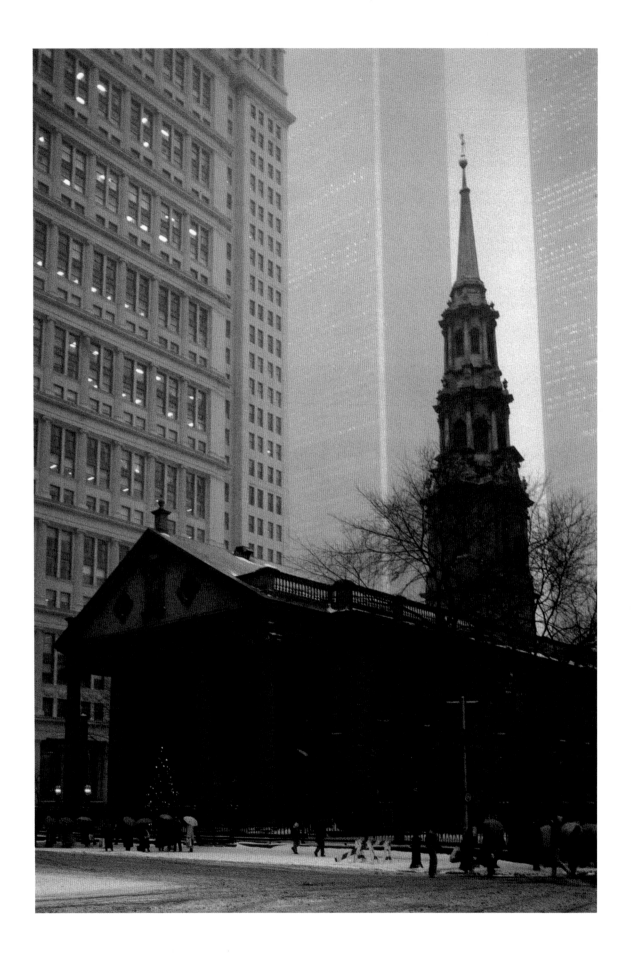

St. Paul's Chapel

This is Manhattan's premier Georgian church, just as Trinity Church is its premier Gothic Revival church. It is also the only pre-Revolutionary building left in New York. There are about twelve other older structures, but these were mostly isolated farmhouses.

The stone for the church is called Manhattan schist and was quarried from the site. Thomas McBean built the church between 1764 and 1766; James Lawrence added the tower and steeple thirty years later. The relatively flat roof of the church is probably responsible for its surviving the great fire of 1776, which destroyed the first Trinity Church and most of the city along Broadway. Members of the congregation were able to stand on St. Paul's roof with pails of water to extinguish the hot embers that blew onto it. This in part explains why St. Paul's is the only building in New York in continuous use that dates from the pre-Revolutionary period.

Originally, the Hudson River extended up to Greenwich Street, creating a pastoral waterfront vista from the western entrance of the church. The churchyard is bound by Vesey Street to the north, named for the Reverend William Vesey, first rector of Trinity Church, and Fulton Street, to the south, named for Robert Fulton, a professional artist. He is also known as the father of the steamship; he built the *Clermont* as well as the first steam warship and the first submarine for the United States Navy.

The elegant interior space of St. Paul's Chapel is created by freestanding Corinthian columns supporting block entablatures. The use of clear windows, Waterford crystal chandeliers and white woodwork—very Georgian and popular in the colonies at the time—results in a bright, cheerful sanctuary. George Washington worshipped here when New York was the nation's capitol and sat to the left of the altar; New York's first governor, George Clinton, sat on the right.

St. Peter's Church

Located at the intersection of Barclay and Church Streets, this church was designed by John Haggerty and Thomas Thomas and completed in 1838, replacing the original structure built in 1786. It is the oldest Roman Catholic parish in New York and the first Catholic church in New York whose exterior follows the Greek Revival style. The interior is of similar spaciousness and grand proportions as the exterior. Above the Baroque altar is a crucifixion scene painted by the Mexican artist José Maria Vallego and donated to the first St. Peter's Church by the New York chargé d'affaires of Charles III of Spain.

In gratitude to the king for his contributions to establishing the first church on this site, the trustees of St. Peter's reserved the front pew in perpetuity for representatives of the Spanish government. The pledge was formally restated in 1976.

The Roman Catholic congregation was formed in 1783 although the first services were held beginning in 1687, during the governorship of Thomas Dongan, who was a Catholic. However, under his successor and thereafter, the Catholic faith was prohibited in the English colonies and services had to be held in private homes. After the Revolutionary War, freedom of religion was established and the first church built by the Catholics was completed here in 1786.

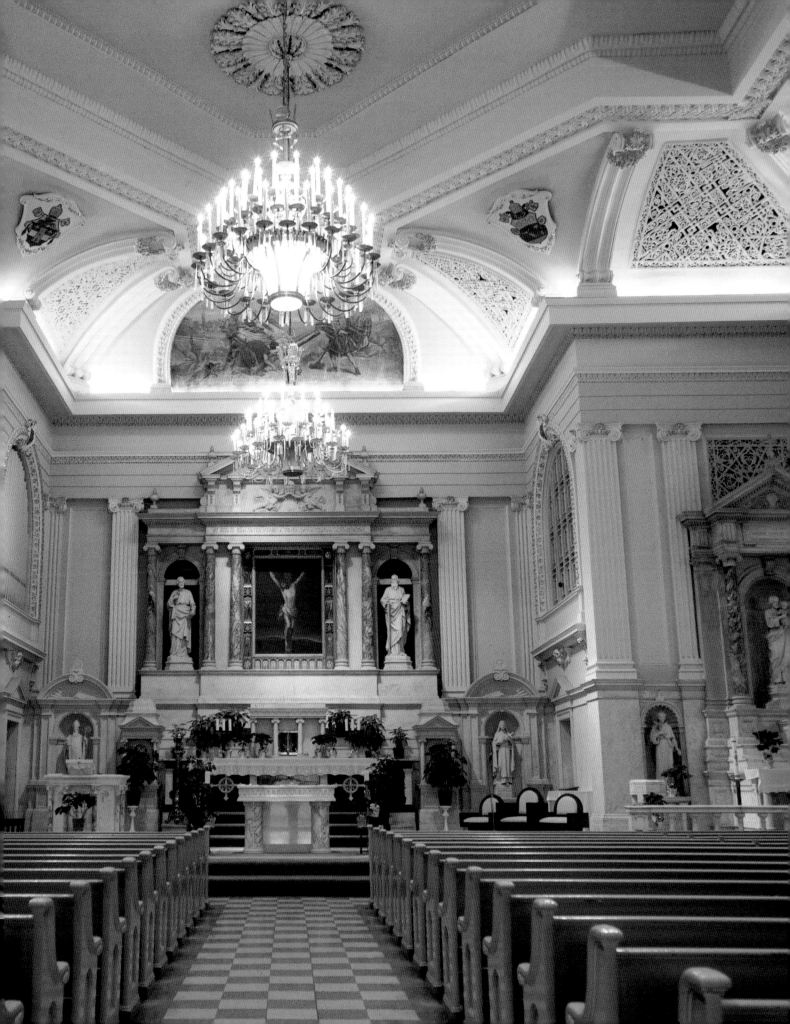

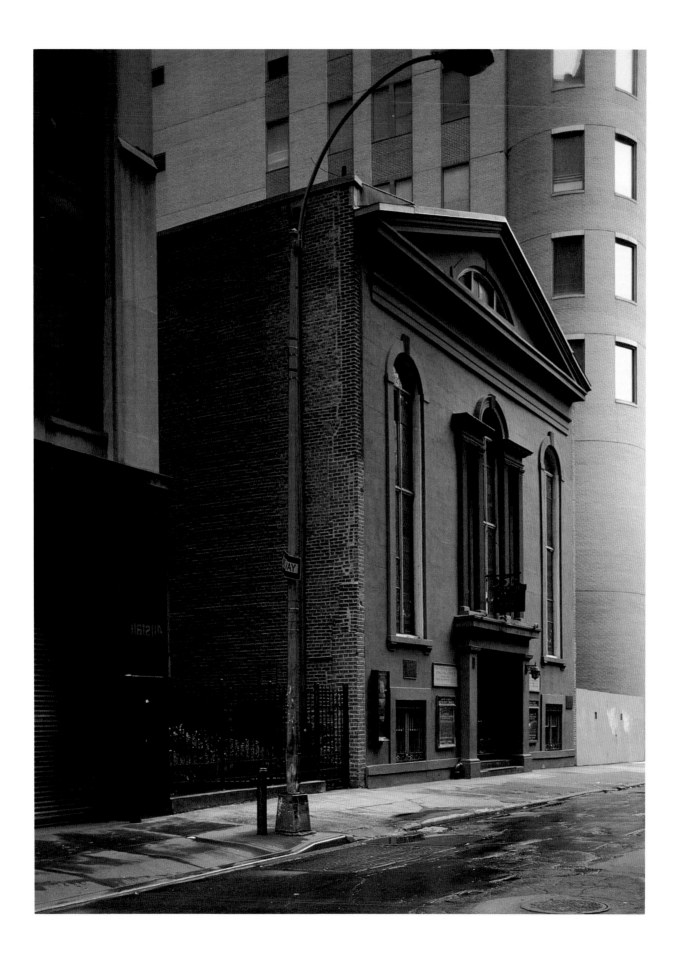

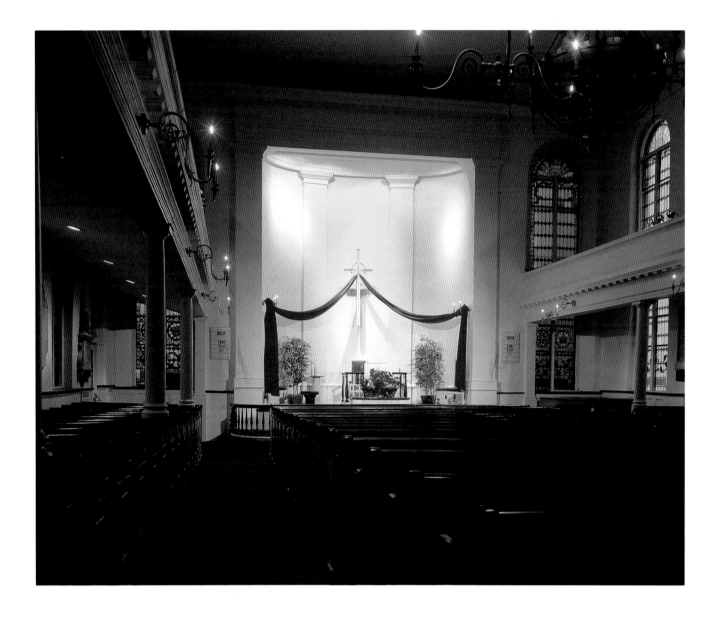

John Street United Methodist Church

Built in 1841 by William Hurry, this is the third Methodist church on this site, where tiny Dutch Street joins John Street. Earlier churches had been constructed in 1768 and 1817. The congregation is the oldest Methodist congregation in the United States. The plain brownstone facade is Greek Revival with the influence of Italianate style; the Palladian window in the center of the facade (a round-topped window flanked by two narrow square-topped windows) is a Northern Italian detail that was popular in England before coming to the United States.

The warm interior of the church has remained unchanged for almost 150 years. It is worth a daily visit just to step back from the pace of the financial district and think about the same area at an earlier time. The church's library contains volumes dating from the 1790s, and its clock, brought over from England in 1767, is still working just fine.

John Street is named for Johannes Haberdinck, a wealthy shoemaker who owned the land that John Street now occupies. During the eighteenth and nineteenth centuries it was inhabited mostly by artisans and craftsmen including a tallow chandler, William Colgate, who later went into manufacturing soap.

"For unto us a child is born.
unto us a son is given,
And the government will be upon
his shoulders.
And he will be called
Wonderful, Counselor, the Mighty God,
The Everlasting Father, the Prince of Peace."
Isaiah 9:6

American Telephone & Telegraph Building

This magnificent classical structure at 195 Broadway was built in three stages during 1915-22 and was designed by Welles Bosworth.

This is a square-topped layer cake with a deep-set facade of eight Ionic colonnades (each embracing three stories) set atop the row of massive Doric columns depicted in the photograph. This building contains more classical columns than any other facade in the world. The site of the building was that of the Western Union Building, a ten-story structure designed by George Post in 1875. (Post also designed the New York Stock Exchange thirty years later.) Along with the Tribune Building on Park Row, the Western Union Building was one of the first to install elevators. When the building codes were changed in 1892 to permit the steel cage construction without self-supporting walls, significantly taller structures evolved, beginning with the American Surety Company at 100 Broadway in 1895.

The unusual and fascinating lobby of almond marble contains a forest of vast fluted columns with splayed tops. The space is grand and dignified. No flamboyant gestures are needed to remind the visitor that this was the lobby of the largest corporation in the world (with sales of $64.1 billion and assets of $149.5 billion) prior to its reorganization in 1984.

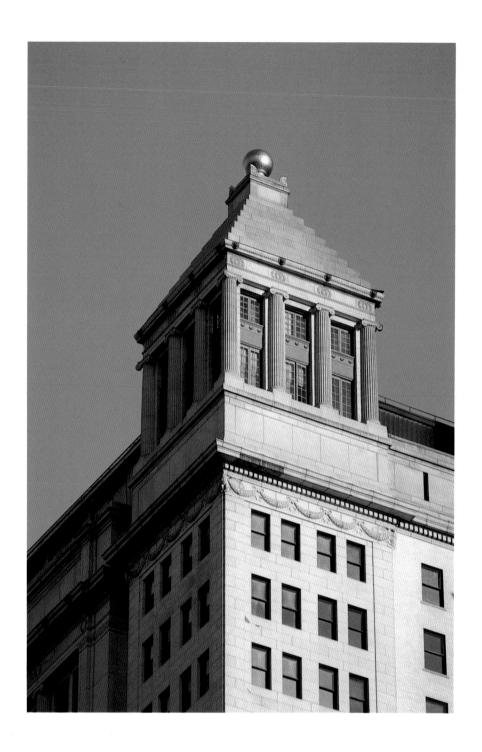

Spirit of Communication

(Opposite) This familiar statue by Evelyn Longman now sits in the lobby of the new American Telephone & Telegraph Company building at 550 Madison Avenue, to which it was moved in 1984. For the previous sixty years it stood atop the round orb *(above)* on the company's former headquarters at 195 Broadway. It also appeared on the covers of telephone directories throughout the country for decades.

Seven World Trade Center

Designed by Emery Roth & Sons, this sleek red granite building is occupied by Salomon Smith Barney, Inc. It has two double-height trading floors providing a copious space for one of the firm's principal activities.

The Millenium Hotel

Nestled beside the former AT&T Building is a new hotel, the Millenium Hilton Hotel, a sleek structure built in 1992 and designed by Eli Attia Architects. The hotel features 561 guest rooms including suites, each with two line telephones and separate data ports and fax machines, all poised to carry this magnificent 55-story hotel well into the 21st century. This is the first hotel in the country to be called the Millenium. It is so named in anticipation of the new millennium, the year 2000.

A Christmas Present

Christmas of 1913 was very special. Cass Gilbert had presented this architectural gem, called the Woolworth Building, to the city that year. The official opening was April twenty-fourth, when 825 guests assembled for dinner on the twenty-seventh floor and President Wilson threw a switch at the White House that suddenly illuminated eighty thousand electric bulbs. As the orchestra struck up *The Star Spangled Banner*, a telegraphic announcement went out across the ocean to all ships at sea and the Eiffel Tower (the only structure that was taller) that the world's tallest building had opened.

Frank Woolworth's demands (and financial capacity) combined with Cass Gilbert's design to create an extraordinary marriage of Gothic ornamentation with massive scale that is refreshing even today. It is the Mozart of skyscrapers. One of the finest tributes to this great landmark is that its owner and principal tenant is still there, and has kept it in excellent condition, for over seventy-five years. Very few buildings have had such a fate and have remained on top of the critics' list continuously over the years.

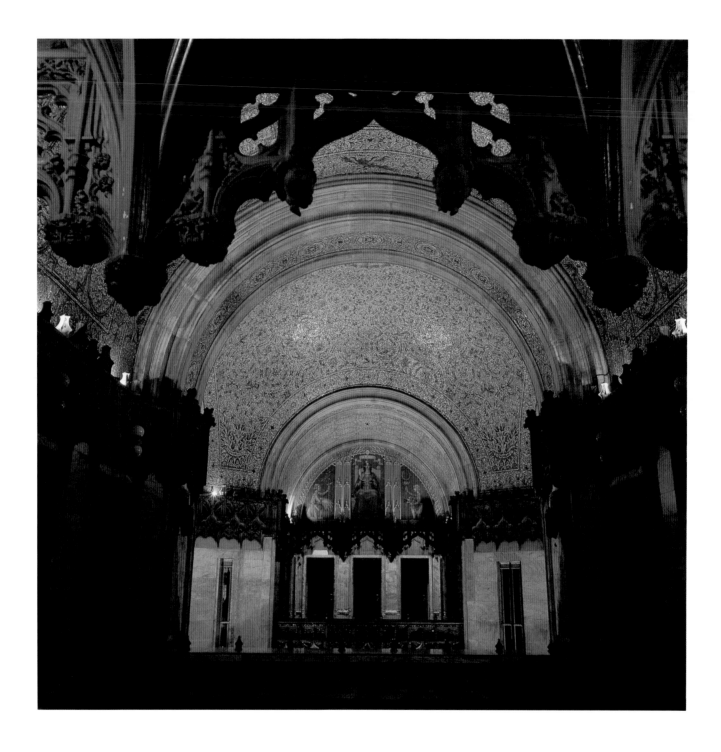

The Woolworth Building

The building was christened "The Cathedral of Commerce" by Reverend Parks Cadman, the first of the great radio preachers in the country. He saw the results as an example of faith, exchange, and barter bringing alien people into unity and peace instead of war.

A three-story lobby contains glass mosaics *Commerce* and *Labor (above)*, surrounded by lacy wrought-iron cornices covered with gold leaf. The ceiling is illuminated stained glass, extending over a grand marble staircase that once led to the headquarters of the Irving Bank *(opposite)*.

As Woolworth's competitive juices started flowing he realized that, after assembling the entire real estate block, he could build a structure that would be taller than the nearby Singer Building. He instructed Gilbert to revise the plans many times, ever increasing the size while keeping the gracefulness he had grown to appreciate in the

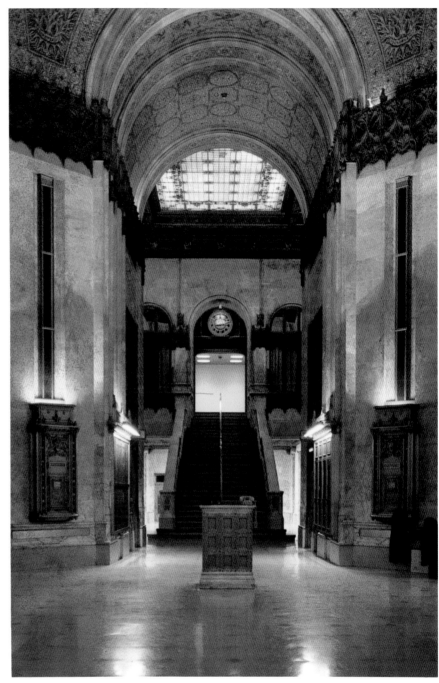

architect's style. The result is a sixty-story structure finished in terra cotta on all four sides, that remained the tallest building in the world until the Manhattan Bank (40 Wall Street) and Chrysler Buildings were completed in 1930. Because many floors have twenty-foot ceilings, the number of stories in a contemporary building might be about eighty. The golden marble for the lobby was quarried on the Greek Island of Skyros, and Tiffany's supplied the elevator doors.

(Above, left) An amusing touch was provided by sculptor Thomas Johnson: corbels of Cass Gilbert presenting the building and F.W. Woolworth paying for it with nickels and dimes. Frank Woolworth was not a man who believed in leverage. He paid for the building with cash—$13,500,000.

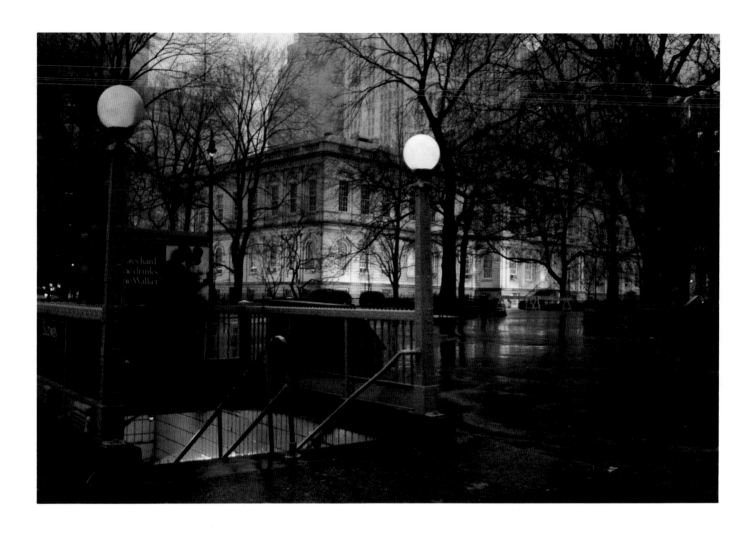

City Hall Park

This was formerly called the Common and lies between Broadway and Park Row, from Vesey to Chambers Streets.

In the early 1700s the City barely extended to Fulton Street, and the eastern edge of the Common (now Park Row) was actually the Boston Post Road.

The Common was officially laid out in about 1730 and surrounds City Hall which was built largely between 1803 and 1812. In 1735 New York's first almshouse was built on the present site of City Hall. In 1842 one of the city's first fountains was installed in the park, to commemorate the completion of the Croton Aqueduct that year, bringing abundant fresh water into the city for the first time. The Croton Reservoir and Aqueduct were hailed as being among the great engineering feats of the nineteenth century. When John Jacob Astor opened his famous Astor House across the street in 1836, he had to dig his own well. That was no problem to Astor, whose 600-bed hotel was larger and grander than any other hotel in London or Paris. It was entirely lit by gaslight, an innovation that some of the guests were not entirely familiar with. On occasion one of them would die peacefully in bed after blowing out the flame before retiring.

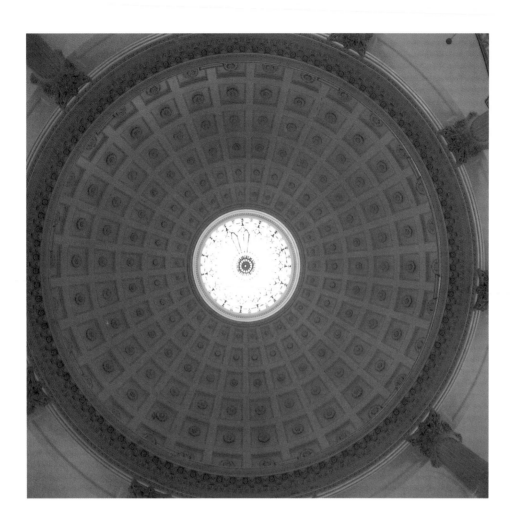

City Hall

This building was designed by John McComb and Joseph Mangin, and it was completed in 1812 after nine years of construction.

It is built with elegant white marble and has an usually graceful double flying staircase embracing a circular gallery and central rotunda.

The dome rests on ten Corinthian columns and has a skylight noted for its delicate rosette design.

A major restoration project in the early 1950s has essentially reclad the building and created a structure as sound as the original. The overall design of City Hall is a rare blend of Georgian and French Renaissance; the elegant exterior is duplicated in the grand central hallway.

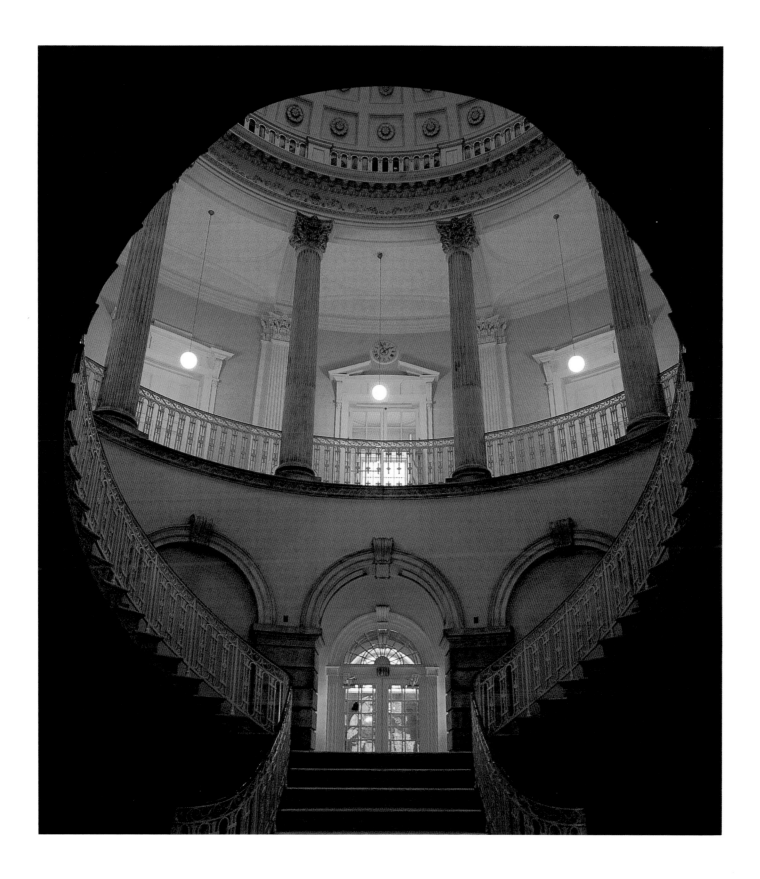

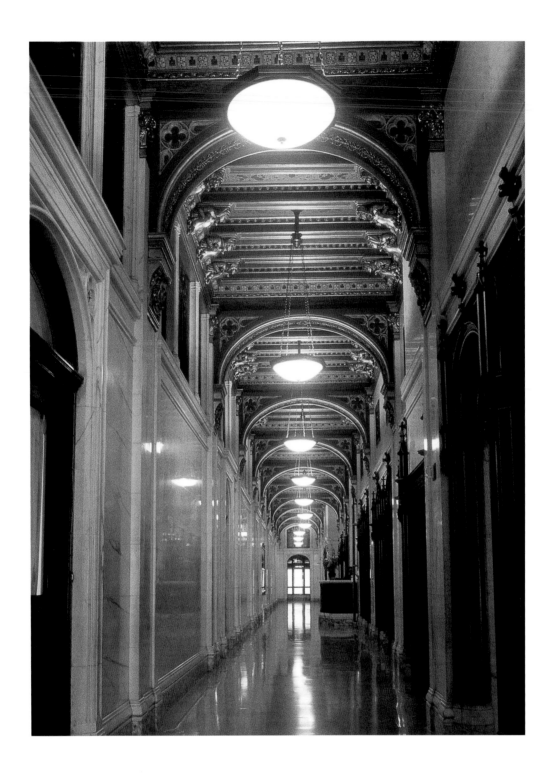

The Lobby of 111 Broadway

The pair of Gothic buildings, 111 and 115 Broadway, stand majestically at the northern edge of Trinity Churchyard. The buildings' entrances are limestone and bronze, the vestibules are Siena marble. The main corridors are a glittering display of marble, bronze, and gold leaf, enhanced by diffused lights and stained glass windows. Each of the lobbies is different and yet they reflect the hand of the same architect, Francis Kimball. No. 111 was completed in 1905 as the Trinity Building and No. 115 in 1907 as the U.S. Realty Building.

This section of Broadway was originally called by the British Church Walk, and the first two streets north of the wall were originally King and Queen Streets, renamed Pine and Cedar, respectively, after the war.

Manufacturers Hanover Trust Company

This was the great banking hall of 40 Wall Street, one of the largest commercial banking spaces in New York. Manufacturers Hanover Trust Company is the result of the 1961 merger of the Hanover Bank, established in 1851, and the Manufacturers Trust Company, which was chartered as the Citizens Trust Company in 1905. At the time of its 1961 merger, the bank had more offices in New York than any other bank. In 1991 it merged with Chemical Bank.

The Equitable Building

At the time of its completion in 1915 this was an extraordinary building. Designed by Ernest Graham and located at 120 Broadway, it contains 1.2 million square feet on a plot of less than an acre. The overwhelmingly massive volume led to New York's and the nation's first comprehensive zoning resolution in 1916—an attempt to regulate the overall height and bulk of buildings in order to assure adequate penetration of light to the streets below. It also limited floor space to twelve times the area of the building's site. The Equitable Building has a floor area almost thirty times the area of its site. The building in-

stalled its own electric generators and even today, during the period of peak electricity demand, Consolidated Edison often asks the building management to fire up its generators to help Con Ed out.

The lobby of the Equitable Building is one of the area's grandest—an ornately coffered barrel vault running the entire block from Broadway to Nassau Street. During the holidays the building's owners provide classical music as an invitation to stop and linger for a few minutes between transactions.

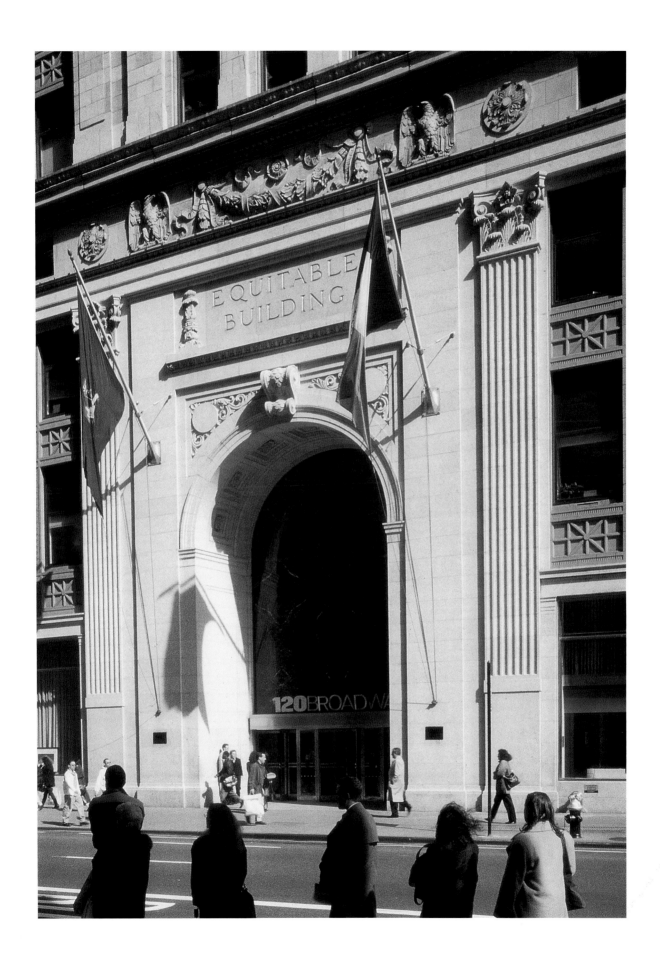

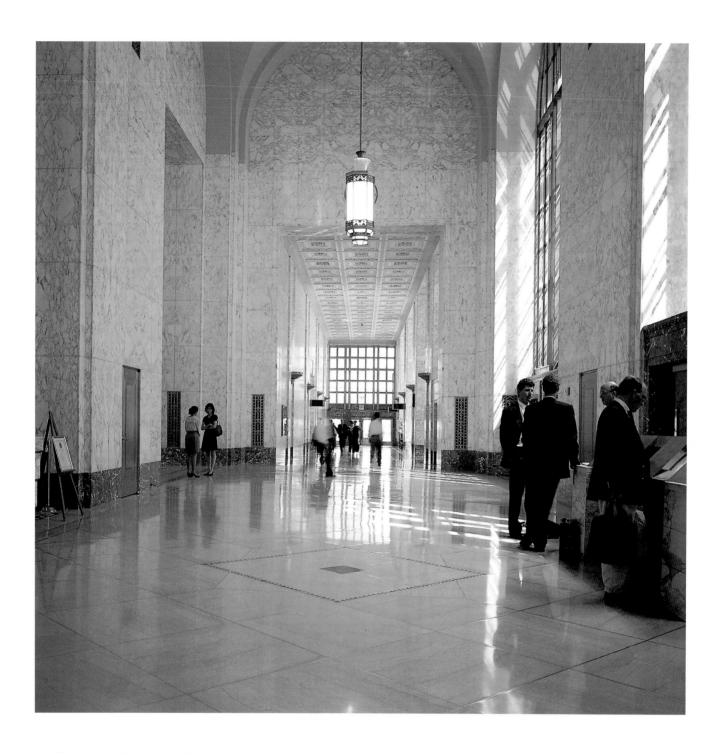

Credit Suisse First Boston's
New York Headquarters

This magnificent structure, Eleven Madison Avenue, was originally planned in November, 1929 by Metropolitan Life Insurance Company to be a one-hundred-story building which would then have surpassed anything else in New York. Dan Everett Waid and Harvey Wiley Corbett were the architects. At the time, Metropolitan Life had over 30,000 employees, and the architects planned moving stairs for the first thirteen floors on the belief that a continuous flow of traffic was more efficient than elevators, within 150 feet of building height.

The depression years changed the company's plans and the building topped out at twenty-eight stories, giving it a distinguished and massive appearance. It was the first large office building to be fully air-conditioned. It is still owned by Metropolitan Life and leased to Credit Suisse First Boston Corporation as a major tenant.

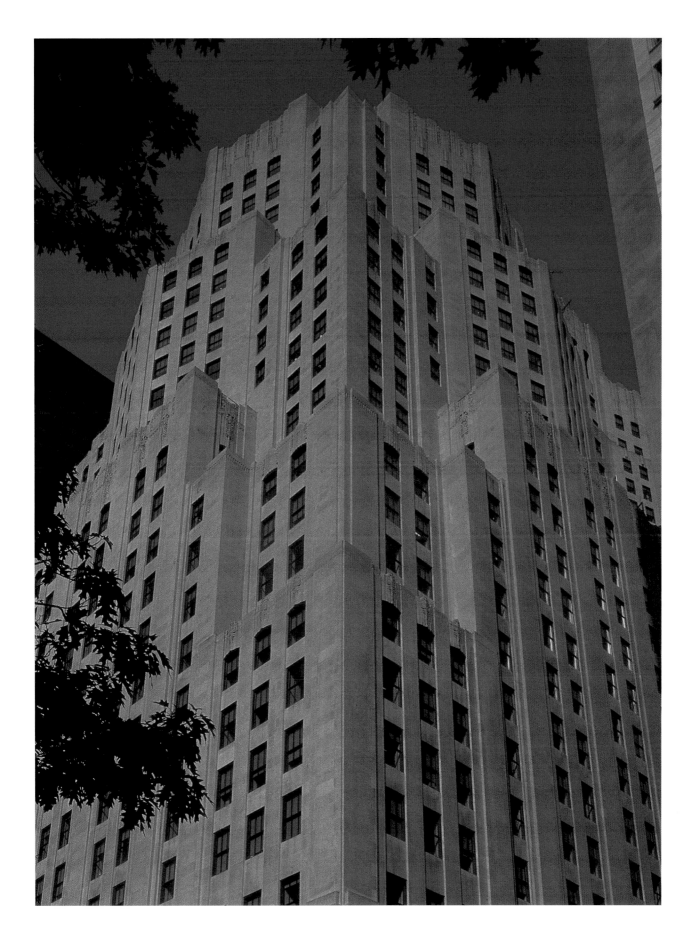

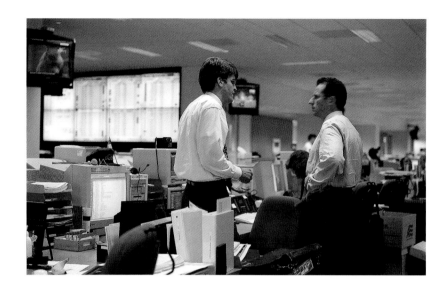

Credit Suisse First Boston

The history of Credit Suisse First Boston dates back to 1932, when The First of Boston Corporation was established as a subsidiary of The First National Bank of Boston. In 1934, as a result of the 1933 Glass-Steagall Act, The First of Boston Corporation severed its ties with The First National Bank of Boston, changed its name to The First Boston Corporation, and became the first (and for many years, the only) publicly-owned major investment banking firm. Several key members of Chase Harris Forbes Corporation, the securities affiliate of Chase National Bank, joined the new investment bank. With 650 employees and $9 million in capital, the Firm soon became a leading bond underwriter and trader.

In 1946, Mellon Securities Corporation merged into The First Boston Corporation. Mellon's franchise with industrial clients led to some major deals: initial debt offers for the World Bank, Hydro Quebec, and a 2.2 million share offering for Gulf Oil Corporation in 1948 (the largest equity offering until that time). By 1947, The First Boston Corporation surpassed $1 billion in new capital issues, and in 1959 it reintroduced the credit of Japan to the American markets with the first offerings by its government since 1930. This lead to significant expansion in operations for The First Boston Corporation. By 1970, the Firm was raising more than $10 billion in new capital annually. In 1971, The First Boston Corporation joined the New York Stock Exchange, developed its equity sales research and trading operations and soon established an equity business to compliment its debt operations.

In 1978, The First Boston Corporation took the first step in its affiliation with Credit Suisse by replacing White Weld & Co. as a shareholder of Financiére Crédit Suisse-First Boston (formerly Société Anonyme du Credit Suisse et de White Weld), a leading international trading, investment banking and asset management group in Europe. Financiére Crédit Suisse-First Boston's main subsidiary, Credit Suisse First Boston Limited in London, became one of the premier Eurobond houses. In 1988, in conjunction with the combination of the Firm's parent company, CS Holding, The First Boston Corporation became a privately-held company, renamed to CS First Boston, Inc. Ownership of Financiére Crédit Suisse-First Boston passed entirely to The First Boston Corporation and, at the same time, The First Boston Corporation acquired all its own shares held by the public. As a result of this reorganization, CS Holding became a direct shareholder of the newly renamed CS First Boston, Inc.

From 1989 to 1993, CS First Boston operated through its three main regional subsidiaries: The First Boston Corporation in the United States, Financiére Crédit Suisse-First Boston in Europe and CS First Boston Pacific in the Asia/Pacific region. In 1993, CS First Boston integrated the three regional operations into one global investment bank and operated under a single name, CS First Boston until 1997.

On January 1, 1997, CS First Boston and Credit Suisse consolidated businesses into Credit Suisse First Boston (CSFB) and the parent company was renamed Credit Suisse Group. Today, CSFB is a leading global investment banking firm and provides a comprehensive range of financial advisory, capital-raising, sales and trading and financial products for users and suppliers of capital around the world. In 1998, CSFB has over 12,000 employees in over 50 offices and over 30 countries. Credit Suisse First Boston is one of the world's largest securities firms in terms of financial resources, with approximately $7.1 billion in revenues in 1997, $7.3 billion in equity capital and $310 billion in assets as of December 31, 1997.

Wall Street's Newcomers: Barclays and Morgan

Two of Wall Street's newest bank buildings are the Barclays Bank Building at 75 Wall Street *(above, left)* and the J.P. Morgan & Co. Building at 60 Wall Street *(above, right)*.

Barclays' building was completed in 1987, designed by Welton Becket Associates. The material is flamed granite, and the lobby is quite lofty. Other British banks have chosen to build on nearby Water Street sites: National Westminster Bank, Standard Chartered Bank, and Lloyds Bank. J. Henry Schroder Wagg was one of the first of the group, moving to the corner of Water and Whitehall Streets in 1969.

The elegant Morgan Building was completed in 1989 and designed by Kevin Roche, John Dinkeloo & Associates. It is distinctive and reminiscent of a classical column.

Kidder Peabody & Co. Incorporated

The headquarters of this venerable firm were located at Ten Hanover Square from 1969 until its merger with Paine Webber in 1995. Founded in 1865, Kidder Peabody was synonymous with relationship investment banking and was the oldest major-bracket underwriting firm still operating under its original name.

The coach lanterns in the foreground are from the India House, which has been a landmark on Hanover Square since 1854, serving as the Cotton Exchange and headquarters of the Hanover Bank and also of W.R. Grace & Company before becoming a luncheon club in 1914.

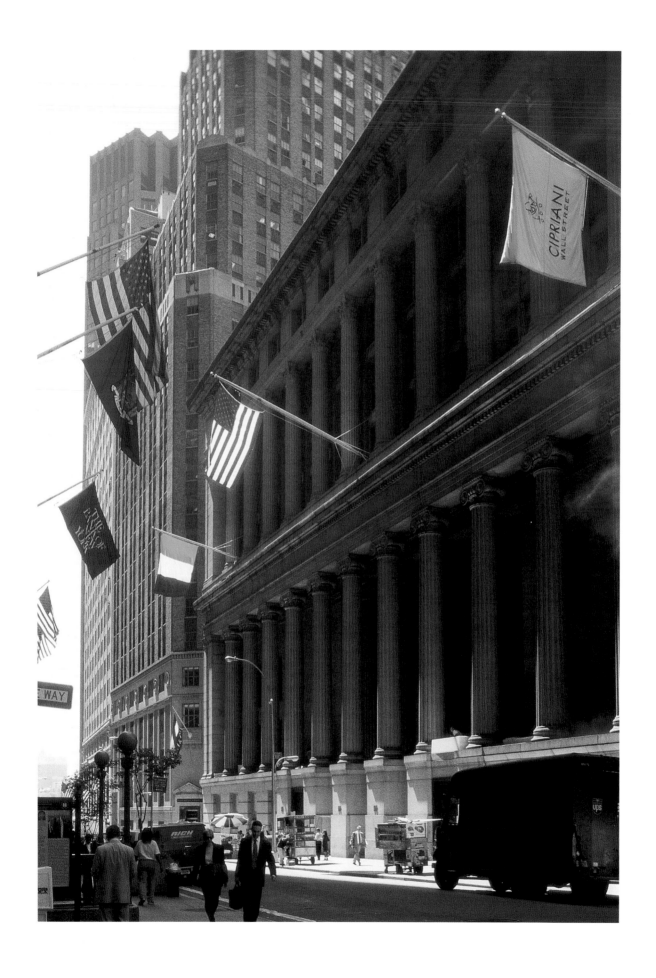

55 Wall Street

(*Opposite*) Formerly the headquarters of First National City Bank, this was originally the Merchants' Exchange. It was built between 1836 and 1842, designed by Isaiah Rogers, and converted to the United States Custom House in 1863 by William Potter. It was remodeled during 1905-07 and doubled in height by McKim, Mead & White. The latter performed excellent architectural surgery when they added a huge Corinthian colonnade to an equally huge Ionic colonnade that had been built sixty-five years before.

McKim, Mead & White did not duplicate what had been done; they added their own interpretation — Corinthian versus Ionic, using similar proportions and emphasis on depth and shadow. The portico contains twelve granite columns rising forty feet and screening an enormous, recessed three-story porch. An interesting interlude is thus created between these massive columns and the main entrance.

The interior is one of Wall Street's grandest. It has had many incarnations, even during Citibank's reign, from a hushed collection of lending officers sitting at mahogany desks to a more contemporary environment of tellers and machines.

Presently, it is used as a special banquet space and operated by the Cipriani family.

Shearman & Sterling, one of the city's oldest and largest law firms, was located in this building before it moved uptown in 1987. It chose to have its own private entrance at 53 Wall Street.

Wall Street Plaza

(*Above*) Also known as the Eighty-eight Pine Street Building, this is one of I.M. Pei's most significant in New York — a white, crisp and elegant building and one of the first to have butted glass filling the entire structural bays without the use of mullions. Together with Skidmore, Owings & Merrill's 140 Broadway, this is one of the area's classiest new buildings. It was completed in 1973 and is presently owned by the Orient Overseas Association.

A.G. Edwards & Sons, Inc.

This is the New York trading and processing center of A.G. Edwards & Sons, Inc. The building was designed by Emery Roth & Sons and built in 1970. It features an unusual water garden entrance. A.G. Edwards is also unusual. Founded in 1887 in St. Louis, it is the largest brokerage firm still run by a member of the original family and one of the largest firms overall in the industry. Still based in St. Louis, today it is publicly-held and listed on the New York Stock Exchange.

Albert G. Edwards was appointed by Abraham Lincoln as Assistant Secretary of the U.S. Treasury. He served in this position under five presidents until his resignation in March, 1887. He then formed a partnership with his son to purchase and sell stocks and bonds, largely for banks. A second son soon joined, as well as other partners. In 1898 it purchased its first seat on the New York Stock

Exchange and in 1900 opened an office at One Wall Street. Until 1917, most brokerage clients were wealthy private investors and banks. But the sale of small-denominated Liberty Bonds to individual investors revealed a large source of investment capital not previously tapped. A.G. Edwards refocused its business and began soliciting the individual investor more actively. By 1923 it added a new position of "customers' man" to actively solicit clients. In 1931 the firm appointed William McChesney Martin as its first floor broker on the New York Stock Exchange. He later became its first full-time, paid president.

During the 1950s, Keith Funston, then president of the New York Stock Exchange, launched the famous "Buy A Share In America" as a continuation of the successful World War II defense bond program. A.G. Edwards concurred with the industrywide effort to encourage private

equity ownership among individual investors. It began to open branch offices, and by the time the Dow Jones Industrial Average crossed 500 in 1956, it had 11 offices in five states. The firm incorporated in 1967, and became publicly-owned in 1971. It acquired nine branch offices from duPont Walston & Co (including 77 Water Street) in 1973. Additional offices were opened at a conservative pace as A.G. Edwards honed its business philosophy of treating its customers first, "the way you would like to be treated." Today, the firm eschews the practice of manufacturing and selling its own products for higher profits. It refuses to place short-term broker profits above the best interests of its customers. It views profits not as a goal but as the result of client-first service. With very low broker turnover and a commitment to quality and excellence, it was named one of the "100 Best Companies to Work For

In America" in the January 12, 1998 issue of *Fortune* magazine.

A.G. Edwards & Sons, Inc. presently has over 6,300 investment professionals in more than 600 offices throughout the country.

The Atrium at 60 Wall Street

(*Above*) This airy public space is part of a large office tower designed by Kevin Roche, John Dinkeloo & Associates and erected in 1989. Its height was made possible by the transfer of air rights from the old United States Custom House at 55 Wall street. The atrium is an extra dividend.

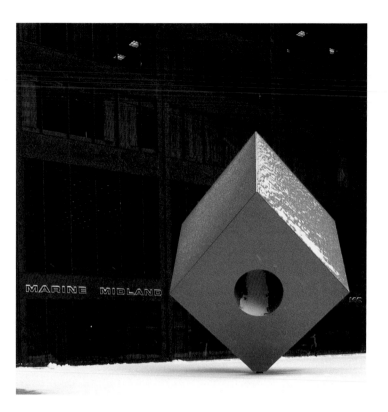

The Red Cube

Isamu Noguchi designed this bright red cube in 1967, placed it on its end with a hole down the middle, and set it next to the dark bronze glass facade of what is often referred to as the Marine Midland Bank building. The cube is technically a rhombohedron—a six-sided figure whose opposite sides are parallel at oblique angles. This element of disharmony creates a field of energy around it.

Marine Midland Bank, headquartered in Buffalo, is the principal U.S. subsidiary of London-based HSBC Holdings plc, one of the world's largest banking and financial services organizations. Today, the building at 140 Broadway, long occupied by the bank's metropolitan New York retail and commercial banking operations, also serves as the headquarters for HSBC Securities, Inc.; HSBC Asset Management Americas, and other HSBC Group subsidiaries.

The building was designed by Skidmore, Owings & Merrill and built in 1967. Lever House may have been Skidmore, Owings & Merrill's most influential building in New York, but 140 Broadway is considered its best. The glass curtain is dark, refined, and discreet. The building is irregular in shape, conforming to its plot rather than defying it.

Marine Midland Bank was founded in Buffalo in 1850 to finance trade along the Great Lakes and later expanded across the "midlands" of New York state. Its parent company, HSBC Holdings plc, has its roots in Asia, where it was founded in 1865 as The Hongkong and Shanghai Banking Corporation Limited. Today, the HSBC Group continues to support international trade and cross-border business through major commercial and investment banking and insurance businesses which operate under long-established names worldwide.

Double Check

(Opposite) This bronze statue by J. Seward Johnson was commissioned in 1982 by Merrill Lynch, which had occupied the offices directly across from it on Liberty Street. The figure is reading a memo on Merrill Lynch letterhead. His briefcase contains a calculator, tape recorder, pencils and occasionally an actual sandwich provided by passers-by.

Merrill Lynch was the primary tenant at One Liberty Plaza, which was built by the U.S. Steel Corporation in 1970. It replaced the famous Singer Building, designed by Ernest Flagg and completed in 1908. At forty-one stories, this was the tallest building in New York ever demolished and is considered the city's greatest loss since Penn Station. The tower was illuminated at night and had its own generator for heat, light and power for its elevators. It also had a central vacuum-cleaning system which included a special set of pipes for cleaning top hats. Flagg built the building in the manner of his clients' products: solid and reliable—never to wear out. When completed, he thought the Singer Building would be as "solid and lasting as the Pyramids." He was off on his timing, but to his credit at least the building took four times longer to demolish than its new replacement took to complete.

When One Liberty Plaza was completed, its principal tenants were Merrill Lynch, Pierce, Fenner & Smith and White, Weld & Co. A third primary tenant, Blyth & Co., did not move in as originally planned but moved in with Eastman, Dillon & Co. at One Chase Manhattan Plaza instead. When Merrill Lynch acquired White Weld in 1978 a number of executives of the latter firm never changed offices—just their stationery and calling cards.

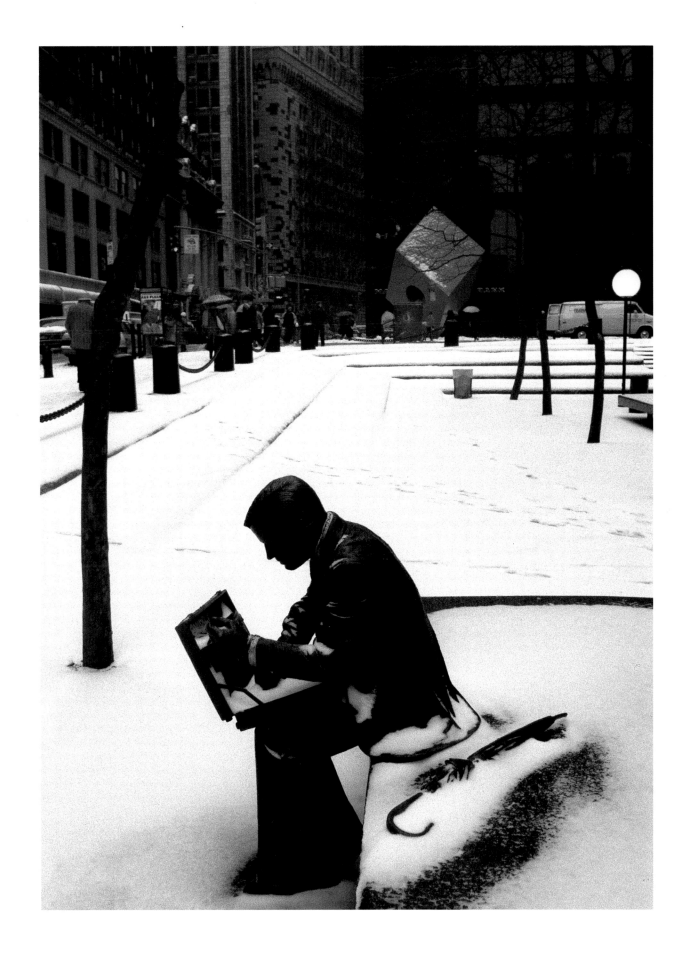

Donaldson, Lufkin & Jenrette, Inc.

In 1959, three classmates in their mid-thirties from Harvard Business School decided to leave their respective firms and create a new one. This was a bold move, because they decided not to create a specialty research boutique but a full-time institutional equity sales organization.

In 1969, Donaldson, Lufkin & Jenrette ("DLJ"), already a New York Stock Exchange member, broke new ground by deciding to go public. Since only First Boston had any public ownership, Donaldson, Lufkin and Jenrette decided to appoint them as manager of its offering, which was brought to market in April 1970. Prior to that name, no Exchange member firms were allowed to be publicly held, the reason why First Boston did not have its own seat until 1971. Donaldson, Lufkin's pioneering efforts, which the Exchange viewed with little enthusiasm at the time, are largely responsible for the tide of equity capital raised subsequently by Merrill Lynch, Reynolds & Co.,

Paine Webber, Dean Witter and others during the early 1970s.

Until the early 1980s, DLJ, as the firm is known, was highly dependent on equities-related businesses, stemming in large part from its excellence in research, institutional sales and venture capital. Since then, however, the firm has expanded its franchise aggressively, particularly in the investment banking area. The firm currently ranks #1 on Wall Street in the origination of high yield bonds, in the top five in mergers and acquisitions and has more than $8 billion in private equity capital available to support its clients in merchant banking transactions.

In these businesses and others, DLJ has developed a reputation for the creativity, flexibility and personal attention that has become the hallmark of what is DLJ's most remarkable accomplishment—the establishment, from a standing start in the mid-1980s, of what is now Wall Street's fourth largest underwriting business.

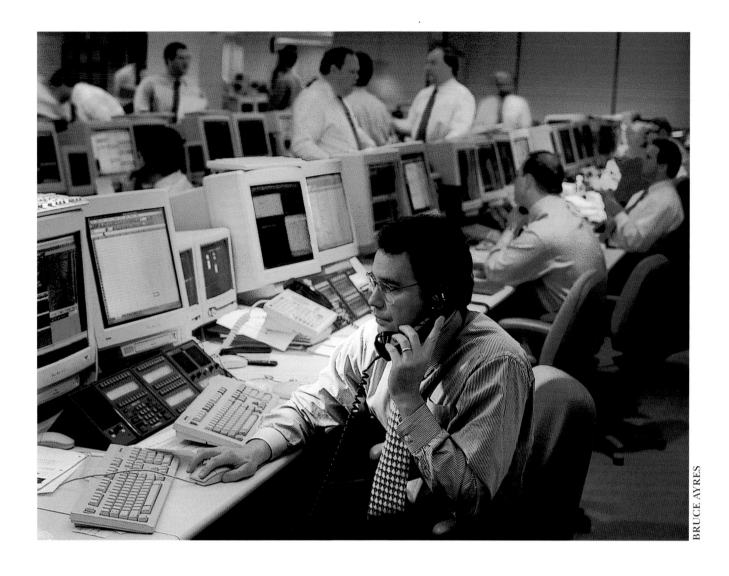

DLJ Today

Having experienced tremendous growth in the mid-1990s, DLJ today has a reputation that rests solidly on six bases: imaginative corporate finance (including a leadership position in high yield bonds), what is now Wall Street's largest merchant banking operation, venture capital (Sprout Group), excellent research, asset management (Wood Struthers & Winthrop), and correspondent brokerage (Pershing). Headquartered in midtown Manhattan amid the industry's most extraordinary collection of early American art, DLJ employs about 7,700 people worldwide and has offices in 14 cities in the United States and 11 cities in Europe, Latin American and Asia.

In the fast lanes of today's financial markets, the personal satisfaction of a firm's employees is often overlooked, DLJ takes the opposite approach and encourages "having fun" as one of its corporate objectives.

The Lawyers' Club

This club was located at 115 Broadway and later became the headquarters for the New York Stock Exchange member firm and specialist, Spear, Leeds and Kellogg.

Organized in 1887, the Lawyers' Club was once one of the oldest and best known downtown luncheon clubs in New York. It was originally located in the old Equitable Building at 120 Broadway. After the Equitable Building burned in 1912, the club was completely destroyed and it relocated to the upper three floors at 115 Broadway. (In 1918, Thomas Masaryk was speaking at the Lawyers' Club when he received a cable that he had been chosen president of the new nation of Czechoslovakia.) The main dining hall was described as one the most beautiful in the country, two stories in height with a stained glass window representing the history of law, designed by J. Gordon Guthrie. This beautiful window had a fountain below, giving the room an atmosphere quite unlike that of any other club.

Unfortunately, the club went out of business in 1979 and remained empty until Spear, Leeds & Kellogg acquired the space in 1982 and carefully refurbished it to its original splendor. The main dining hall is now a trading room with the famous stained glass window remaining intact. The entrance lobby remains much the same as in the days of the original club and the old members' lounge is now Spear, Leeds & Kellogg's floor members room.

Spear, Leeds & Kellogg was established in 1931 by Harold Spear, Lawrence Leeds and James Kellogg III (who joined the firm in 1941, and became chairman of the New York Stock Exchange in 1956). The firm is the largest specialist on both the New York and the American Stock Exchanges, making markets in 280 and 185 stocks, respectively. Its affiliate, Troster, Singer & Co. trades five thousand stocks over the counter.

Rockefeller and Morgan

Here are the inner sancta of Wall Street's two most influential men, John D. Rockefeller *(above)* and J.P. Morgan *(opposite)*.

When he was the chairman of the Standard Oil Company, Rockefeller maintained an office on the twenty-first floor of this building at 26 Broadway. It is designed in an elaborate Tudor style with mahogany beams dissecting a decorative ceiling, all supported by massive stone walls with arched windows. It is pure fantasy, but the owner could have whatever he chose, and an English castle seemed appropriate to him at the time.

J.P. Morgan selected a pyramid on the top of the Bankers Trust Building at 14 Wall Street for his office while his own building was under construction at 23 Wall Street. Of great influence in banking circles, he was not as wealthy as some thought. In fact, when he died in 1913 and left an estate valued at just over $100 million, Rockefeller commented, "And to think, he wasn't even a rich man."

Today, Rockefeller's offices are occupied by Carr Securities Corporation and Morgan's pyramid by a fine French restaurant.

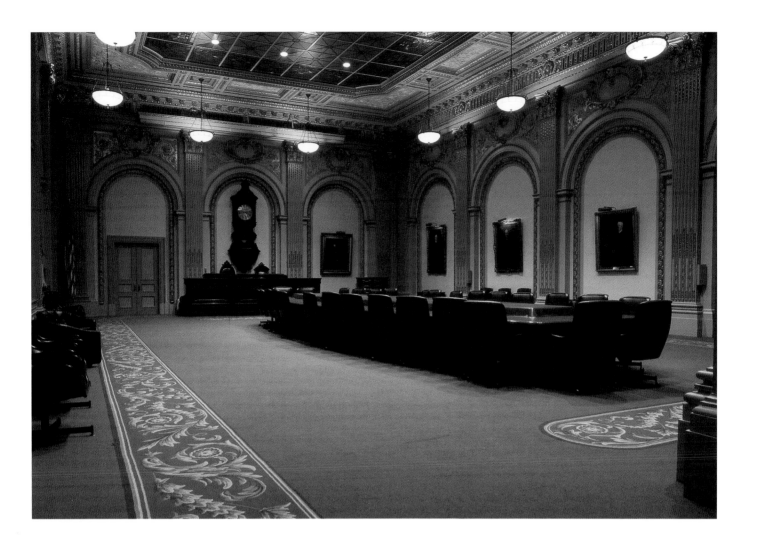

Broad and Wall Streets

(*Opposite*) A large Christmas tree dominates outside the New York Stock Exchange, whose main building (1903) was designed by George Post. It duplicates the Greek Revival temple design of the Federal Hall National Memorial across the street with its own columned facade, adding a frieze of life-size figures in its pediment. The 23-story tower was designed by Trowbridge & Livingston (who did J.P. Morgan & Co.) and completed in 1922. Additional trading space known as the "garage" was located on the street level of this building.

Upstairs at the New York Stock Exchange

(*Above*) The Exchange's main board room is magnificent to an extent beyond almost any other American corporation including the powerful Federal Reserve Bank of New York. There are twenty-seven chairs at the thirty-five-foot-long table, each with a director's name plate on the back. The portraits are all of past governors, and the tall clock and president's podium used to be on the floor of the Exchange of the last century.

The New York Stock Exchange

The floor of the NYSE is one of the most active in the world. A system of conduits for electronic cables now extends into the vast interior space above the floor. Prior to this, large annunciator boards on each side of the floor would flash a broker's number calling him to his trading post, which may have given the Exchange the nickname of "the Big Board."

The evolution of the New York Stock Exchange began in 1869, although its trading association stretches all the way back to 1792. Continuous trading of stocks throughout the day, rather than only during the morning and afternoon roll calls, began in 1873 with some brokers dealing in particular stocks at one location on the trading floor instead of wandering about. Two technological inventions were crucial to the Exchange: Morse's telegraph (1844), which provided quick communications between brokers and investors throughout the country and the stock ticker (1867), which replaced the messenger boys, known as "pad shovers," who constantly ran (often late) between the trading floors and brokers' offices. By 1880 the telephone replaced the telegraph and enabled trading volume to reach into the millions by 1900. The first million-share day was in 1886, but this became more frequent in the early part of the next century, fueled by the growth of the railroads and the trusts.

Trading volume exceeded three million shares for the first time just before its move into greatly expanded facilities in 1903. The new trading floor was one of the grandest spaces in the nation, with marble walls, generous dimensions, an ornate gilt ceiling, 79 feet high and the famous annunciator boards.

In mid-October (a favorite panic month) of 1907, there was a run on banks and stock prices began to fall. The precipitous decline was halted through the intervention of J.P. Morgan, who organized a consortium of major banks to subscribe over $25 million to hold up the market. The panic was halted by mid-November. This was the last time that one man could command the financial resources adequate to change the course of an unfavorable market. The era of the market titans and speculators came to an end with World War I.

A bull market ensued after the war, due to the expansion of the United States' consumer market and its emergence as a creditor to Europe. New York replaced London as the center of international finance, and during the next decade, over 1700 foreign issues were offered publicly in the United States. With the growth in personal income came the cash available for investment, and popular interest directed these funds into the stock market. Annual trading volume increased from 450 million shares in 1925 to over one billion in 1929. When the market crashed on October 29, 1929, over 16 million shares were traded, a record not surpassed for thirty-nine years. Much of the panic derived from the breakdown in communications and the long delays in the ticker's ability to report prices.

After that, high-speed tickers were installed and computers replaced the pneumatic tube system. By April 1968 trading volume surpassed the 1929 record for the first time, and brokers who had not adequately automated their back offices were awash in the paperwork crisis. The Exchange was forced to curtail trading hours and ultimately had to arrange the sale of Goodbody & Co. to Merrill Lynch lest the former's collapse bring down the entire system. By 1973 member firms' back offices were under control, and the Exchange introduced the fully automated Designated Order Turnaround ("DOT") system to route electronically small orders and reports between member firms and the NYSE. Later systems speeded processing of market orders received before the opening and made processing of limit orders easier. One of the great credits to the New York Stock Exchange was that during the high volume and uncertain days of October 19-20, 1987, the NYSE market system continued to function, preventing, with the assistance of the Federal Reserve Bank, more serious repercussions. As a result of studies following the October 1987 market break, the NYSE undertook close to 30 initiatives designed to strengthen its market system. Among them: increased volume capacity; accelerated routing of individual investors' small orders through its SuperDOT System during active and volatile markets; and an agreement with the Chicago Mercantile Exchange on various circuit-breaker procedures to provide cooling-off periods in times of extreme volatility.

Last year, 133.3 billion shares were traded on the NYSE, representing a dollar volume of $5.8 trillion. The busiest day was October 28, 1997 when over 1.2 billion shares were traded, and the Dow Jones Industrial Average gained 337.17 points—its largest single-day gain ever. Also, last year, the NYSE began trading stocks in "sixteenths," an interim step toward quoting stock prices in decimals.

There are 3,047 domestic and foreign companies listed on the NYSE. Sixty-three foreign companies joined last year alone, bringing the total to 343. The total market capitalization of all listed companies is $11.8 trillion.

Clearly, the NYSE is, and it plans to remain, the "Big Board."

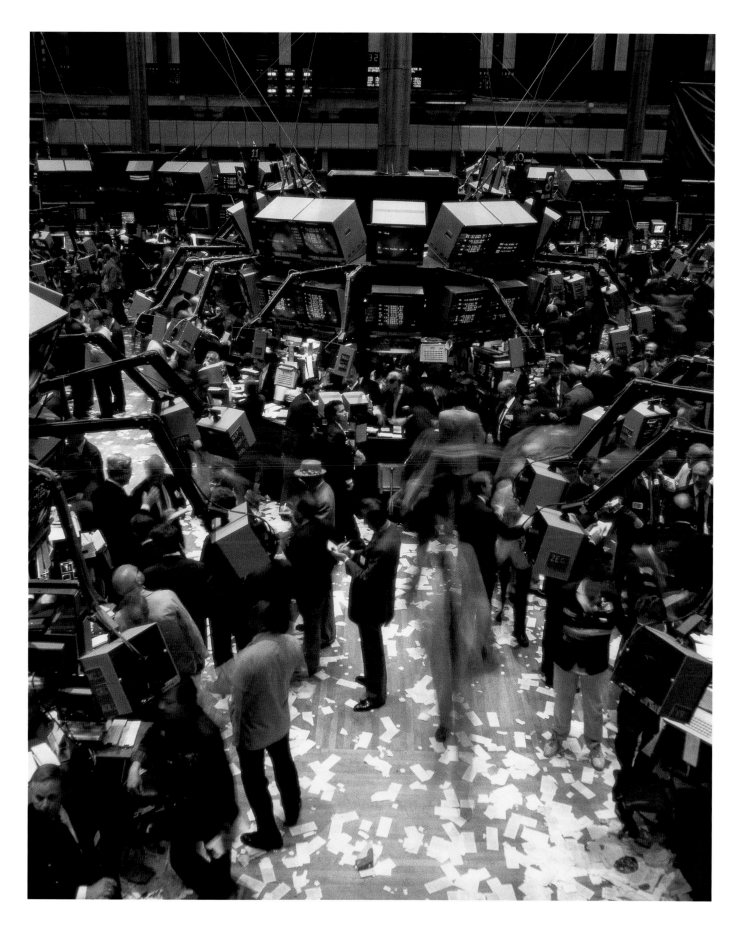

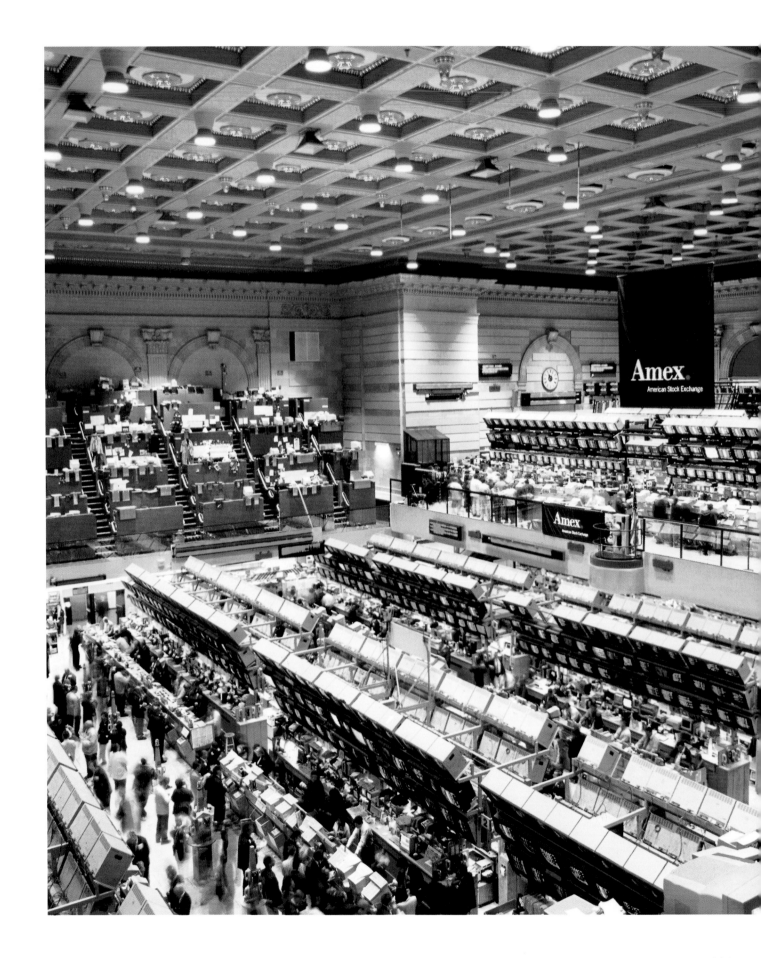

JEAN MIELE

The American Stock Exchange

The origins of the American Stock Exchange (the "Amex") are colorful and equally as modest as the beginnings of the New York Stock Exchange. The latter began as a trading forum under a buttonwood tree while the Amex started at the curbstone on Broad Street near Exchange Place. Nothing stopped the curb brokers; even in the snow and rain they gathered around the lamp posts and mail boxes, putting up lists of stocks for sale. By 1900, millions of dollars' worth of securities in mining companies, farm machinery, railroads, life insurance, and printing and textile companies were being traded in the street. With the increase of volume, the more enterprising brokers rented rooms above the street, where their clerks could receive telephone orders and call them down to the curb. This worked fine until the level of shouting reached such an extent that special broker hand signals were substituted, a system that has prevailed on the Amex for decades after it moved indoors.

In 1921, the New York Curb Market, as it was called, moved inside. In 1929, it became the New York Curb Exchange and moved to new expanded facilities at 86 Trinity Place in 1931. It was not until 1953 that it officially became the American Stock Exchange.

Today, a listing on the Amex affords companies greater liquidity, visibility and analyst coverage, resulting in an increased propensity for major institutions to hold its shares. Another benefit is the national recognition, which is measured by the marked increase in the number of large brokerage firms holding shares for their accounts. The Amex also provides ongoing services to its listed clients, including the access of several thousand retail brokers and portfolio managers through its luncheon meetings clubs, industry seminars and conferences. It also prepares a bimonthly report for investment professionals focusing on a different group of listed companies in each issue.

The American Stock Exchange is the only primary marketplace in the United States for both equities and derivative securities. The Amex trades more than 900 issues on its primary list. The Amex trades options on 30 broad-based sector indexes and more than 1,000 domestic and foreign stocks, as well as Long-term Equity AnticiPation Securities® (LEAPS®) on 116 stocks. In addition, the Amex is a leader in listing warrants on foreign currencies and indexes as well as hybrid instruments and other structured products.

Earlier this year, the Amex announced its intention to merge with the National Association of Securities Dealers. At the transaction's close, the Amex would become a subsidiary of the NASD. The NASD, the American Stock Exchange (Amex) and the Philadelphia Stock Exchange jointly agreed in principle to add the Philadelphia Stock Exchange as a charter member to the proposed NASD/Amex family of companies.

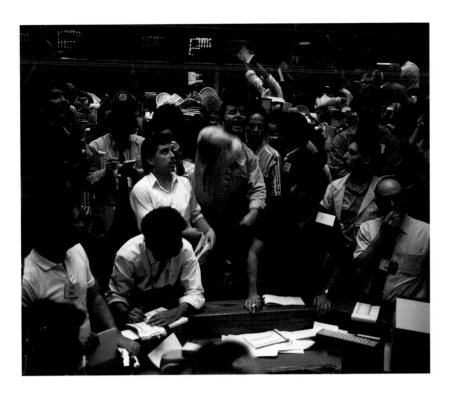

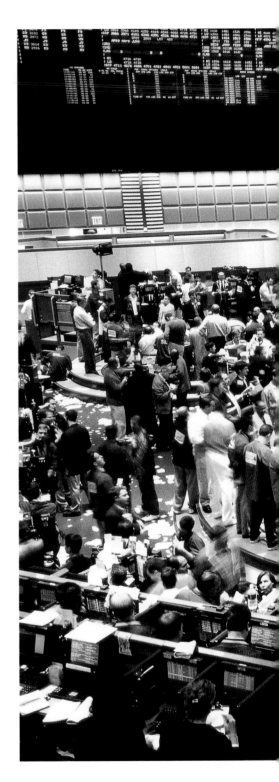

The New York Mercantile Exchange

This is the world's largest physical commodity exchange and the third largest U.S. futures exchange. Trading activity on its floors determines worldwide benchmark prices for the energy, precious metals and copper industries.

Founded in 1872 as a market for agricultural products, it diversified into platinum futures in 1956 and palladium in 1968. The demand for these high-technology metals, plus the introduction in 1978 of the first successful energy contract, heating oil futures, has enabled it to become the fastest-growing futures exchange in the U.S. It is the only one devoted exclusively to pricing, hedging and trading essential industrial commodities.

Since its merger with the Commodity Exchange, Inc. on August 3, 1994, trading is conducted through two divisions: the NYMEX Division and the COMEX Division.

Last year, more than eighty-three million contracts were traded on the Exchange. The NYMEX Division has 766 members holding 816 seats, while the COMEX Division has 713 members holding 772 seats.

On July 7, 1997, the Exchange opened its new 500,000 square-foot trading facility on the riverside front of the World Financial Center (shown in the photograph). There are two 25,000-square-foot, column-free trading floors, with observation galleries overlooking the open outcry activity. Fiber optics are used throughout the communications system, providing reliable, noise-free data and voice transmission. The open configuration allows for more efficient movement and a smoother flow of operations. As in the photograph on the left, taken in 1989, shouting and enthusiasm still prevail.

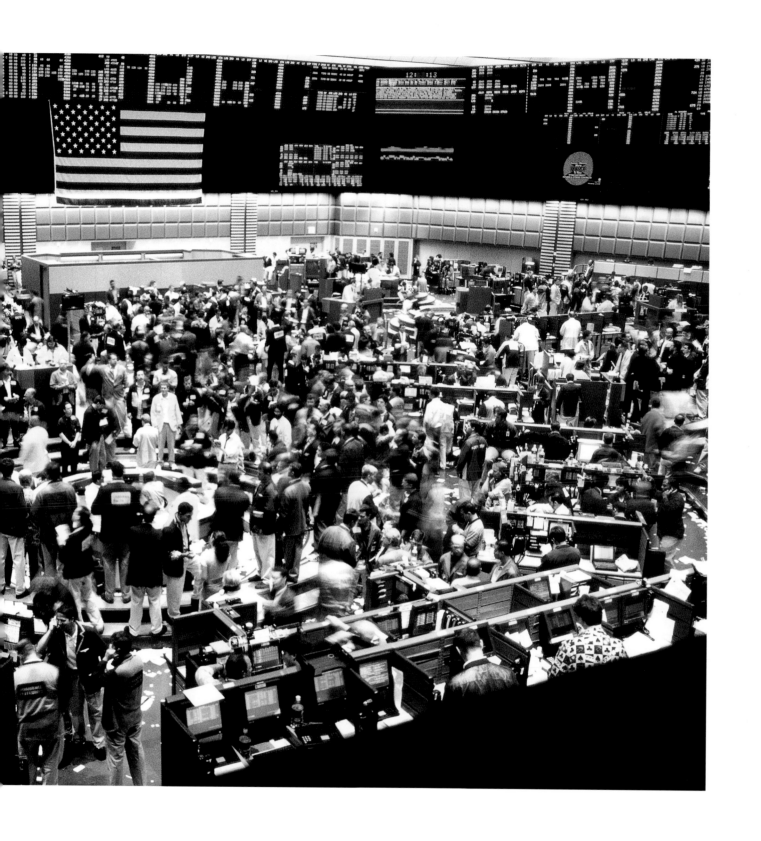

Salomon Brothers Inc.

Salomon Brothers & Co. was formed in January, 1910 as a partnership of three brothers (Arthur, Herbert and Percy) plus a clerk, Benjamin Levy, to continue their father's business of money brokerage. The firm was long on ambition but short on capital, and in April of that year had to merge with Martin Hutzler & Co. because the latter had a seat on the New York Stock Exchange, which Salomon Brothers could not afford.

But the principal activity of the firm was issuing and trading bonds, whose importance during the early part of the century eclipsed that of equities in the raising of new capital funds. The issuers were American railroads and other corporations as well as foreign governments. The United States Government was absent from the capital markets because its expenditures were modest and it had no deficit. The firm's clients were financial institutions and trusts who were generally required to invest only in bonds. Starting first with bankers' acceptances, the firm moved into rail equipment trust certificates, tax anticipation notes, federal land bank notes, and foreign currency obligations. It became one of the first primary dealers in government paper, and in 1922 it moved its headquarters to 60 Wall Street, with branch offices in Boston, Chicago, Philadelphia, Minneapolis and Cleveland.

There were numerous big bond firms with lots of capital, but none ventured as far as Salomon to the extent of its market making. Salomon always made a market in everything it sold and was the one firm where a bid for a debt instrument could be obtained. By the 1950s bond offerings were considered unsalable if Salomon would not touch them. Being outside of Wall Street's establishment, the firm broke the "capital strike" in 1935 with an offering of first mortgage bonds for Swift & Co. The boycott had been created by the issuing houses as a protest to Joseph Kennedy's tough new SEC regulations. Most public offerings were turned into private placements. Salomon went ahead anyway and earned grudging respect by the other houses. Still it needed more origination business and in 1962 it teamed up with Merrill Lynch, Lehman Brothers and Blyth & Co. to form "the Fearsome Foursome" to get more competitive bidding opportunities. In the mid-1960s it began to transfer its institutional relationships to stocks as well as bonds and became a major player in block trading.

For decades the historical syndicates were considered to be absolutely sacrosanct. Once a firm was in a particular syndicate as a major, it was a major for life. Dillon Read and Kuhn Loeb were in a special bracket that excluded others who felt they were more capable. The landmark issue that broke all historical ties came in 1979 when IBM Corporation replaced its traditional lead manager, Morgan Stanley, with Salomon Brothers and Merrill Lynch. Morgan Stanley was in part responsible because of its policy not to have co-managers or to appear in tombstones unless it was first. In one stroke the IBM deal simply said that companies were free to choose their own investment bankers and not be dominated by historical circumstances. John Gutfreund is credited with laying the groundwork. During the 1960s, he would call up the major firms such as Dillon Read in the midst of a large debt offering and simply buy a major portion of the transaction. The bonds were sold and gradually major corporations realized the tremendous placing capacity of Salomon.

Barely noticed in the 1950s, Salomon was instrumental in helping to save New York City from bankruptcy in 1975 and the Chrysler Corporation in 1980. The latter's deficit exceeded $1 billion in 1979 and it had run out of all available funds. Salomon coordinated a rescue plan that included unprecedented federal loan guarantees of $1.5 billion.

From 1981 until 1986, it had a stormy marriage with Phibro Corp. (née Philipp Brothers) which ended in divorce. Salomon Brothers was always a loose federation of independent traders and salesmen, cooperating more like a medieval guild than a structured corporation.

In 1970 the firm moved to One New York Plaza and created the largest private trading floor in the world, commonly referred to as "the room." The Hutzler name was dropped that year when the firm reverted to its original Salomon Brothers. It opened offices in London in 1971 and Tokyo in 1980 so that it now maintains round-the-clock trading activities with a portfolio of approximately $11 billion, adhering to one of Arthur Salomon's principal tenets, to stand prepared to repurchase whatever it sold.

In 1997, the firm combined with Smith Barney Inc. See pages 70 to 73.

Wall Street Patriarchs

The Bankers Trust Building (1912), designed by Trowbridge & Livingston, and to its right the Equitable Building (1915), designed by Ernest Graham, are two of Wall Street's most famous landmarks. At the time of its completion, the Bankers Trust Company Building was considered the world's tallest structure (540 feet) on so small a plot (94 by 97 feet). J.P. Morgan took up residence in the pyramid, long the bank's logo, to watch construction of his own building at 23 Wall Street, designed by the same architect. The bank subsequently acquired three properties adjacent to 16 Wall Street—Fourteen Wall Street and Seven Pine Street, both in 1917, and Fifteen Pine Street in 1927. All three were replaced by a 25-story structure

that year which had floor levels matching 16 Wall Street, abutting the latter on the west and south, producing internally a single building covering the eastern half of the block bounded by Wall, Nassau and Pine Streets and Broadway.

The Equitable Building was simply the largest building in the world when it opened in 1915. This photograph is taken from the location of the Curb Exchange on Broad Street, approximately where the original canal stopped. Outdoor trading began in 1865 and continued until 1921 when the brokers moved to indoor quarters on Trinity Place.

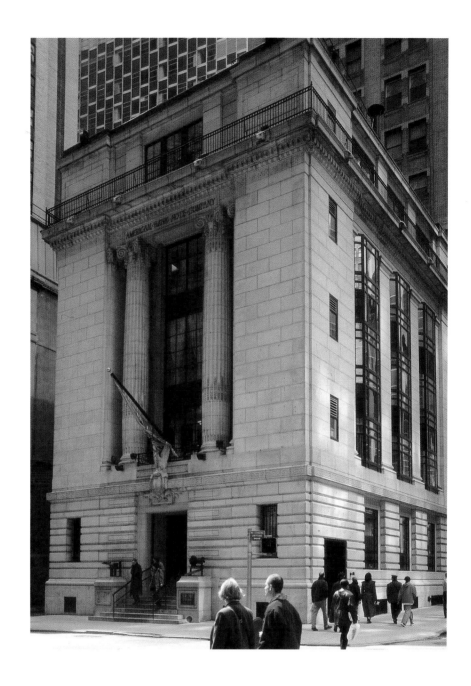

The American Bank Note Company on Broad Street

This company was formed in 1858 through a merger of seven banknote engraving firms. It was originally located in the Merchants' Exchange at 55 Wall Street and soon became the most renowned financial engraver in the country. In addition to paper money, the firm printed stamps and stock certificates. It built these headquarters on Broad Street in 1908 and opened a large engraving facility in Hunts Point that remained in operation until 1985. When American Bank Note was acquired by the United States Bank Note Corporation in 1990, its offices were relocated to Hudson Street.

Broad Street's unusual width derives from its origin as a canal, called *de Herre Gracht* ("the Gentlemen's Canal"). It reached to today's Exchange Place, where a ferry to Long Island docked. The canal was filled in during the 1680s when the Dutch began to push the city limits further out. Pearl Street was initially at the edge. Later came Water, Front and South Streets—all built on landfill. The wide section of Beaver Street stretching from Broad Street to Bowling Green offers a clue to its history: it too was originally a canal called *de Begijn Gracht*.

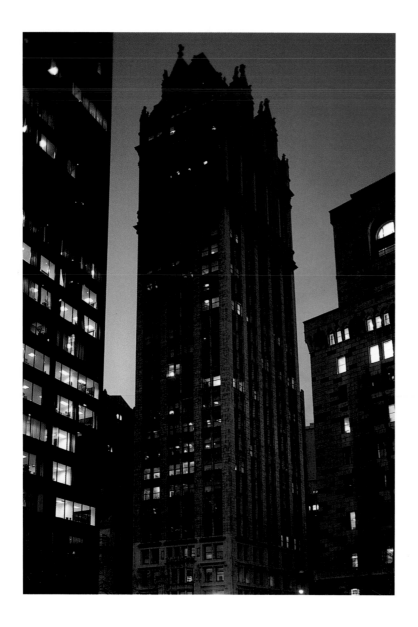

Liberty Tower

(Above) This tower at 55 Liberty Street was designed by Henry Ives Cobb and constructed between 1909 and 1910. For many years this was the headquarters of the Sinclair Oil Company which was acquired by British Petroleum in 1969. The design is one of the first to expand on the newly approved steel cage construction and create a unified rather than tripartite system of composition. The highly ornamental Gothic exterior is created with terra cotta, a technique later used by Cass Gilbert at 90 West Street and on the Woolworth Building.

Architectural Extravaganza

(Opposite) This experience exists only downtown, with its irregular streets and mixture of structures of different centuries. Take a moment to savor the variety because they represent a rich selection of different styles.

In the foreground are buildings constructed along Pearl Street from 1829 to 1858 on what was New York's first landfill. To the left is the massive Goldman Sachs Building, with J.P. Morgan's distinctive new classical column in the center. In front of J.P. Morgan, reflected in the puddle, is the columned facade of the W.R. Grace & Co. Building. Between Morgan and a new red brick office building at Seven Hanover Square is the Cities Service Building (1932), now known as the American International Building.

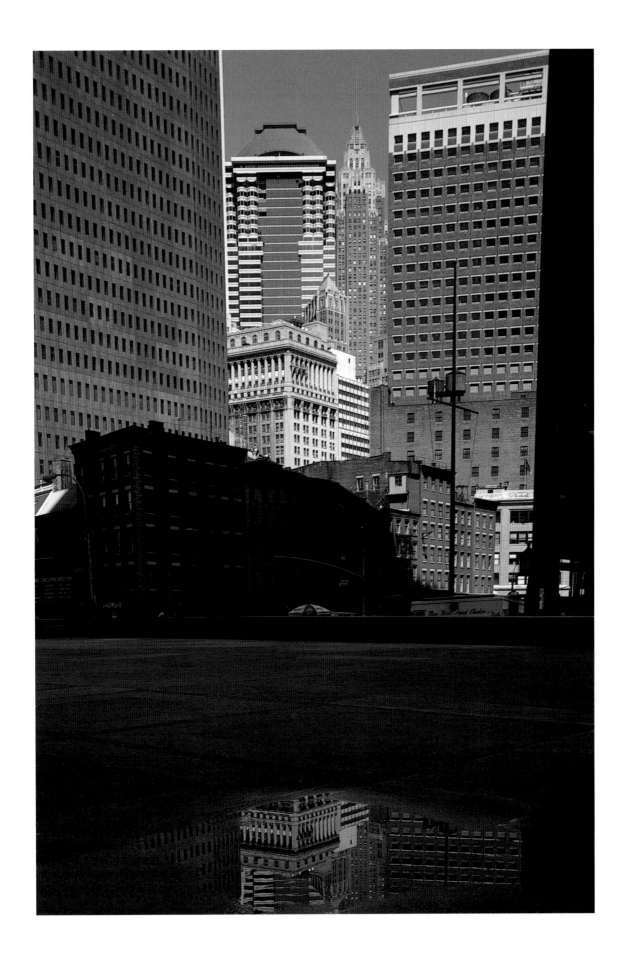

One Wall Street

(Above) This shimmering limestone tower, designed by Ralph Walker in 1932, is skyscraping at its best— massive and yet finely detailed. It is a fitting companion to Trinity Church whose chapel roof I have captured in the foreground.

The building was built for the Irving Trust Company, which was founded in 1851 and named for Washington Irving. The bank's previous headquarters were in the Woolworth Building before moving to One Wall Street in 1932. The bank was acquired by the Bank of New York in 1989.

100 Broadway

(Opposite) The American Surety Building was designed by Bruce Price and completed in 1895, with an extension in 1921 by Herman Lee Meade and a renovation in 1975 by Kajima International.

This is one of Wall Street's loveliest buildings in every respect. At its base is a colonnade of massive Ionic columns on which stand a row of full-sized classical figures. The elaborate multistoried cornice on the top projects six feet. When completed not only was this the tallest build-

ing in the world, it was also the most admired. It was built by the American Surety Company for its headquarters as one of the country's major surety companies. Transamerica Corporation acquired the company in 1947 and the Bank of Tokyo acquired the building in 1974, making careful renovations to enable it to last another hundred years.

In the 1870s New York had a series of tall buildings (Equitable Life—1871, Western Union—1875, and the Tribune Building—1875) called "elevator buildings." They all still had heavy masonry walls. In 1892 the city adopted a change in its building codes that permitted the steel cage construction (Chicago was first—in the 1880s). This important modification permitted the development of the modern skyscraper as we know it today, with 100 Broadway being one of the earliest examples in New York—the center of skyscraper development for the past century.

Wall Street Canyons

(Above) From the corner of Hanover Square one can see the classical spire and eagle on top of the Bank of New York Building at 48 Wall Street. This tasteful Renaissance Revival building was designed in 1929 by Benjamin Morris, who also is known for the Cunard Line Building. The Bank of New York's rich upper stories are stepped back and contain a Greek temple, a tower to the west of the temple, and an eagle atop the tower.

(Opposite) The Trinity Building, 111 Broadway (1905) and the U. S. Realty Building, 115 Broadway (1907), were both designed by Francis Kimball.

These magnificent long and narrow structures were built by Harry Black of the George Fuller Construction Company. Their rich Gothic facades harmonize with Trinity Church and glow in the late afternoon sun. The famous Lawyers' Club, one of Wall Street's oldest luncheon clubs, was located atop the U.S. Realty Building, and Goodbody & Co. was on lower floors. Those who remember this spot will also recall that one of Brooks Brothers' first branches in the country was located on the ground floor of the Trinity Building.

One day a colleague of mine was invited to dine with his uncle at the Lawyers' Club and had mistakenly gone to the top of the wrong building. Because he was running late, he decided to try the open catwalk connecting the two buildings rather than retrace his steps. The rusting bridge was on its last legs with loose or missing planks. My friend finally made it to the other side and stumbled into the Lawyers' Club kitchen, a bit shaken. His appetite was temporarily sated from the experience.

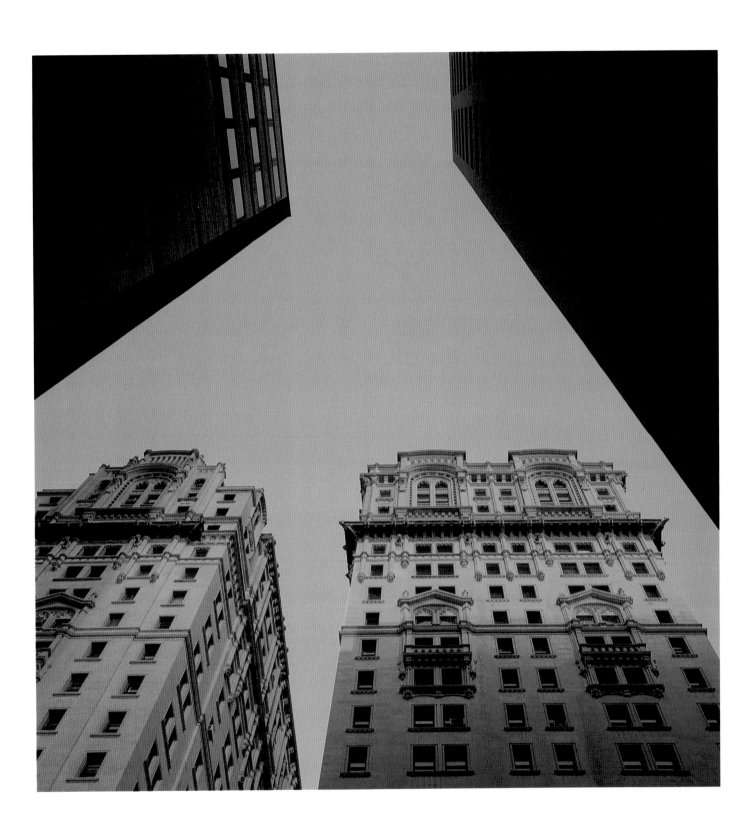

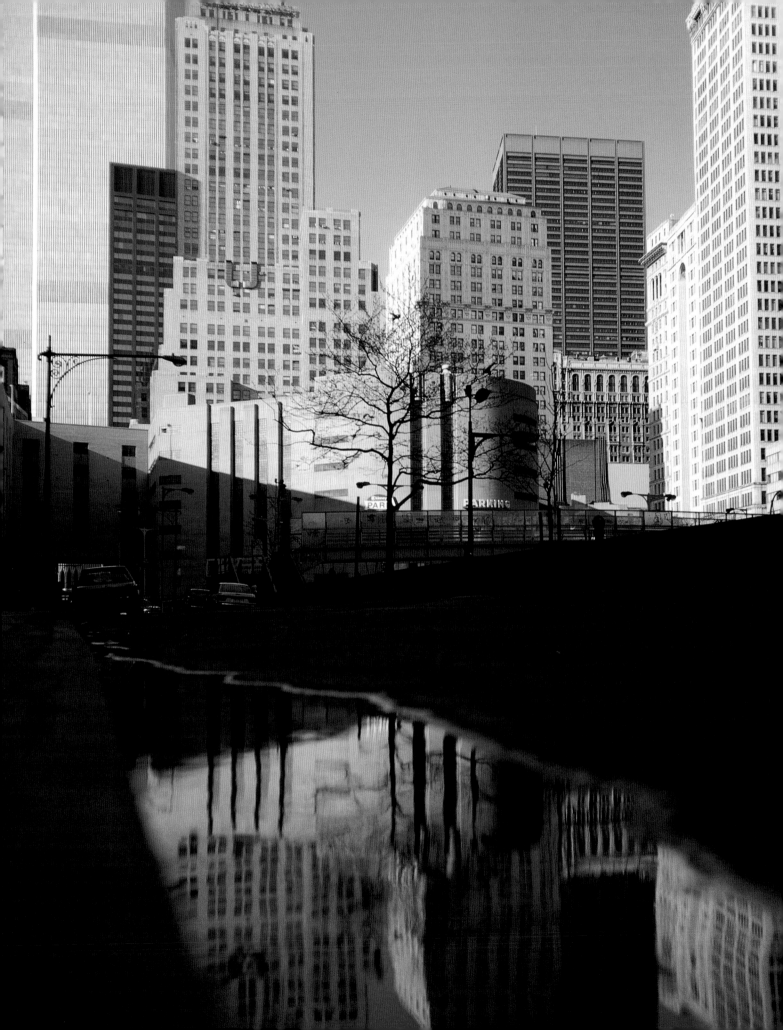

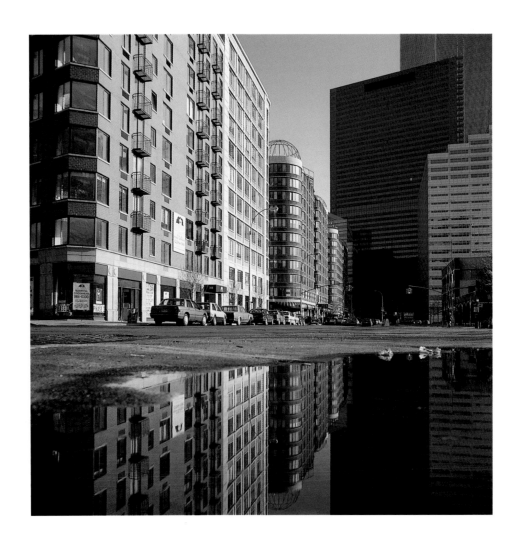

Wall Street from Washington Street

(Opposite) This view of the financial district is from the Downtown Athletic Club's Washington Street entrance. From the left in the photograph are No. Two World Trade Center, One Bankers Trust Plaza, Nineteen Rector Street, Two Rector Street with the Port Authority parking garage in the foreground, One Liberty Street with the elegant Trinity Building in its foreground, and Nos. 71 to 39 Broadway.

Beginning TriBeCa

(Above) This is the view of Wall Street from its northern edge, TriBeCa. Residences have sprouted along Greenwich Street serving the financial district, especially the World Financial Center and the World Trade Center. The term TriBeCa derives from the triangular-shaped area below Canal Street.

The American Express Building

(*Above*) This is the firm's former headquarters at 65 Broadway, completed in 1917 and designed by Renwick, Aspinwall & Tucker. It was also home for many years to J. & W. Seligman & Co. after they moved from One William Street. American Express was formed in 1850 and occupied different locations on Wall Street and lower Broadway until 1874 when it moved to old 65 Broadway, the site of the present structure that replaced the earlier one in 1917. Prior to its demolition, American Express acquired old 65 Broadway in 1902 for $2.2 million, the largest private cash real estate transaction ever negotiated in New York up to that time.

After American Express moved to 125 Broad Street the building became headquarters to the American Bureau of Shipping and in 1989 was acquired as the new headquarters of J.J. Kenny & Co. The graceful 21-story building is designed in an H-plan with light-filled courtyards on both sides connected with an enclosed arcade on the upper floors.

Nos. 71, 65 and 61 Broadway

(*Opposite*) These handsome structures were built as follows: 71 Broadway, completed in 1894 and designed by Renwick, Aspinwall & Tucker. It was known as the Empire Building and was home to the U.S. Steel Corporation for many years. At 65 Broadway is the American Express Company Building, built by the Aspinwall firm in 1917. Next door is 61 Broadway, completed in 1916 and designed by Francis Kimball for Adams Express Co. It was also home to J. Henry Schroder Bank & Trust Co. until their relocation to One State Street in 1969. Presently Ingalls & Snyder is headquartered here, among other firms.

This section of Broadway is believed to be the site of the original structures put up in 1613 by Captain Adriaen Block. He had come to America seeking to profit from the beaver-fur trade. In November of that year his ship accidentally caught fire and burned down to the waterline. With no other means of returning to the Netherlands, Block and his crew set up their winter camp on the hill near Exchange Place. With the assistance of the natives, they built four small shelters and became the first colonists.

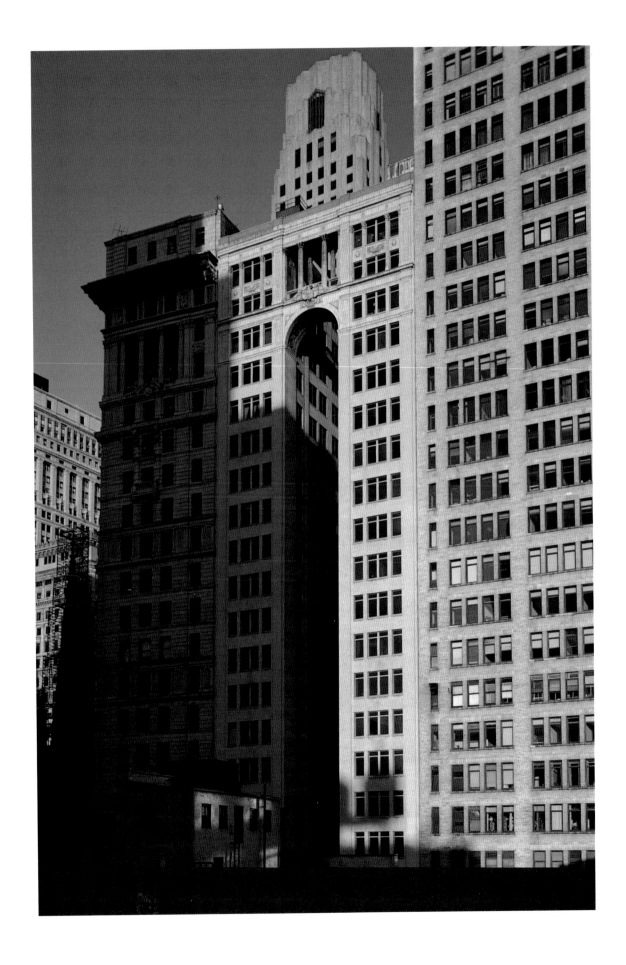

One Hundred Broadway

(*Above*) These three Greek goddesses (including stern-faced Prudence holding a mirror) are from a series of life-sized figures on top of the colonnade at 100 Broadway. They are by J. Massey Rhind, a noted sculptor at the turn of the century and were installed in 1895. Rhind is also known for his massive frieze on the South Wall of Alexander Hall at Princeton University.

America

(*Opposite*) This is one of *The Four Continents* at the U.S. Custom House by the sculptor Daniel Chester French (1903-1907).

French is best known for his statue of Abraham Lincoln at Washington's Lincoln Memorial. The collection of four continents at the U.S. Custom House is the most celebrated of his sculptures in New York, and it is perhaps the one he took the greatest pride in.

America is depicted by a woman of the pioneering days, an abundant sheaf of corn (representing material prosperity) across her lap. Her right hand holds the torch of liberty and enlightenment. At her left side Mercury sets in motion the winged wheels of commerce—a straightforward reference to America's growing industrial power at the beginning of the twentieth century.

John Watts

(*Above, left*) He was the last Royal Recorder of the City of New York and died in 1836. This statue was erected in Trinity Churchyard by his grandson, James Watts de Peyster in 1893.

John Wolfe Ambrose

(*Above, right*) This sculpture of Ambrose (1838-1899) was completed by Andrew O'Connor in 1899 and is presently installed on the south side of the Battery Park concession building. One of the financial district's many unsung heros

is John Ambrose, an engineer, who is largely responsible for transforming New York from just another shipping town into the greatest port city in the world.

For more than forty years, Ambrose fought for Congressional support of his plan to widen the shipping channel into New York. The plan cut the distance into the port by six miles, and the wider, deeper channel allowed access by the larger ships. The *Ambrose* lightship guided vessels approaching the channel from 1908 until 1963. It has been part of the South Street Seaport since 1968.

Those with good eyes will notice a pigeon hatching her family under the protection of Mr. Ambrose's flamboyant whiskers.

U.S. Steel Corporation

(*Above, left*) This is one of four of U.S. Steel Corporation's eagles at 71 Broadway. The building was originally known as the Empire Building, built in 1894.

Abraham de Peyster

(*Above, right*) This statue was completed by George Bissell in 1896. De Peyster was an affluent gentleman who was born in 1657 in Nieu Amsterdam. He became a successful merchant and served, alternately, as mayor, alderman, chief justice, acting governor and colonel of militia. Since he was born at 3 Broadway, for many years this statue stood in Bowling Green. It was moved to Hanover Square in 1972. The pigeons on His Honor's head and shoulders are a more recent addition.

Originally Hanover Square was called Printing House Square. The first printing presses were set up here by William Bradford in 1693. He published various almanacs and pamphlets. But in 1725 he published the *New York Gazette*, the city's first newspaper. The presses were located at 81 Pearl Street and then moved to Park Row after a great fire in 1835.

Benjamin Franklin

This statue of Franklin the newspaperman was made by Ernst Plassmann in 1872. It stands at Printing House Square, where Nassau Street meets Park Row. His location is in front of where the *New York Times* was located. The *Times* occupied a five-story building built in 1859 and enlarged in 1888. In 1904 the paper moved uptown in its quest for additional space, to a newly-constructed skyscraper in Longacre Square, which was then renamed Times Square. The name Longacre prevailed for many years in a telephone exchange of the area and also as a Broadway Theatre. Horace Greeley, the editor of the *New York Tribune*, made the principal addresses at the dedication on January 12, 1872, as the statue was unveiled from its "star spangled robe" by an elderly statesman, inventor and artist—Samuel F.B. Morse.

Franklin holds a copy of his first newspaper, the *Pennsylvania Gazette*.

Printing House Square became so-named in the 1860s because of the concentration of nineteen newspapers in this area, chiefly the *New York Times*, the *Tribune*, the *Sun*, the *Telegram*, and the *New York Staats-Zeitung*. All chose to be close to the source of most of the news: City Hall.

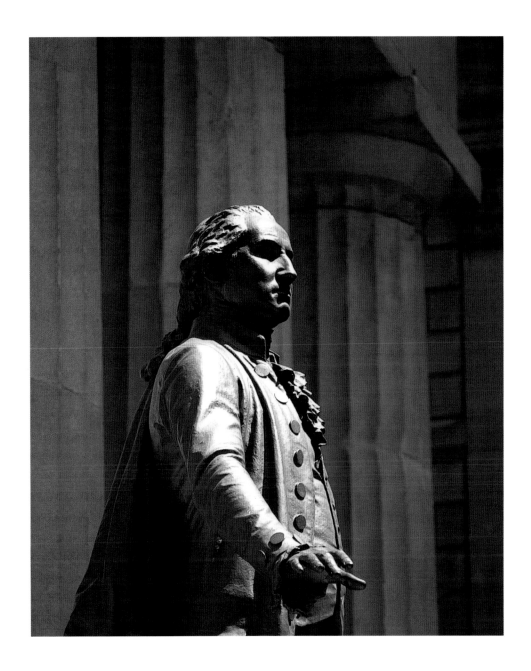

George Washington

This statue, familiar to all Wall Streeters because of its prominent location in front of the former Subtreasury Building (now the Federal Hall National Memorial), was sculpted by John Quincy Adams Ward in 1883. It was sponsored by the New York State Chamber of Commerce for the centennial of George Washington's Inauguration in 1889. The statue shows the president lifting his hand from the Bible as he completes his swearing-in ceremony. The occasion was reenacted with great fanfare for the Bicentennial of Washington's Inauguration on April 30, 1989, including a prelude of a parade of tall ships in the harbor.

When Queen Elizabeth decided to visit New York in 1976, a respectful four days after July 4th, she addressed a large gathering on Wall Street from this same location. I was there, and it seemed that my colleague and I waited an eternity for her appearance, after we had seen her motorcade pass by Trinity Church. Apparently, she had to go around the building and enter through Pine Street because after all, my friend advised me, the Queen did not climb steps in public.

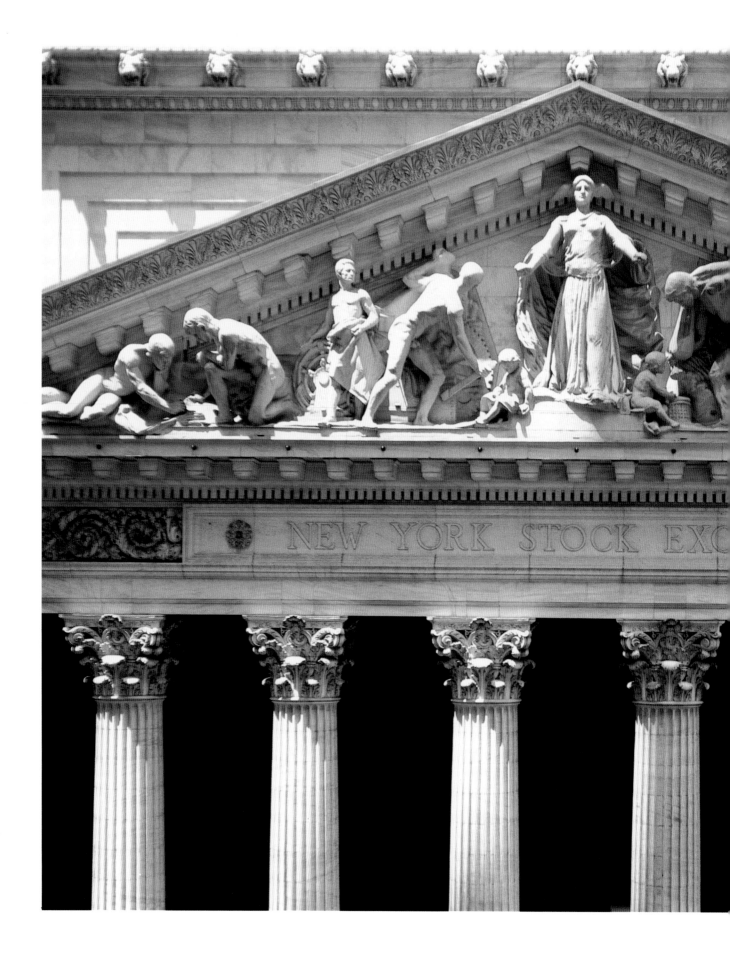

Integrity Protecting the Works of Man

The great pediment sculpture on the New York Stock Exchange was designed by John Quincy Adams Ward and executed by Paul Bartlett in 1903.

These larger than life-sized figures may be identified as follows: Integrity stands in the center, holding the world's business at her sides: mechanical arts, electricity, surveyors, and builders on the left, and mining and agriculture on the right—the products of invention versus those of the earth. The agriculture contingent includes a pregnant farmhand.

Wall Street Sculptures

(*Opposite*) Madonna and Child. This unusual Art Deco-styled Madonna and Child adorns the main entrance of Our Lady of Victory's church on Pine and William Streets. Located right in the very heart of Wall Street, Our Lady of Victory has heard many prayers over the years from bankers and brokers.

(*Above, left*) EZ Face. This is one of a series of large Easter Islanders that decorate the frieze on top of the EZ Directory Building at 80 Washington Street. Few people even know these sculptures exist on the hundred-year-old structure. But many people can readily identify the familiar red EZ Book of securities firms, which has been published semi-annually since 1927.

(*Above, right*) The Seamen's Bank. These friendly nautical motifs frame the main entrace of 72 Wall Street, which was designed for the Seamen's Bank for Savings by Benjamin Morris in 1926, one hundred years after the bank's founding. The same architect was also responsible for another nautically inspired building, the Cunard Line Building at 25 Broadway (1925), and also the Bank of New York Building at 48 Wall Street (1928). The Seamen's moved to 30 Wall Street in 1955 and this became a Williamsburg Savings Bank until its recent acquisition by the American International Group, Inc. This location also marks the original site of the New York Stock Exchange. On May 24, 1792, merchants and auctioneers gathered under a buttonwood tree and came to an agreement that led eventually to the formation of the Exchange in 1817.

American International Building

Seventy Pine Street was built by the Cities Service Company in 1932 and designed by Clinton & Russell. This 66-story building represents a wild celebration of Wall Street's riches. The company had its insignia duplicated throughout the lobby. (*Opposite*) On the outside, knowing the impact of the building could not be fully appreciated from street level (because of the proximity of other structures on the narrow streets), the company reproduced a model of the entire building.

(*Above, left*) The lobby of 70 Pine Street is one of the finest Art Deco experiences downtown. It has been faithfully restored and maintained by its new owner, American International Group, Inc. The building once contained the first double decker elevator cars ever installed in an office structure. They proved to be unpopular, however, and were soon replaced.

The building was once connected to 60 Wall Street via a bridge and was often referred to as the "60 Wall Tower."

Salomon Brothers & Hutzler, a somewhat sleepy bond house, was located at 60 Wall Street from 1922 to 1970, and Merrill Lynch, Pierce, Fenner & Bean was headquartered in the tower. Sixty Wall Street was torn down and the lot, remaining empty for many years, has now been graced with the new J.P. Morgan tower.

(*Above, right*) One of the lovely brass doors of American International Group's building at 72 Wall Street. This was originally built for the Seamen's Bank for Savings in 1926, which explains the maritime design. The Seamen's is the second oldest bank in New York after Bank of New York (whose headquarters at 48 Wall Street were designed by the same architect—Benjamin Morris). The original street address was 76 Wall Street, but seamen depositors persuaded management that the address be changed to 72 because the combination of 7 and 6 totalled 13, "a thing to make a good seaman worry."

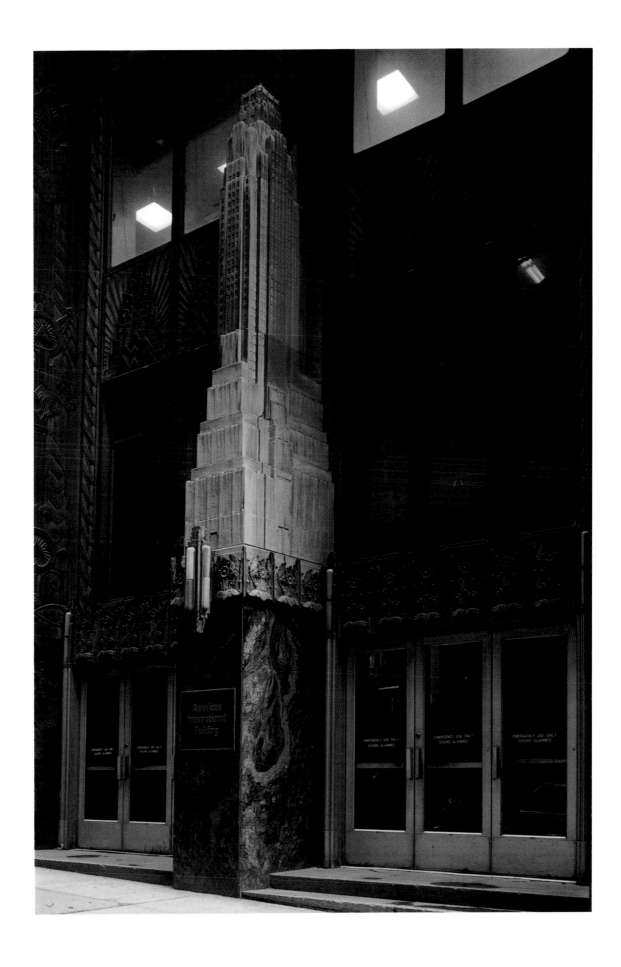

The AIG Observatory

One of Wall Street's best-kept secrets is also one of its most spectacular: the rooftop observatory of Seventy Pine Street. Since its opening in 1932, the senior executives of first Cities Service, then Merrill Lynch and now American International Group have enjoyed this garden in the center of the financial district. The elevator pushes up through a trap door at the side of the observatory, behind the chrome gate at the right in the photograph, and then disappears completely upon its descent, leaving an unobstructed view in all directions. The brass globe attests to AIG's presence in international markets.

AIG is a leading international insurance and financial services organization and the largest underwriter of commercial and industrial insurance in the United States. With

more than 40,000 employees and assets of approximately $170 billion, its member companies write property, casualty, marine, life and financial services insurance in more than 130 countries and jurisdications.

The firm was started in China in 1919 as American Asiatic Underwriters by Cornelius Vander Starr. It soon established branches throughout the Far East, and dur-ing the 1940s-1960s expanded further into Latin America, Europe and the Middle East. American International Group's world headquarters have been located in New York for fifty years.

Early Morning

(*Opposite*) As the roosters crow, an early morning sun falls on the Farmers Trust Company. This is presently the entrance to the great 20 Exchange Place banking hall of Citibank. The National City Bank merged with the Farmers Loan & Trust Co. in 1929 and this structure became their main headquarters when it was completed in 1931.

This view is from Hanover Street which, along with Hanover Square, is named for the German family from which British monarchs were directly descended after 1714. Together with Nassau Street these are among the only streets whose names were not changed after the Revolutionary War. King and Queen Streets, for example, became Pine and Cedar.

Untitled

(*Above*) This is the name of the unnamed sculpture by Yu Yu Yang completed in 1973. This large intriguing sculpture is located at 88 Pine Street, also known as the Orient Overseas Building. It was commissioned by C.Y. Tung of the Orient Overseas Association.

The highly polished steel disk is twelve feet in diameter and weighs four thousand pounds. It appears to have been cut out of the matte-finished slab in front, set at a slight angle and reflecting the scene around it, including its own frame in this case. The disk and the hole create an interesting tension between each other. The latter might even be considered an oversized porthole, representing C.Y. Tung's shipping interests.

John Street Wreath

(Above) This is the front entrance to 127 John Street, built in 1969 by Emery Roth & Sons. The whimsical lobby and plaza, including a neon tunnel and other extravaganzas, were designed by Corchia-de Harak Associates, who were also responsible for the street-level pools and bridges of 77 Water Street.

SG Cowen Securities Corporation and Financial Square

(Opposite) Wall Street ends up at the East River near Old Slip and Gouverneur Lane. Financial Square was designed by Edward Durell Stone Associates in 1987 and is located at the foot of Hanover Square on Front Street. Its largest tenant is SG Cowen Securities Corporation, an investment banking, trading, research and brokerage operation with a history dating back to 1918. Recently, it has been acquired by Société Générale Group, a leading international bank headquartered in Paris. SG Cowen focuses on the industries of the twenty-first century: technology, health care, telecommunications, and media & entertainment.

One Seaport Plaza

This gray granite building was designed by Swanke Haydon Connell & Partners and completed in 1983. Like many of its corporate neighbors, it is a large building of approximately one million square feet. It is headquarters to Prudential Securities Incorporated. Outside a light rain falls on the evening limousines waiting to fulfill their uptown missions.

Inside, a collection of bright Frank Stellas enlivens a gray stone lobby. These oversized geometric designs can be seen from outside the building as well as their glow in the puddle forming (appropriately) on Water Street.

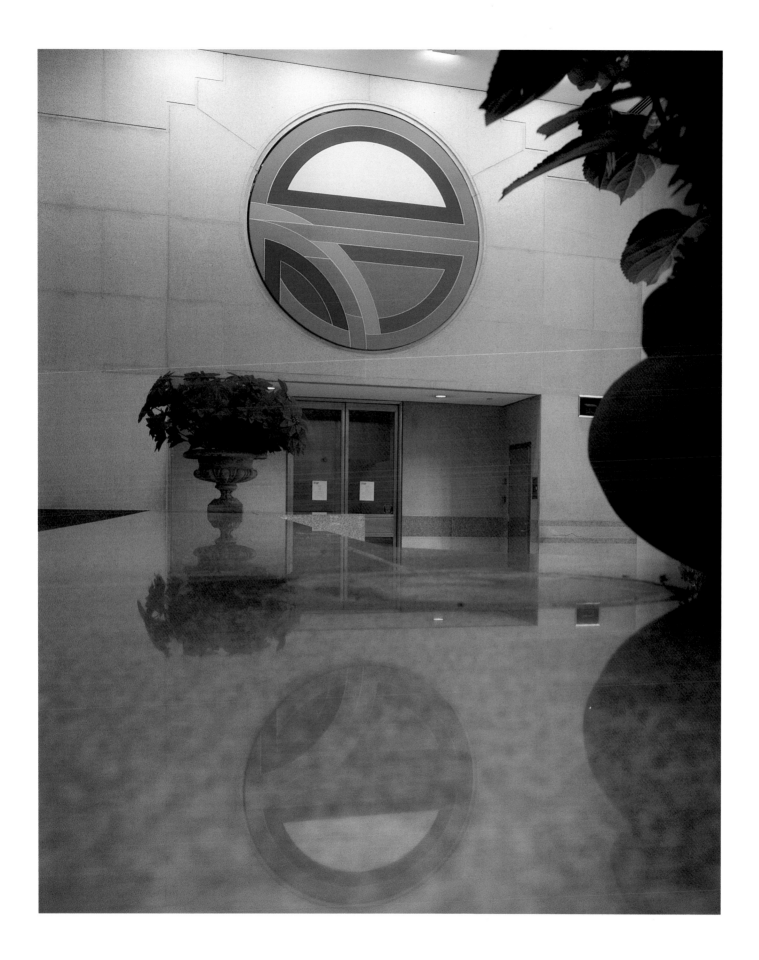

Prudential Securities Incorporated

Jules Bache and his family relocated to the United States from Germany in 1870s. He took over a brokerage operation started by his uncle and named it J.S. Bache & Co. in 1882. His nephew Harold joined the firm in 1914 and renamed it Bache & Co. in 1945. For many decades the firm vied with Merrill Lynch as one of the largest securities brokerage firms in the country. During the early 1970s, it made a series of strategic acquisitions, bringing it recognition in the areas of research and utility finance as well as additional brokerage capacity—Halsey, Stuart & Co., Shields & Co., and Model, Roland & Co. (which had the only foreign equities research department on Wall Street for many years).

In 1981 the firm was acquired by the Prudential Insurance Company of America and changed its name the following year to Prudential-Bache Securities Inc. Underscoring the ever strengthening relationship between Prudential Insurance and the firm in 1991, Prudential-Bache Securities changed its name to Prudential Securities Incorporated. In 1996, it became the first full-service brokerage firm to give clients Internet access to their account information. Today, Prudential Securities has almost three hundred offices in twenty countries around the world. It employs approximately eighteen thousand, including approximately 6,700 financial advisors. The firm provides individuals, institutions, corporations and governments with such services as investment advice, asset management, securities brokerage, investment banking and retirement planning. Its ties to Prudential Insurance provide a strong source of capital for its many private transactions. In addition, the firm has developed industry leadership in the offering and management of closed-end investment companies.

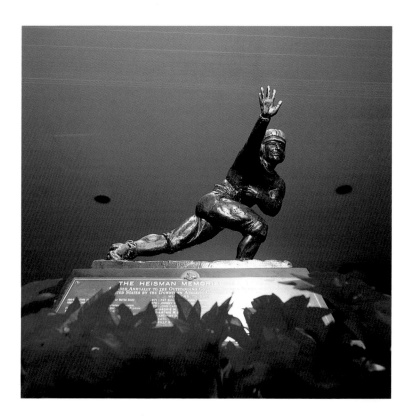

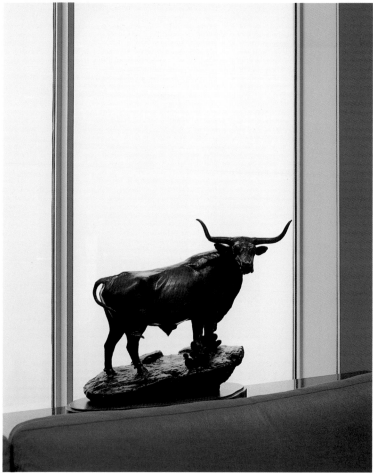

Famous Wall Street Bronzes

A sampling of famous Wall Street bronzes: (*above*) the Heisman Trophy at the Downtown Athletic Club, college football's most coveted award and named for a famous football coach of the 1930-1950s, John Heisman; (*right*) Merrill Lynch's famous bull, which became the firm's mascot when it switched its advertising focus from "We the People"; (*opposite, top*) Telerate's Rodins, easily the largest such collection in the financial district if not in New York; and (*opposite, bottom*) the New York Stock Exchange's familiar bull and bear duo.

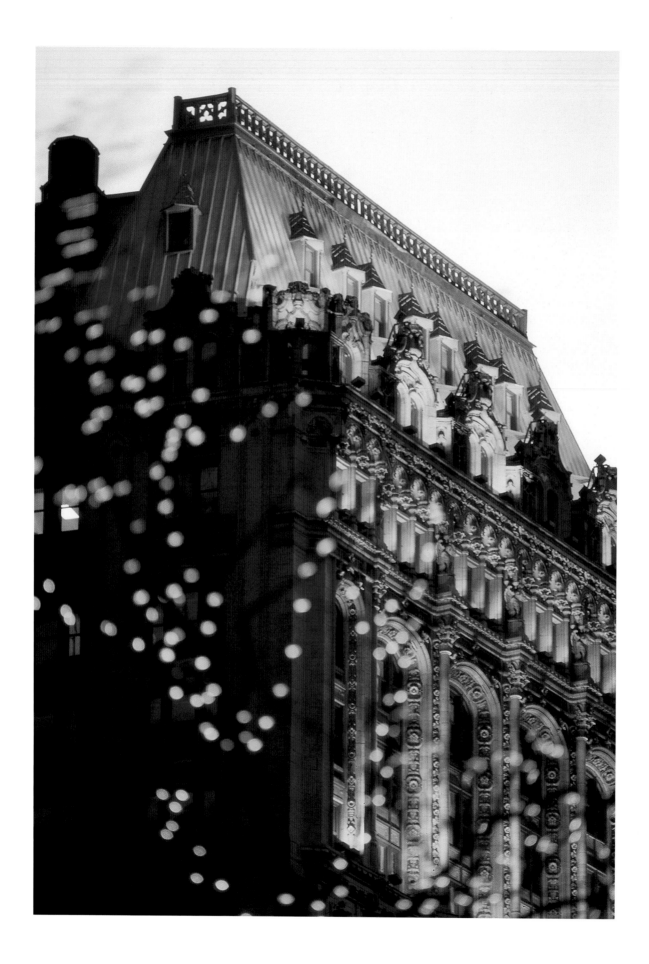

World Trade Center and World Financial Center

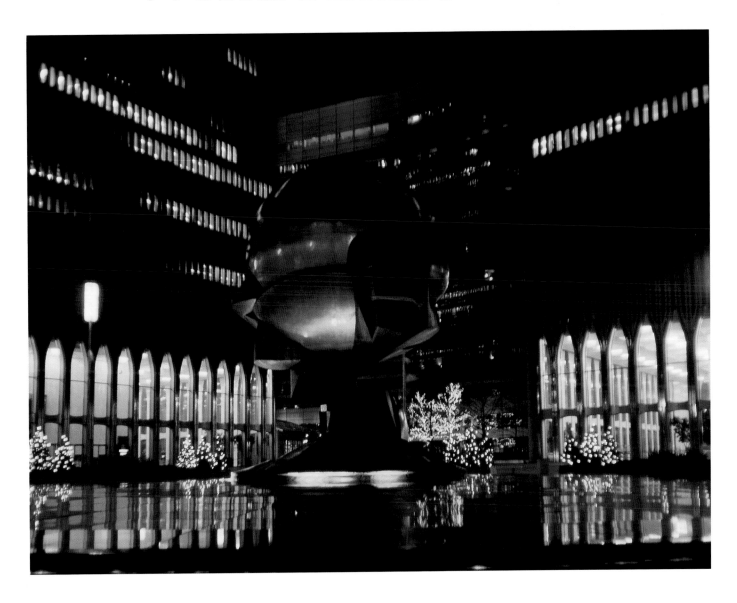

Ninety West Street

(Opposite) This lovely limestone and terra cotta building was completed in 1907 and designed by Cass Gilbert, who gave us the Custom House in 1907 and the Woolworth Building in 1913. Until its upper-floor colonnades and copper mansard roof were illuminated in 1985, few people were aware of the extraordinary beauty of this out-of-the-way building. The lights in the photograph framing the illuminated roof are from a tree across the street.

Sphere for Plaza Fountain

(Above) The bronze globe is by Fritz Koenig, who completed it in 1971. The ruptured sphere suggests both cosmic forces as well as cellular life. It was commissioned by the Port Authority of New York & New Jersey as part of its art-in-the-architecture program. The Authority also commissioned works by Alexander Calder and Louise Nevelson.

The Plaza of the World Trade Center

(*Opposite*) The graceful arches of Tower Number One, with Christmas trees grouped along the edge, are reflected on the plaza's wet pavement during a winter drizzle. For a brief moment the viewer is reminded of the Metropolitan Opera House at Lincoln Center. This is the only gentle aspect of the twin towers whose relentless soar is difficult to grasp comfortably even after almost twenty years. The plaza, with its 25-foot bronze sphere by Fritz Koenig in the center, is often devoid of people—certainly when compared with the flow of pedestrians through the underground concourse. It does, however, offer a secret escape on sunny days to enjoy a moment of relative solitude.

The World Trade Center consists of seven office buildings, six of which were designed by Minoru Yamaski and Emery Roth & Sons. They were completed as follows: 2 W.T.C. (1972); 1 W.T.C. (1973); 5 W.T.C. (1972); 4 W.T.C. (1977); and 6 W.T.C. (1974). No. Seven was built in 1987 by Emery Roth & Sons. The aggregate amount of office space exceeds ten million square feet —over seven times that of the Empire State Building.

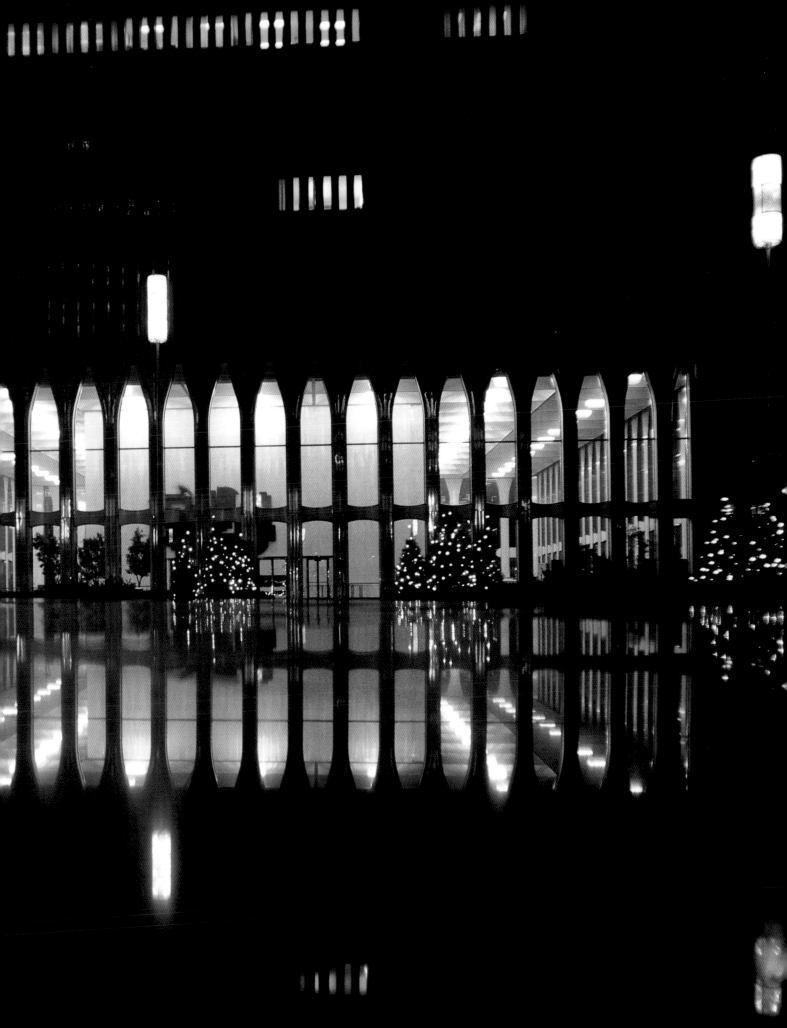

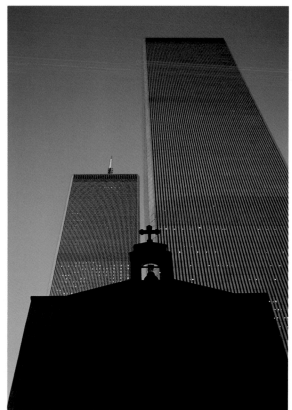

The Marriott Hotel

(Above, left) Shown at the left in the photograph, this hotel joined the twin towers at the World Trade Center in 1981, nine years after the first tower was constructed. Skidmore, Owings & Merrill have provided a handsome design of horizontal aluminum and glass stripes on a soft, bow front structure. The Marriott Hotel provides a refreshing complement to the stark twin towers.

St. Nicholas Church

(Above, right) Resting at the feet of the twin towers is the little St. Nicholas Church (1832), a Hellenic Orthodox church on Cedar Street. This is one of the last vestiges of the days when lower Washington Street was a neighborhood of Greeks, Lebanese, Syrians, and Armenians.

The twin towers rise to an extraordinary height of 110 stories, more than a quarter of a mile above street level. When the World Trade Center was under construction in 1967, a cannon was discovered during excavation, marked with the insignia of the Dutch West India Company. It probably belonged to Captain Adriaen

Block's *Tiger* which burned at this location in 1613, forcing Block and his crew to be the first European residents on Manhattan that winter.

Contrasting Spires

(Opposite) New York is a city of contrasts and none is greater than the view of the twin towers from the churchyard of St. Paul's Chapel. The World Trade Center project was commissioned by the Port Authority of New York & New Jersey, which decided to squeeze maximum space out of it. The results are oversized, flat-topped boxes that are a bit too harsh, even today, for a neighborhood that otherwise consists largely of a cluster of filigreed towers. The disheveled neighborhood of electronics stores called Radio Row that was replaced by the World Trade Center is now only a memory to some.

In their design of the twin towers, the architects did accomplish an interesting engineering feat: the walls are load-bearing, which is unusual in this era of steel frame construction. The walls are like a mesh cage supporting the entire building.

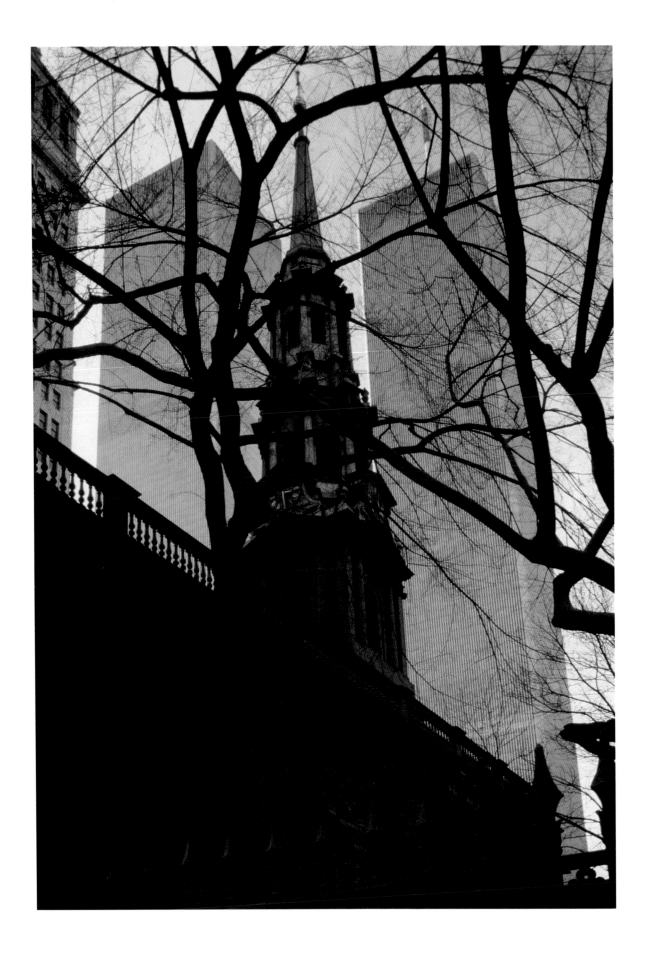

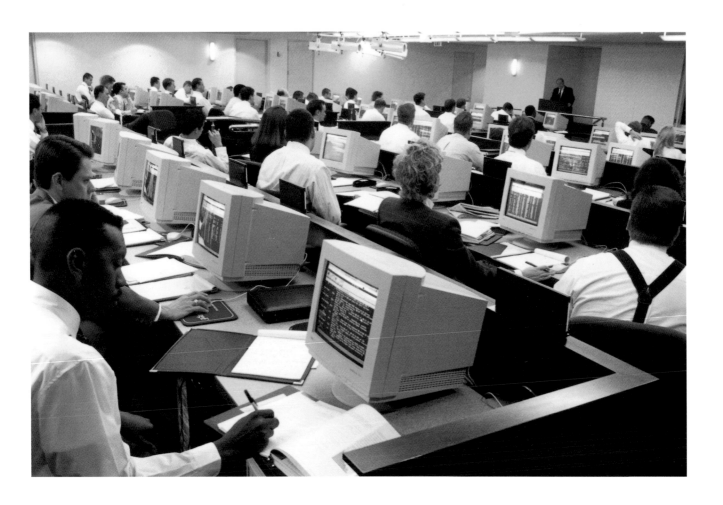

Morgan Stanley Dean Witter & Co.

Morgan Stanley Dean Witter was created by the merger of Morgan Stanley and Dean Witter in 1997 (see pages 222-3 for Morgan Stanley's history). Dean Witter had been started by Dean, Jean and Guy Witter in San Francisco in 1924, primarily as a dealer in municipal and corporate debt obligations. In 1929, Dean Witter opened as office in New York (although it was not until almost sixty years later that New York and not San Francisco was considered the firm's principal headquarters). Also in 1929, it became a member firm of the New York Stock Exchange for the first time. Given the importance of attracting qualified sales representatives, Dean Witter & Co. established one of the first formal brokers' training programs in 1945. The photograph above shows today's training center, the only one of the major firms that is maintained in the Wall Street area.

In 1972, Dean Witter & Co. Incorporated was one of the first of the Wall Street firms to sell its shares to the public. It acquired Reynolds & Co. in 1978. Through acquisitions and internal growth, Dean Witter became the first brokerage house with offices in all fifty states and the District of Columbia in 1979. In December 1981, Dean Witter joined Sears Roebuck & Co. as the nucleus of its financial services group, and was instrumental in the successful launch of the Discover Card in 1986. In 1993, Sears spun off Dean Witter, Discover & Co. and Dean Witter continued to grow rapidly.

The latest chapter is now unfolding as the firm with the large distribution network has joined Wall Street's preeminent investment bank to form Morgan Stanley Dean Witter & Co.

American Express Company

The firm is located at Three World Financial Center, which was completed in 1985, designed by Cesar Pelli, Dean of the Yale School of Architecture, and Adamson Associates.

From its tasteful entrance and spectacular lobby the viewer can see that American Express is an exceptional firm. It conducts its affairs the way it furnishes its facilities—just a cut above the rest. This is where one would expect the issuer of the original "gold" charge card and the originator of the international travelers' checks to be headquartered. The strong black marble columns and the dramatic geometry of the ivory, black and rust floor are reminiscent of the great banking halls of the 1920s.

It is fortunate that American Express has chosen to remain a prominent fixture in the Wall Street community since its inception. It is a full financial service organization in the broadest sense, with brokerage, overseas banking, insurance, travel and charge card activities—a greater spectrum than any other organization. Many banks and securities firms may be larger both in assets and employees, and some of these also may offer credit card services, but none do with the élan of American Express.

The American Express Company was organized on March 18, 1850 to carry on the business originally established nine years earlier by Henry Wells to transport goods, valuables, and bank remittances between New York City and various cities upstate. By 1852 Henry Wells and the company secretary, William Fargo, decided to open an office in San Francisco to participate in the rapidly expanding freight and shipping needs of the

California Gold Rush. The directors of American Express decided against expanding their services west of the Missouri, which was as far as the railroad had extended. Wells & Fargo formed a separate company in San Francisco with their own funds while remaining in New York and running American Express which concentrated on delivery of valuable shipments via railroads and assisted the U.S. Government with the delivery of supplies to army depots during the Civil War.

In 1891 the company introduced the Travelers Cheque to replace the cumbersome letter of credit that was often used by overseas travelers. Within ten years the company was issuing over $6 million travelers' checks annually. Today sales are in the billions of dollars in a variety of international currencies.

By 1915 American Express had expanded into another important area: travel, which during the 1920s and again beginning in the 1950s, has become an increasingly important part of the firm's activities.

With the prosperity of the 1950s, and the increase in travel and entertainment, American Express recognized another opportunity: a charge card. During the first year of its introduction in 1958, the company issued 253,000 cards. It also played a major role in persuading the Civil Aviation Board to allow airline ticket purchases with charge cards. The first cards were paperboard, but by the following year the familiar plastic card was in full bloom. Railroads, cruise lines, hotels, and oil companies all began accepting the card during the early 1960s, which by then was becoming available in foreign currencies including

Venezuelan bolivars and Yugoslav dinars. In 1972 Macy's became the first major department store to accept the card. Today, there are over 43 million green, gold and platinum cards in force, being accepted at millions of service establishments worldwide—a truly remarkable accomplishment for an institution that, unlike its commercial banking competitors, had no preexisting customer base to draw from.

American Express has also expanded into the fields of investment banking, asset management and insurance. The firm's initial venture into the securities business was its 1966 acquisition of W.H. Morton & Co., an underwriter and distributor of corporate and government bonds. In 1981 it acquired Shearson Loeb Rhoades, Inc.,

the second largest securities firm in the country, which subsequently acquired Lehman Brothers, Kuhn, Loeb & Co. Inc. in 1984 and the E. F. Hutton Group, Inc.

American Express sold the Shearson retail brokerage and asset management business to the Travelers Group in 1993 and spun off its ownership in Lehman Brothers to American Express shareholders in June, 1994. American Express remains in the asset management, mutual fund, insurance and annuity business in a major way through its ownership of IDS Corporation since 1984. IDS was re-branded as American Express Financial Advisors Inc. in 1996 and has in excess of $200 billion in owned or managed assets.

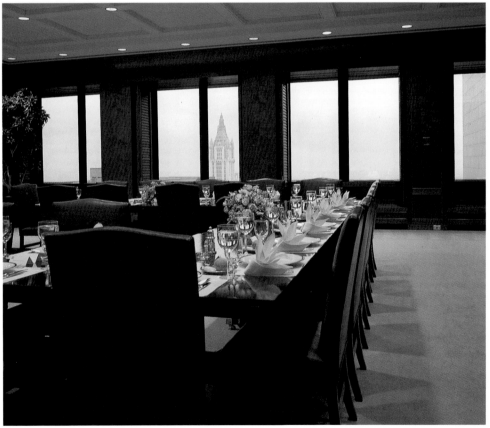

American Express Company

(Opposite, top) The board room in the American Express Tower has a table as large as the New York Stock Exchange's board room.

 (Opposite, bottom) The Board of Directors' main dining room is capable of serving up to ninety guests. At dinner this evening, the entertainment is being provided by the Woolworth Building.

(Above) The visitors' library has a collection of rare old books, globes, telescopes, and other antiques appropriate for a firm that has had a strong international presence for over one hundred years.

Lehman Brothers

This firm's origins date from 1850 when it was engaged primarily in trading cotton and other merchandise. In fact it helped organize the New York Cotton Exchange in 1870, which was the first experiment in commodity futures trading. Hedging transactions brought stability to growers, consumers and manufacturers. In 1906 Lehman Brothers co-managed an offering for Sears, Roebuck, beginning a long tradition of assistance in the financing of retailers and consumer goods manufacturers.

Over the years the firm's underwriting prowess became noticeable both on the street and in corporate board rooms. Initial public offerings include those of Polaroid Corp., Litton Industries, Hertz, Digital Equipment and many hundreds of others, as the bound volumes in the firm's library, a small portion of which is shown on the opposite page, can attest.

Another unusual aspect of the firm is its commercial paper activity. Lehman Brothers founded an organization dedicated solely to these instruments, which had been in existence since the late nineteenth century but little used until the 1960s. Today, Lehman is the largest commercial paper dealer in the world.

Lehman presently employs over 8,400 in thirty-five offices around the world. It remains a leader in equity and debt underwritings, privatizations, mergers & acquisitions, and financial futures. It is a member of every major commodity exchange worldwide and is a leading provider of cash and derivative commodity products. It is a leader in financial futures and structured products. It also engages in real estate transactions, emerging markets activity and merchant banking. Lehman Brothers is the oldest independent investment banking firm in the business. With a history of 150 years of dealing—far longer than most others in the business, it brings an unusual perspective to the table.

The Winter Garden at the World Financial Center

This is a welcome, sunny structure similar in spirit if not design to London's Crystal Palace of the last century. Its palm-filled interior is roughly the size of Grand Central's concourse and is easily one of the greatest interior spaces constructed during the twentieth century. The forty-foot trees barely reach halfway to the top. There are only sixteen trees, not a forest, so they become part of the architecture.

During the evenings and weekends Olympia & York, in cooperation with American Express Company and Merrill Lynch & Company, sponsor a wide variety of cultural events ranging from the Brooklyn Philharmonic, ballroom dancing and the Vienna Boys' Choir to Bali dancing and the Herbie Hancock Trio.

Cesar Pelli and his wife designed the Winter Palace in 1988 as a living room for the twenty thousand workers in the World Financial Center—a place to be in instead of simply to pass through.

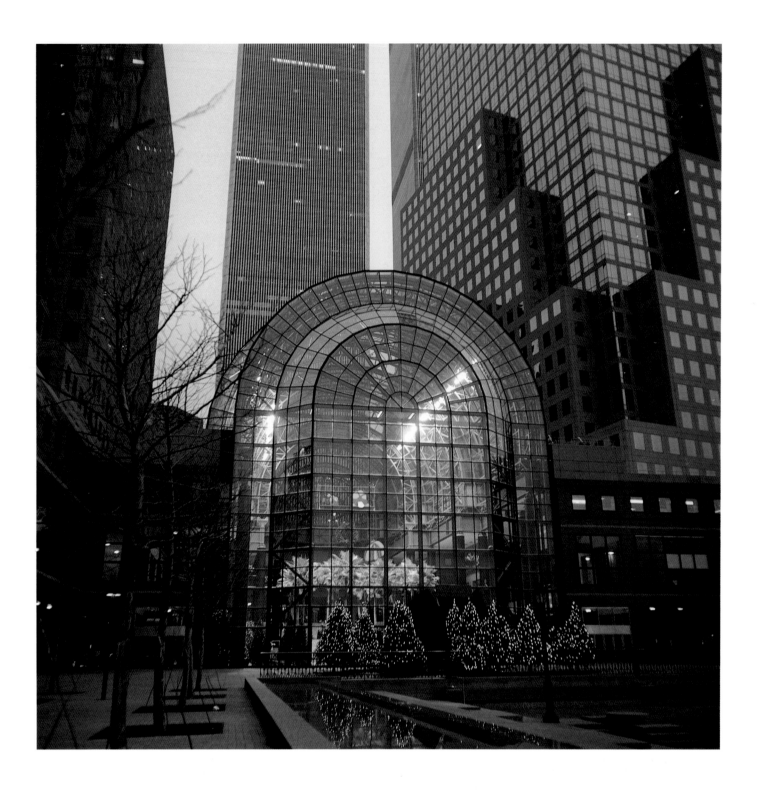

Outside the Winter Garden

The landscape architect was Paul Friedberg & Partners which was also responsible for the redesign of Bowling Green and Jeannette Plaza. Although the Winter Garden appears dwarfed by its surrounding neighbors, the enormous height of this great space may be grasped by noticing the tops of the palm trees in the lower part of the photograph. The trees are already forty feet tall. A cluster of Christmas trees rings the outside plaza, duplicating similar clusters inside.

CIBC World Markets

This is the wholesale banking arm of Canadian Imperial Bank of Commerce (CIBC). CIBC was founded in 1867 and is now the largest bank in Canada and one of the ten largest in North America. CIBC is the largest credit card issuer and the leader in Canadian personal computer banking. In 1997 CIBC World Markets acquired Oppenheimer & Co., Inc., one of the last privately-owned, full-service firms in the U.S., headquartered in this building, One World Financial Center.

With more than 9,000 employees in 63 cities around the world, CIBC World Markets offers a full range of integrated credit and capital markets, securities brokerage and asset management services. Its clients include a wide range of governments, institutions and individuals. In the U.S., CIBC Oppenheimer continues to provide investment advice and management, financial planning and retirement solutions to high net worth individuals.

The World Financial Center

Shown here are Merrill Lynch & Co.'s world headquarters, No. 4 World Financial Center (1985) (*above*), and American Express Company headquarters, No. 3 World Financial Center (1986) (*opposite*). Cesar Pelli was the design architect for both towers, assisted by Haines Lundberg Waehler on Merrill Lynch's and by Adamson Associates on American Express's.

All four towers at the World Financial Center are of different heights and are topped by different roofs. Merrill Lynch has a stepped pyramid on its North Tower

(shown here) and a dome on its South Tower. American Express has a regular pyramid and Oppenheimer & Co. has a mastaba (a flat-topped pyramid). The entire World Financial Center complex contains over seven million square feet of space. It consists of four towers and two gatehouses, all of glass and granite, and all set slightly irregularly to each other in order to soften the harsh impact of the oversized twin towers of the neighboring World Trade Center.

In the foreground is the new North Cove being devel-

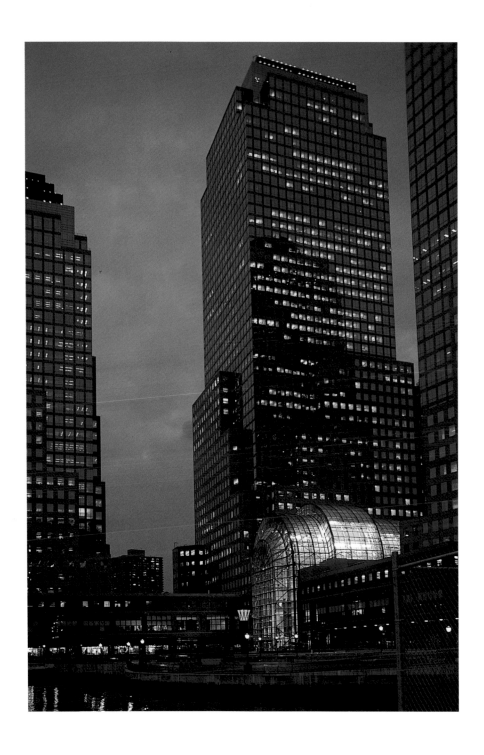

oped by Watermark Associates and designed to return New York to an era of mega-yachting not seen since 1929. At the turn of the century, the New York Yacht Club's fleet included 195 sailboats and 207 steamships, the largest of which was the *Lysistrata* belonging to the *New York Herald* publisher James Gordon Bennett. It was a 314-foot, 2,282-ton steamer that required a full-time crew of a hundred.

City of the world! (for all races are here,
All the lands of the earth make contributions here;)

City of the sea! city of hurried and glittering tides!
City whose gleeful tides
continually rush or recede,
whirling in and out with eddies and foam!
City of wharves and stores—city of tall facades of
marble and iron!
Proud and passionate city—meddlesome, mad,
extravagant city!

Walt Whitman
Leaves of Grass (1881)

Merrill Lynch & Co. Inc.

This is one of the world's leading financial management companies. As an investment bank, it is the top global underwriter and market maker of debt and equity securities, and it is a leading advisor to corporations, governments, institutions and individuals worldwide. Merrill Lynch also serves households, small to mid-sized businesses and regional institutions using a planning-based financial services approach.

The Merrill Lynch & Co. name was adopted on October 15, 1915 as a successor to the firm started by Charles E. Merrill in 1914. Edmund Lynch joined later that year. Messrs. Merrill and Lynch felt there were many potential investors outside the social and economic elite catered to by the old-line Wall Street houses. Charles Merrill had an ambition to bring "Wall Street to Main Street" and built his business on strong values, solid ethics and the idea, which was new to the financial industry at the time, of addressing the concerns of the individual client. The firm has benefited from a course of steady progress toward achieving its preeminence based on this simple philosophy.

In the early years, Merrill Lynch pioneered in raising capital for the emerging chain store industry. It broke ground in 1919 with the hiring of Wall Street's first bond saleswoman, Annie Grimes, and also by opening its uptown New York office every weekday evening from 7 p.m. to 9 p.m. beginning in 1924 in order to cater to the "average investor" who had to work during normal business hours. In 1930, Merrill Lynch transferred most of its business to E.A. Pierce & Co., founded in 1885 and by then, the nation's largest wire house. During the 1920s, Pierce had established branches across the country, connected by a network of private wires to transmit orders and quotations. In 1940, Merrill Lynch combined with Pierce to create a new style brokerage company that could reach more investors than ever.

In 1941, Merrill Lynch was the first Wall Street firm to issue an annual report showing its operating results for the year. Also in that year the company merged with Fenner & Beane, resulting in offices in 92 cities around the United States. When the Ford Motor Company made its initial public offering in 1956, it selected Merrill Lynch

as one of seven co-managers to bring the car manufacturer public. The offering gave Merrill Lynch its first billion-dollar underwriting year. By 1971, Merrill Lynch was ready to sell its shares to the public for the first time. It was the second New York Stock Exchange member company to go public.

Merrill Lynch broke ground in the financial services industry again with the creation in 1977 of the Cash Management Account (CMA®), the first combined money market, brokerage and credit card account. This has proven to be an outstanding financial innovation and today is widely imitated by other institutions.

The firm has always been an industry leader in using technology, as evidenced in 1955 when it became one of the first American businesses to computerize its operations with the purchase of three IBM 650s. It was also the first Wall Street firm to install the more powerful second generation transistorized IBM 7080. During the late 1960s, the surge in trading volume on the New York Stock Exchange caught many companies unprepared for the commensurate paperwork. Across Wall Street, firms had

difficulty keeping up with the mass of stock certificates and orders to process. Trade confirmations and securities certificates were lost, and by the second half of 1970 many major firms were on the verge of collapse or had already gone under. In October 1970, the fifth largest member firm, Goodbody & Co., was close to failing as a result of the "Paperwork Crisis." Had it done so, the Exchange would have had a serious panic. Merrill Lynch stepped in to absorb the floundering Goodbody & Co. Merrill Lynch was the only firm capable of handling such an acquisition. It had already built a solid technological foundation and was thus able to rise to the occasion.

Again, the firm played a leading role in restoring peace to Wall Street by calming investors in 1987, when an historic market drop of 508 points occurred on October 19th Merrill Lynch worked around the clock, helping to ease investors' fears with reasoned advice and information.

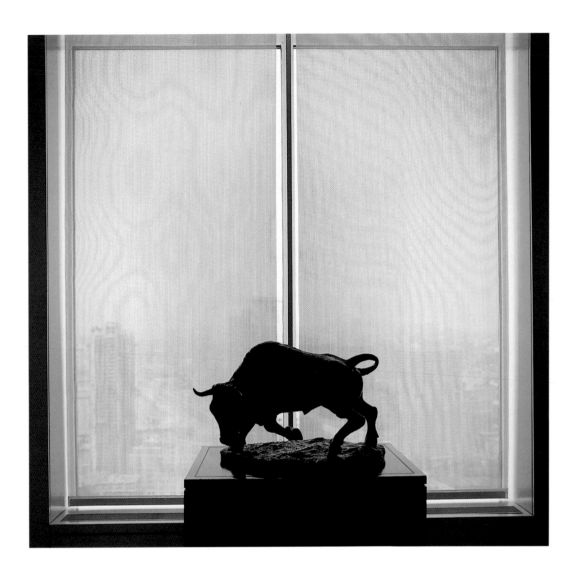

Merrill Lynch's World Headquarters

The bull is a popular motif at Merrill Lynch as evidenced in these photographs. The unusual jade bulls on the conference table *(opposite, bottom)* attest to the firm's long-standing interest in the Far East. It established its regional headquarters in Hong Kong in 1982. In 1984, Merrill Lynch was among the first foreign securities permitted to underwrite Japanese Government bonds and, in 1985, to become a regular member of the Tokyo Stock Exchange. It now has thirty-three offices throughout Japan. In 1993, Merrill Lynch was invited to become the first U.S. securities company to do business in China.

Through its planned growth and a series of strategic acquisitions, the firm has evolved from a national wire house to a dual franchise serving individual investors and the capital markets, and ultimately to a global financial services company. One benchmark addition to Merrill Lynch was the 1978 purchase of White, Weld & Co., an old-line company with innovative financing techniques, an international presence and a strong history of successful initial public offerings.

More recently, its global expansion has included the 1995 acquisition of Smith New Court plc, positioning Merrill Lynch as the most powerful equity organization in the world with excellence in research, trading and sales. The following year, it purchased McIntosh Securities Ltd., one of Australia's leading brokerage firms. In 1997, it added the well-known Mercury Asset Management Group, allowing Merrill Lynch to take a dramatic leap into the fast-growing asset management business. Further acquisitions have included one of the largest securities firms in South Africa, Smith Borkum Hare.

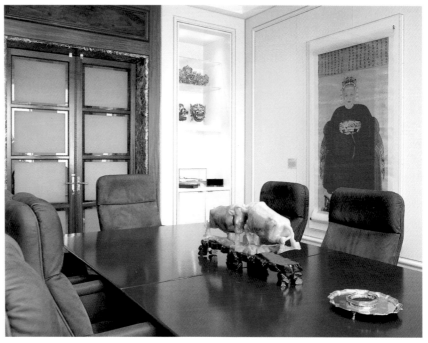

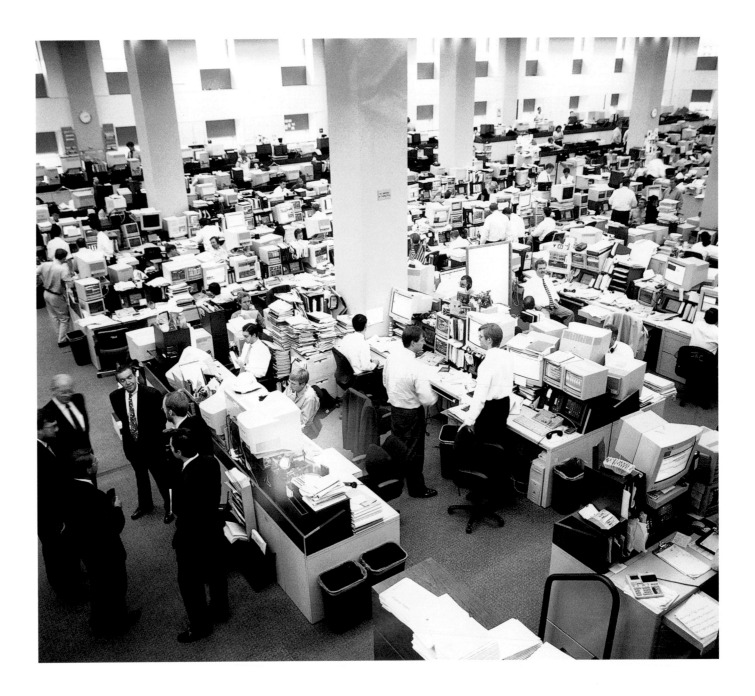

Merrill's Trading Floors

Merrill Lynch has three trading floors at the World Financial Center, each two stories in height, for an aggregate of approximately 80,000 square feet of floor space, one of the largest trading areas in the world.

By mid-1998, client assets at Merrill Lynch exceeded $1.4 trillion, a remarkable figure attesting to the relationships with its clients. The foundation of these achievements is expressed through Merrill Lynch's five Principles: Client Focus, Respect for the Individual, Teamwork, Responsible Citizenship and Integrity. These Principles, which are based on Charles Merrill's "Ten Commandments" published in 1941, are an unchanging philosophy by which the company does business. The Merrill Lynch Principles are the standards by which all decisions are made, and they are the means by which the firm has achieved global success.

The Wall Street Journal

(Above, left) Dow Jones & Co.'s *Wall Street Journal* originates from the company's building at the World Financial Center. The view above is of the Journal's news desk.

(Below, left) An artist is creating a drawing utilizing the pinpoint design that has become a tradition with the newspaper. Photographs are rarely used. They are converted into engraving-like drawings, as may be seen on the artist's table, with each such conversion taking four to six hours.

This is the headquarters for the famous publishing firm organized in 1882 by Charles Henry Dow and Edward Jones. Their first financial newsletter was called the *Customers' Afternoon Letter* which evolved into *The Wall Street Journal* by 1889. By 1884 they had started another important element of American financial information—the Dow Jones Average, consisting of eleven stocks listed on the New York Stock Exchange. *Barron's National Business and Financial Weekly* was started in 1921 with Clarence Brown as its first editor. The tabloid was an immediate success and reached a circulation of 30,000 in its sixth year.

The architect of today's *Journal* was Bernard Kilgore who became managing editor in 1941. He turned the financial newspaper into one that encompassed all aspects of business, economics and consumer affairs as well as everything else that had an impact of business.

The *Journal* was able to become a national newspaper before the advent of microwave and space satellite transmission (which are used today) with an invention by one of its employees, Joseph Ackell. He repaired the paper's news tickers and came up with a method of inputting data onto perforated tape much like a player piano. The tape was played by typesetting machines around the country with the stories having to be manually typeset only once.

Today, thanks in part to more advanced transmission technology. *The Wall Street Journal* has a paid circulation of approximately two million and is the largest newspaper in the United States,

The Wall Street Journal Interactive Edition is the largest paid subscription site on the entire World Wide Web, with a circulation of more than 200,000. *Wall Street Journal* Special Editions—bannered pages of *Journal* news in leading newspapers around —appear in 34 newspapers in 32 countries and in 11 languages; they have an aggregate circulation of nearly seven million copies.

The publisher of *The Wall Street Journal* is Dow Jones & Company which also publishes *Barron's, Smart Money* and other periodicals. In addition, it provides news content to CNBC and lends its name to the world-famous New York stock indexes.

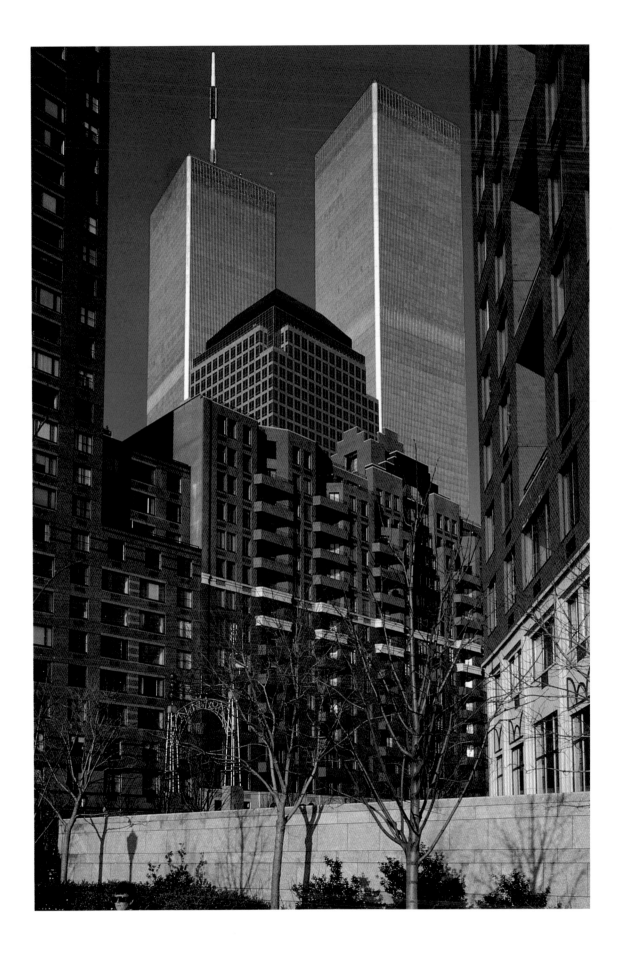

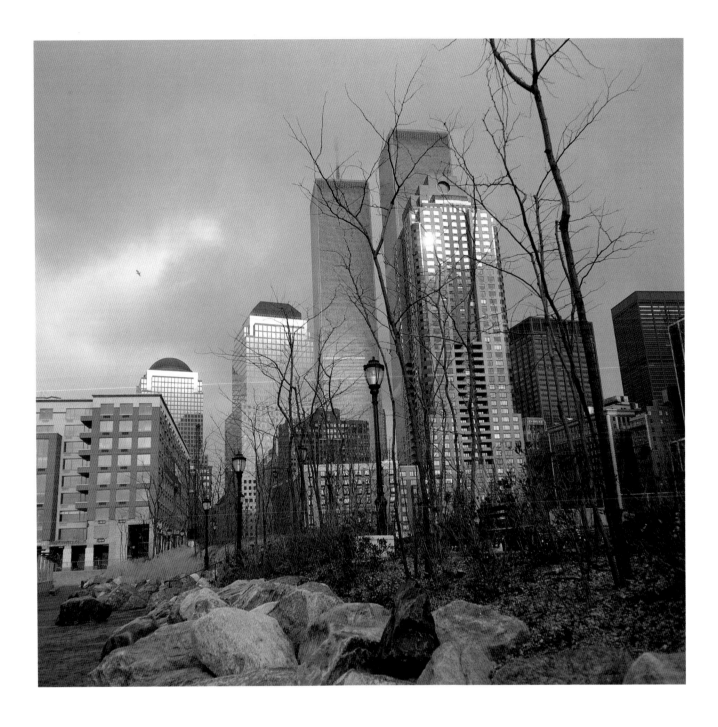

Battery Park City

(*Opposite*) New residential buildings along Rector Place, at the southern edge of the World Financial Center, demonstrate a variety of styles by different architects in a harmonizing, non-competing group. The totality of the complex was the objective, the means were left up to the individual firms in order to provide a mixture of styles.

The twin residential towers of Liberty House and Liberty Terrace frame the towers of the World Trade Center and the Oppenheimer Tower. The apartments in the foreground are called Rector Place.

(*Above*) A rich variety of apartments and office structures may be seen from South Cove. From the left are: the Regatta, the Merrill Lynch South Tower, the Oppenheimer Tower, the World Trade Center Towers, the new Rector Place Apartment Tower, One Bankers Trust Plaza, and One Liberty Plaza.

Wall Street from South Cove

(*Above*) This is the view from the rocks of South Cove. It is hard to imagine that the world's largest financial district is only a few yards away from this rugged shoreline. Battery Park City and the World Financial Center are part of an extraordinary 92-acre landfill extending from Battery Park itself up to Chambers Street. It is a gift from the World Trade Center whose excavation of over one million cubic yards of soil was deposited here. From the left in the pho-

tograph are: One Bankers Trust Plaza, One Liberty Plaza, 19 Rector Street, the Chase Manhattan Bank, the Irving Trust Company Tower, 67 Broadway, 40 Wall Street's pyramid, two new buildings at 47 and 45 Broadway, the Bank of New York's West Street offices, the Downtown Athletic Club and 17 Battery Place.

Governor Nelson Rockefeller first proposed creating a Battery Park City in the 1960s; the state owns the land.

After several false starts at design, many of which conceived of the City as separate from the rest of its urban environment, a master plan was presented by Cooper, Eckstut Associates that saw the entire project as an historical extension of the city's best waterfront communities rather than in futuristic isolation. The streets are aligned with the city's grid; the esplanade with its turn-of-the-century lamps is more old-fashioned than Carl Schurz Park; the canopied apartment foyers and townhouses on South End Avenue and vicinity might just as well have come from East End Avenue.

Stanton Eckstut was responsible for the southern residential areas, which are designed to reflect the neighborhoods of Gramercy Park, Riverside Drive, and Tudor City. The result is an entirely new neighborhood with a distinctive, historical patina.

Christmas in Rector Park

The park is located at the intersection of South End Avenue and Rector Place. Innocenti & Webel with Vollmer Associates were the landscape architects who designed a finely detailed space in keeping with the spirit of Gramercy Park. In this case, however, there are open sections in the fence so a key is not needed. The buildings on the left are Battery Pointe and Liberty Terrace, 300 and 380 Rector Place, respectively, and on the right is River Rose at 333 Rector Place.

An Evening Stroll on the Esplanade

This extraordinary gift to the city extends for over a mile at the edge of Battery Park City. It was designed by Stanton Eckstut and built from 1983 to 1989. He has incorporated some of the best of New York's existing parks, including the promenades at Carl Schurz Park and Brooklyn Heights. The benches are replicas of the turn-of-the-century cast-iron and wood design that were popular many years ago, as were the Victorian lampposts that have also been carefully duplicated.

Eventually the Esplanade will connect with Battery Park itself, and, upon completion of the northern section of Battery Park City, it will be nearly two miles long. Accessible to all and frequented by few, it is an excellent place for a quiet walk in the early evening, where the soothing clang of a buoy is the only sound one hears.

Harrison Street

(*Opposite*) Just north of the World Financial Center is a cluster of ten row houses on Harrison Street. They are all of the Federal period and date from 1819 to 1928. Two were designed by John McComb, who designed City Hall. They represent a fine example of the houses that became popular at the time—three-story brick facades, three bays across, with double dormers. They were generally built in units of three, with common walls.

The row house evolved because the city adopted a plan in 1811 to organize its future development according to a grid system of twelve avenues and perpendicular streets. Federal row houses were built along the grid, including the residential development of the estate of a classical scholar, Clement Clarke Moore. His estate was named Chelsea and was developed between Eighth Avenue and the Hudson River, from 20th to 28th Streets.

Moore is better known for his Christmas poem, "A Visit from St. Nicholas."

Washington Market Park

(*Above*) A memorial to the famous outdoor Washington Market, this little jewel on Greenwich Street between Chambers and Duane Streets is a modern interpretation of the best of Olmstead and Vaux: hills, a gazebo, a witty fence, and even some Art Deco ornaments from the old West Side Highway.

Washington Market sprang up on the West Side when shipping shifted from the South Street area over to the Hudson or North River after the Civil War. The Hudson was able to accommodate the larger and more numerous steam-powered vessels. Increased trucking and congestion resulted in the construction of the West Side (Miller) Highway, which lasted until the early 1980s. The Washington Market Park contains two stone Art Deco entrance monuments from the elevated highway, each with an automobile headlight in its leading edge.

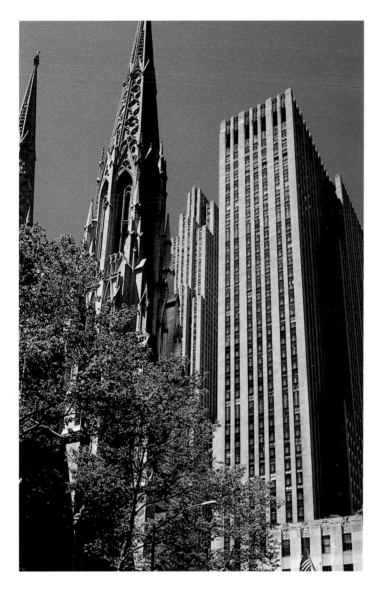

Rockefeller Center and St. Patrick's Cathedral

The office complex of 19 commercial buildings was originally planned in 1929 by John D. Rockefeller, Jr. to include three tall office buildings plus the Metropolitan Opera House around a broad plaza. With the stock market crash, the opera could not afford to move and Rockefeller was forced to devise an alternative plan. Teams of consultants and architects were engaged: Todd, Robertson & Todd, Reinford & Hoffmeister, Cobert Harrison & MacMurray, and Hood Godley & Fouilhoux. The first group of buildings opened in 1939. One of the many imaginative designs was the series of underground corridors and shops linking the complex with the subway.

Lazard Frères & Co. became the first Wall Street firm to move uptown in 1968 and has remained a prominent tenant at Rockefeller Center for 30 years. Another Wall Street firm that has joined the complex more recently is B.W. Capital Markets Inc., a subsidiary of B.W. Bank in Stuttgart.

Citibank

(Opposite) For many years, this has been the nation's largest bank. The City Bank of New York was chartered in 1812. When it became part of the national banking system in 1865, its name was changed to the National City Bank of New York. The 1955 merger with the First National Bank of the City of New York created the First National City Bank name, which was shortened to Citibank in 1976. For almost one hundred years, its headquarters were at 52 Wall Street. In 1908 it moved to the Merchants Exchange Building at 55 Wall Street, and in 1961, it relocated to 399 Park Avenue. Citicorp Center, with additional offices, was completed in 1977.

During the last quarter of the 19th century, the bank grew from a small commercial institution into the largest bank in the United States. Its reputation for safety attracted deposits from leading corporations, and the bank also became a major underwrite of corporate securities. The National City Company sold foreign and domestic bonds to retail customers. Beginning in 1927, it added common stocks, selling them to clients over the world's largest private telephone line.

The Glass Steagall Act of 1933 separated commercial and investment banking activities, and the operations of National City Company were shut down. The commercial bank continued to expand, creating the negotiable certificate of deposit in 1961, extending across state lines and emphasizing consumer products as regulatory barriers fell. In 1978 it was the first bank to introduce automatic teller machines on a wide scale. By 1979, Citibank became the world's leading foreign-exchange dealer, a position maintained today. Citibank is definitely one of the country's preeminent financial institutions with a presence throughout the United States and overseas.

The distinctive Citicorp Center was designed by Hugh Stebbins with Emery Roth and Sons and was completed in 1977. It stands on four 127' pillars, has a distinctive asymmetrical roof, double-decker elevators and a massive atrium on the lower floors. It is the tallest building in midtown and one of the most dramatic ones constructed since the 1930s.

Wall Street Midtown

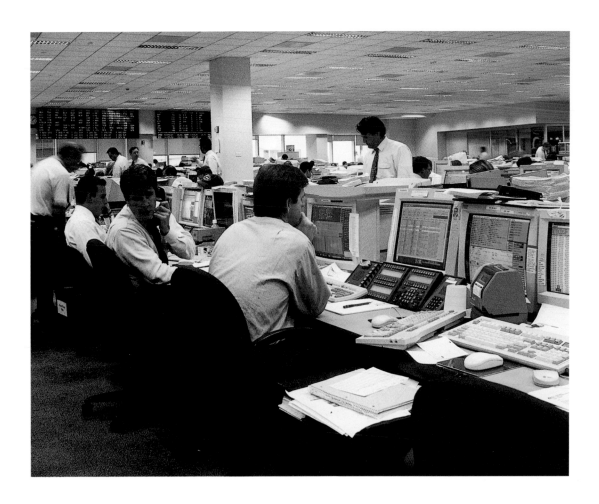

Morgan Stanley Dean Witter & Co.

On February 5, 1997, Morgan Stanley & Co. and Dean Witter, Discover & Co. announced the $10.2 billion merger that created the global financial services firm, Morgan Stanley Dean Witter & Co. With over 47,000 employees in over 440 offices across 28 countries, the merger paired Morgan Stanley's investment banking, asset management, and its sales and trading experience with Dean Witter's large retail distribution network. Because of its capital and overall financial strength, the firm is well-positioned to meet the financial needs of clients on a global basis.

Morgan Stanley & Co. Incorporated was founded as a result of the 1933 'Banking Act' which required J.P. Morgan & Co. to split its securities and commercial banking business. J.P. Morgan & Co. chose its banking business and in the following year, several of J.P. Morgan's partners and staff resigned to organize the investment-banking firm of Morgan Stanley & Co. Incorporated. With seven officers and a staff of thirteen employees, the new organization commenced business on September 16, 1935.

The firm's initial offices, where it remained for almost forty years, were located at Two Wall Street. In 1941, the company retired all outstanding shares of common and preferred stock and created the partnership, Morgan Stanley & Co. In 1970, Morgan Stanley began a reorganization of its corporate structure in order to provide for better management of the risks and growth opportunities of its business. The corporate entity, Morgan Stanley & Co. Incorporated, was established on June 5, 1970, and by July of 1975, had assumed all the business of the partnership. In 1973, the firm relocated to midtown and started to build its top-ranked research department and asset management business.

In 1986, Morgan Stanley offered its stock to the public and became a listed member of the New York Stock Exchange.

From its most recent location at 1585 Broadway, the firm continues to execute first-class business in a first-class way.

Paine Webber Group Inc.

In July 1879, Charles Cabot Jackson and Laurence Curtis opened a brokerage office on Congress Street in Boston. One year later, William A. Paine and Wallace C. Webber opened their office up the street. When these two firms merged in 1942 to form Paine, Webber, Jackson & Curtis, they had grown to a combined total of 22 branch offices.

The firm moved its headquarters to New York in 1963 and was incorporated in 1970. It went public in 1972 with the acquisition of Abacus Fund, Inc., a listed, closed-end investment company. Through the acquisition of Abbott, Proctor & Paine in 1970; E.S. Smithers & Co. and Mitchum, Jones & Templeton Inc. in 1973, and Rotan Mosle Financial Corp. in 1983, Paine Webber, Jackson & Curtis built a strong, nationwide distribution network.

In 1977, it acquired Mitchell Hutchins, Inc., a firm that traces its history to 1919 and had evolved to become one of America's leading equity research boutiques.

Two years later, Blyth, Eastman Dillon & Co. was acquired, adding 70 branch offices and more than 700 investment executives in addition to a well-developed investment banking capability.

Blyth, too, had a long and involved Wall Street history. The firm was founded in San Francisco in 1914 by Charles Blyth and Dean Witter. It was known as Blyth, Witter & Co. until 1928 when Dean Witter left to set up his own brokerage business. In 1935 Charles Mitchell, former chairman of the National City Bank of New York and a director of the Federal Reserve Bank of New York, joined the firm to assist in developing its underwriting and distribution businesses, which were intended to complement the company's established West Coast investment banking operation. Blyth & Co. merged with Eastman Dillon Union Securities & Co. in 1972. Eastman Dillon was a full-time investment banking firm, founded in Pennsylvania in 1912 by Herbert Dillon and Thomas Eastman, which merged with Union Securities in 1956. Union Securities was founded in 1939 to assume the underwriting business of J.&W. Seligman and established a successful track record during the 1940s and 1950s in what is known today as merchant banking; buying up, restructuring, and selling companies.

PaineWebber moved its headquarters from 140 Broadway to 1285 Avenue of the Americas in midtown, in 1985, and the following year a new complex at Lincoln Harbor in New Jersey became home to the firm's technology and transaction processing operations.

In 1995, PaineWebber acquired the Kidder, Peabody Group from General Electric Company. Founded in 1865, Kidder, Peabody maintained a preeminent position in investment banking and private services.

Today, PaineWebber is a full-service securities firm serving the investment and capital needs of a worldwide client base. Its principal lines of business include retail brokerage, investment and merchant banking, trading and asset management, each supported by a distinguished research capability and technology support systems. With 17,045 employees (including more than 6,500 investment executives) in 300 offices worldwide and a capital base in excess of $6.5 billion, it remains one of the few major independent, publicly-held firms in the industry.

Since its move to midtown in 1985, PaineWebber has been a visible presence on Sixth Avenue. The illuminated name on the building is unique among investment banks, and the ground floor gallery of ever-changing exhibitions of Americana is a genuine contribution to the cultural scene. This gallery is also unique among investment banks and is a reflection of the firm's creativity in all aspects of its business.

Paine Webber Group Inc.

(Opposite) The headquarters of PaineWebber are clearly visible at night with its name in lights.

Bear Stearns & Co. Inc..

(Above) This is a photographic rendering of the future headquarters of Bear Stearns.

Bear Stearns & Co., Inc.

Bear Stearns was founded as a partnership in 1923 primarily as an equity trading house. Within ten years, the firm moved into the institutional bond business and arbitrage, followed by investment banking and correspondent clearing. Today, Bear Stearns is an investment banking and brokerage firm serving domestic and international corporations, governments, institutions and private investors. As a leading worldwide investment bank, Bear Stearns has built its franchise across a wide spectrum of capabilities, industries and product lines, including corporate finance, mergers and acquisitions, public finance, institutional equities and fixed income sales and trading, private client services, foreign exchange and futures sales and trading, research, derivatives, asset management and correspondent clearing.

On October 29, 1995, Bear Stearns became a public company and listed its shares on the New York Stock Exchange. Three years later, the firm completed its relocation to 245 Park Avenue from its previous headquarters at 55 Water Street. The years since have witnessed an extraordinary and exciting transformation across its entire business. The period has been one of substantial capital growth and geographic reach. It has been one in which the firm continued to strengthen its core business as well as commit to many new and profitable ones. Of utmost significance has been the emergence of a premier investment banking capability. The result has been Bear Stearns' participation in some of the most high-profile transactions in its industry.

Throughout its 75-year history, Bear Stearns has not had an unprofitable year. Bear Stearns has solidified its reputation by carefully managing its capital and underwriting commitments in order to achieve disciplined and sustained growth. It has been generated without any outside acquisitions or mergers. Concurrent with its domestic growth in recent years, Bear Stearns has been able to maintain its unique client-driven culture which fosters strong management and leadership, entrepreneurial drive, teamwork and adept risk management.

As the firm celebrates its 75th anniversary this year, it is planning a new technologically sophisticated worldwide headquarters, a rendering of which appears on the previous page.

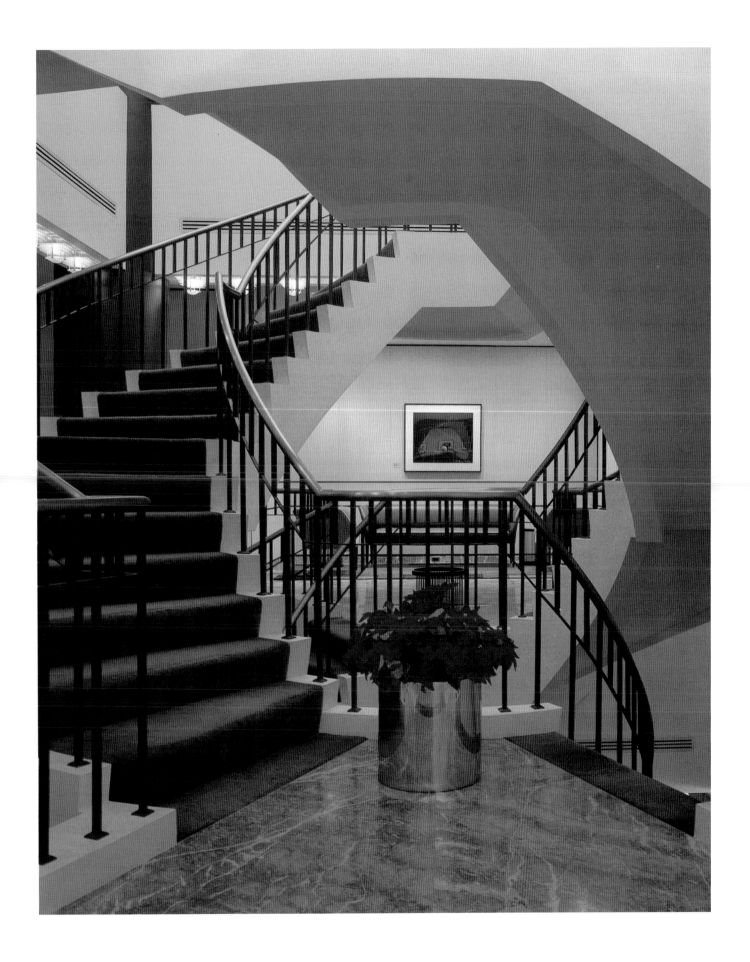

Milbank, Tweed, Hadley & McCloy

Predecessor firms to this famous organization date back to 1866. The present name of the partnership was assumed in 1963. The firm's name partners were all leaders in the profession: Albert C. Milbank was a well-known lawyer, particularly in New York real estate, and he maintained an active involvement in educational, charitable and welfare matters. While his practice focused on trusts and estates, Harrison Tweed played a prominent role in bar association and other professional activities. Morris Hudley's corporate practice had an international scope and involved the firm in Far East matters from the 1920s onward. John J. McCloy's career was the most celebrated, combining an unparalleled record of public service with years of substantive contributions as a practicing lawyer.

Long recognized as the prinicpal outside counsel to The Chase Manhattan Bank and the Rockefeller family, Milbank currently serves a number of the world's largest industrial, commercial and financial enterprises, several foreign governments and agencies, and many prominent families, educational institutions and charitable organizations. The majority of the firm's more than 400 lawyers are based at the principal office at One Chase Manhattan Plaza in New York. Milbank also serves clients domestically through Washington, D.C. and Los Angeles offices, and internationally through branches in Tokyo, Hong Kong, Singapore, London and Moscow. It was the first American firm to be permitted to establish an office in Tokyo. A leader in finance and related areas of the law, Milbank in recent years has developed particular expertise in such growing areas of practice as project finance, transportation finance, telecommunications, secularization, emerging markets securities offerings and restructurings, and intellectual property.

J.P. Morgan & Co. from Davis Polk

The new Morgan bulding is seen from the library of Davis Polk, its counsel of many years. One of Morgan's partners was Dwight Morrow—a lawyer and banker, father of a writer and father-in-law of a famous aviator. In l933 he wrote to his son, who was graduating from Amherst and about to enter law school,

"The world is basically divided into two camps—those who do the work and those who seek the credit. Try as best you can to align yourself with the first group because there is a lot less competition."

Law Firms and Luncheon Clubs

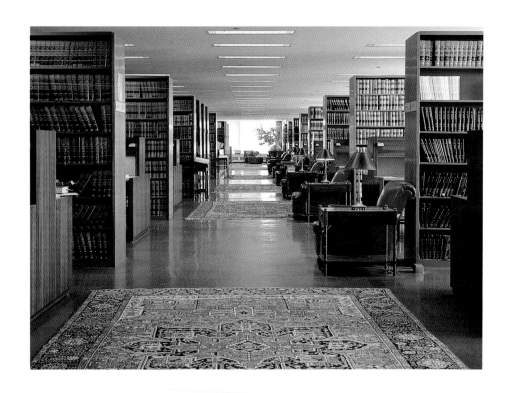

Davis Polk & Wardwell

This firm and its predecessors trace their origins to 1849 when General Zachary Taylor was in the White House and Manhattan had a population of 500,000. Allen Wardwell joined in 1898 and, as was customary, received no salary for two years. The sole telephone was in a corner booth, and, being a law clerk of less than two years' experience, he was not supposed to touch it. The filing department consisted of a series of tin boxes in which legal documents and letters were folded. Although there were two typewriters, most letters were hand-written and copied with a wet blanket on a letter press.

The principal activities of the firm before 1900 were litigation, bankruptcy, plus railroad and utility organizations and reorganizations.

In 1887 the firm's longstanding relationship with J.P. Morgan began when Morgan retained Francis Lynde Stetson, the firm's head. The latter was asked in 1910 to assist in the combination of the Guaranty Trust, Morton Trust, and Fifth Avenue Trust Companies. An increase in capital stock was required then and again in 1912. The firm participated in the 1915 Anglo-French loan of $500 million, which was arranged by J.P. Morgan & Co. and for decades remained the largest public offering of foreign securities ever made in the United States. In fact, the transaction was considered the cornerstone of the U.S. Government's case of alleged conspiracy to divide markets and control prices brought against Morgan Stanley and sixteen other investment banks in 1948 (in which Judge Harold Medina found the Antitrust Division's position to be erroneous).

Frank Polk joined Wardwell in 1920 from Washington where he had been Acting Secretary of State. At the same time, John Davis, a former congressman, was the American ambassador to the Court of St. James's in London. He also joined the firm and became its managing partner in 1921. Not only did he develop the first large litigation department in a Wall Street firm, but he formed the first tax department of a major firm in 1925.

Frank Polk concentrated on international financial problems, especially the difficulties Guaranty Trust Co. and other banking client had in obtaining the recognition of past obligations by the Soviet Union. Mexico was another trying situation, owing not only to its delinquencies on foreign obligations but to its outright nationalization of properties in the early 1930s. Dwight Morrow of J.P. Morgan & Co. had become the American ambassador to Mexico and was able to provide some guidance to both sides during this difficult time.

Davis Polk & Wardwell, and its predecessors, had occupied offices at 15 Broad Street since 1891. In 1926 it was decided that the structure had to be replaced. For the next two years the firm resided at 44 Wall Street and then returned to 15 Broad for another thirty-five years.

During the 1930s the firm was busy in mopping up the aftermath of the stock market collapse and particularly the collapse of the businesses of the Swedish financier Ivar Kreuger, whose enormous frauds resulted in the economic death of one of Wall Street's most famous firms, Lee Higginson & Co.

During the post-World War II period, the firm concentrated on two new developments: the creation of pension trusts for corporate employees, which J.P. Morgan & Co. sought with dispatch, and the popular real estate sale/leaseback transactions. In 1953 the government's case of conspiracy by Morgan Stanley et al. was so successfully defended by the firm that the government did not appeal.

Davis Polk was involved with the first major cross-border securities offering in 1957 by Royal Dutch/Shell, assisted in the negotiations for the transfer of ownership of the Suez Canal in 1958 and has been in a wide variety of other complex transactions since then. It has extended its reach to include unit investment trusts and other financings for several of Wall Street's leading securities firms as well as bankruptcy, public finance and oil and gas work. The firm helped to devise the counter-tender offer strategy dubbed the "pac man" defense in the early 1980s.

Davis Polk is best known today in three very different areas. First is its global securities practice, in which corporate and tax lawyers represent Morgan Stanley Dean Witter, J.P. Morgan, Donaldson, Lufkin & Jenrette, other underwriters and a number of issuers in debt or equity offerings. Second is its large international mergers and acquisitions practice, whose average transaction is valued at over $1 billion. And third—an anomaly for a Wall Street firm—is its extensive white collar criminal defense practice involving six partners who were former government prosecutors.

Presently, the firm has grown to almost 500 lawyers including 124 partners, most of them in international practice. The firm has five offices in Asia and Europe representing clients in matters involving more than 66 countries and 35 industries. Over half of the corporate transactions the firm is engaged in have international features.

Brown & Wood

The law firm known today as Brown & Wood LLP was founded on May 15, 1914, by William M. Chadbourne, Richard C. Hunt and Albert F. Jaeckel. The original firm, Chadbourne, Hunt & Jaeckel, set up shop in the old Singer Building at 165 Broadway. William Chadbourne was not the only legal entrepreneur in his family. His cousin, Thomas Chadbourne, founded the firm now known as Chadbourne & Parke. Richard Hunt and Albert Jaeckel, both younger than Chadbourne but no less talented, were associates at Winthrop, Stimson, Putnam & Roberts.

The new firm scored a major coup with the addition of Merrill Lynch & Co., then a small brokerage firm, to the client roster. Also founded in 1914, Merrill Lynch & Co. began to thrive in 1918 with the end of World War I. Charles E. Merrill, its co-founder, and Albert Jaeckel were fraternity brothers. One Saturday afternoon, when Merrill was unable to reach his attorney to handle a pressing legal matter, he called Jaeckel, who just happened to be at work that day. The rest is history. Neither Merrill nor Jaeckel could have foreseen the far-reaching consequences and the long-standing relationship that would result from that fateful phone call.

Howard H. Brown, another one of Jaeckel's fraternity brothers, joined the firm as a partner in 1920. The name of the firm was accordingly changed to Chadbourne, Hunt, Jaeckel & Brown. John M. Wood, a future name partner, joined the firm in 1923 and later developed an impressive list of clients from the world of entertainment, including one of the most popular actors of Hollywood's Golden Age, Gary Cooper.

With its fortunes tied to a number of Wall Street clients, the firm barely survived the stock market crash in 1929. By 1932, however, the firm's revival was marked by a move to 70 Pine Street. The enactment of the Securities Act of 1933 and the Securities Act of 1934 especially contributed to the firm's resurgence. Although Wall Street protested this vast body of federal legislation, the firm seized the opportunity to guide securities firms through the regulatory minefield. In fact, John Wood is credited with preparing one of the first registration statements filed under the 1933 Act.

The firm has gone through several moves and name changes over the years. By 1955, Jaeckel and Hunt had died and Chadbourne had left the firm to set up a separate partnership. With the departure of so many distin-

guished partners, the firm was renamed Brown, Wood, Fuller, Caldwell & Ivey after the remaining leaders of the firm. This firm moved in 1972 to One Liberty Plaza and to its current location at One World Trade Center ten years later. The World Trade Center offices, elegantly decorated with traditional furniture and an impressive collection of contemporary art, drew a constant parade of visitors during the firm's first few months of occupancy. In 1976 the firm became Brown, Wood, Ivey, Mitchell & Petty following a merger with the New York bond firm of Mitchell, Petty & Shetterly. The name was shortened to Brown & Wood ten years later, and in 1996, the firm became a limited liability partnership.

The three-person law firm founded by William Chadbourne, Richard Hunt and Albert Jaeckel today has more than 300 lawyers in eight offices around the globe. Brown & Wood LLP is the recognized leader in the development of asset securitization programs, having first pioneered mortgage-backed securities in the 1970s. It is also one of the principal law firms providing counsel to companies and underwriters active in the domestic and global capital markets.

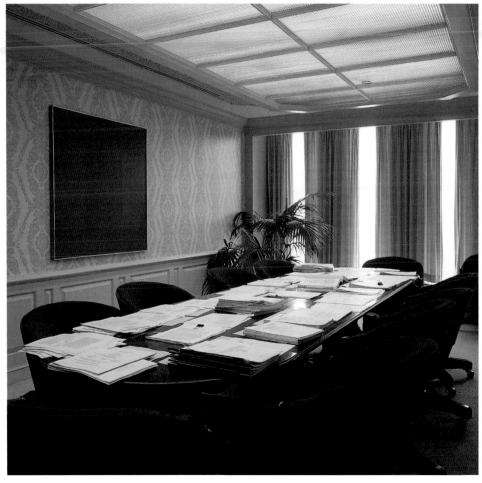

Sullivan & Cromwell

This firm was founded in 1879 by two partners who were instrumental in developing the practice of law specializing in business and not simply litigation. This concept of counselors with a grasp of both law and economics has been an important element in the growth of American industry. The firm has continuously treated the law as a living force that not only regulates but also advances enterprise. It has maintained a high degree of flexibility in matching creativity within the law to the changing forces of commerce.

Algernon Sydney Sullivan went into the practice of law in 1849. His early years were difficult: his wife died in the first year of their marriage, and in the depression of 1856 he was called upon to repay the notes of friends and clients which he had co-signed, an obligation that took him most of the rest of his life to fulfill. He was known for his gracious and highly principled practice of law, and he was joined in 1879 by William Nelson Cromwell, a lawyer entrepreneur who was the archetype of a new breed crucial to the expansion of American industry. Until that time, the country was one of extractive and agrarian businesses. But with the developments of Messrs. Edison, Westinghouse, and Bell, the men of mechanical and electrical inventiveness began to change America into a modern industrial society. Manpower, ideas, and natural resources were all readily available. The critical shortage was capital, and it was this opportunity–developing a new kind of legal practice to facilitate the flow of capital–that Sullivan & Cromwell was successfully able to meet.

When Sullivan died in 1887, William Cromwell stayed the course, emphasizing the need to serve business clients by analyzing their financial conditions and getting to understand their total needs–a concept that may seem logical today but was pioneering a century ago.

The firm orchestrated the formation of U.S. Steel Corporation, for example, a large block of whose stock was paid to the firm as a major part of its fee. It assisted in the complex issue of debt by the Pennsylvania Railroad in 1906 to Credit Lyonnais and Banque de Paris et des Pays-Bas, under which proceeds were drawn down over an extended period. And it played a pivotal role in the formation of, and obtaining presidential approval for the construction of the Panama Canal.

Sullivan & Cromwell moved its offices to 48 Wall Street in 1929, a space it occupied for over forty years. At this time, John Foster Dulles was the managing partner. He was a man of forbidding personality who saw the law as a dynamic force. At one point he described it as "a codification of what the community believes to be a sound and constructive way of living." He went on, "it does seek to prevent men's desires from clashing in ways that are destructive of the social order. But it should also point the way to doing what is creative and constructive. Law, particularly the so-called common law which underlies, and sometimes in practice overrides, statutory law, is flexible. It can, and should, be added to, so as constantly to open new avenues for the accomplishment of what will serve the common good."

John Foster Dulles helped draft the Charter of the United Nations, was the chief negotiator of the Japanese Peace Treaty, and served as Secretary of State under President Eisenhower.

During the 1950s Sullivan & Cromwell was an active participant in bringing overseas issuers to the United States capital markets-foreign governments and cities as well as the public international organizations, such as the World Bank, the European Coal and Steel Community, and the European Investment Bank. The firm has developed extensive expertise in the disclosure of material information about foreign issuers in domestic registration statements.

In 1970 the firm worked with the leading advocates of public ownership of securities of New York Stock Exchange member firms, acting as counsel on the first such offering and many subsequent ones. It played a principal role in creating the Securities Investor Protection Act of 1970 and has been active in the creation and amendment of a variety of federal securities laws. Its expertise in banking and investment company activities is perhaps the most extensive available anywhere.

In the areas of tax, estate and corporate reorganizations (mergers and acquisitions) the firm has developed specialist teams that are well known for their expertise and capability. Twenty years into its second century, the firm has 475 attorneys, three domestic and six foreign offices, continuously focusing on serving its clients as creative business lawyers.

Wall Street Spires

(*Above, left*) The pyramid atop 40 Wall Street. This rich, somewhat flamboyant 66-story skyscraper was designed by Craig Severance and Yasuo Matsui and opened in 1929 as headquarters to the Bank of Manhattan Company. Later it became the headquarters of the Manufacturers Trust Company.

This building was intended to be the tallest in the world, at 927 feet. The architects did not reckon with the determination of Severance's former partner, William Van Allen, to make his Chrysler Building the world champion. The latter's 925-foot height was already publicly announced, but Van Allen withheld a secret: inside the crown he fabricated a 123 foot stainless steel spire which he pushed through at the last minute, taking the title away from Severance, who remained in second place.

Seventy Pine Street (*opposite*) and the Woolworth Building (*above, right*). These remind us that Wall Street has its due share of skyscrapers, as bold and majestic as anywhere else. Seventy Pine Street, the American International Building, was built in 1932 for the Cities Service Company by Clinton & Russell. The strong crown is best described as "Jazz Gothic." It contains one of Wall Street's best-kept secrets—an Art Deco solarium on the 66th floor. Originally this building had double-decker elevators, serving two floors at a time such as are found in the Citicorp Center. Their lack of popularity caused their removal, however.

The spire of the Woolworth Building is pure Gothic—one of the most extraordinarily successful mergers of cathedral design and a modern skyscraper. When it was opened in 1913 by President Woodrow Wilson, who threw a switch at the White House to illuminate the Broadway tower, the Woolworth Building was, as it remained for nearly twenty years, the tallest building in the world. It is a fitting headquarters for a company that has also built the largest network of retail stores.

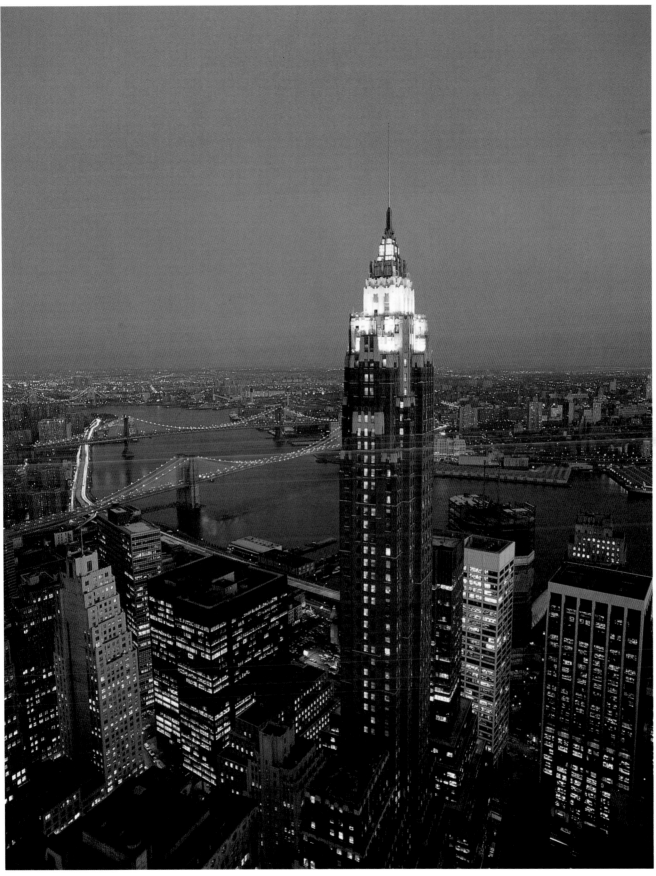

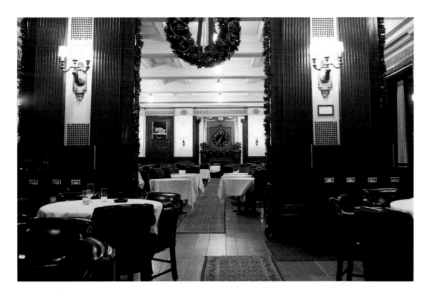

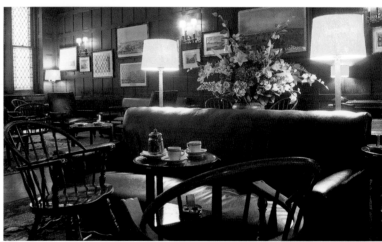

The Stock Exchange Luncheon Club and the Down Town Association

(Above, left) The Stock Exchange Luncheon Club is located on the seventh floor of the New York Stock Exchange's building at Eleven Wall Street. Since 1903 members have enjoyed the convenience of dining upstairs in a more quiet atmosphere than typically prevails on the floor. Like the Down Town Association, it offers members a chance to step off the fast track and enjoy camaraderie in an unhurried atmosphere. Its menus are basically the same as they were in the 1940s.

(Above, right and opposite) The Down Town Association is the oldest club in lower Manhattan and the fifth oldest social club in New York. It was incorporated in 1860 and moved to its present quarters at 60 Pine Street in 1887. The original architect was Charles C. Haight. In 1910 Charles D. Wetmore, designer of Grand Central Terminal, expanded and renovated the club, keeping its Romanesque revival exterior and magnificent Edwardian interior.

The original purpose of the club was to "furnish persons engaged in commercial and professional pursuits facilities for social intercourse and such accommodations as are required during the intervals of business while at a distance from their residences, also the advancement of literature and art, by establishing and maintaining a library, reading room and gallery of art, or by such other means as shall be expedient and proper for such purpose."

In November 1929, a questionnaire was sent to all members relating to an offer by an unnamed developer who had acquired the adjacent property and was planning to erect a building of fifty stories. The proposal was to buy the club's property and give it space on one or more of the upper floors of the new building. While the trustees were against such a plan, they nevertheless asked each member to express an opinion

Members of the Down Town Association have provided public service for over a century. Most noteworthy members are Franklin Roosevelt, John Foster Dulles and other Secretaries of State, five Attorneys General, three Secretaries of War and numerous others. It is indeed a club that has served its members and the community well for 140 years.

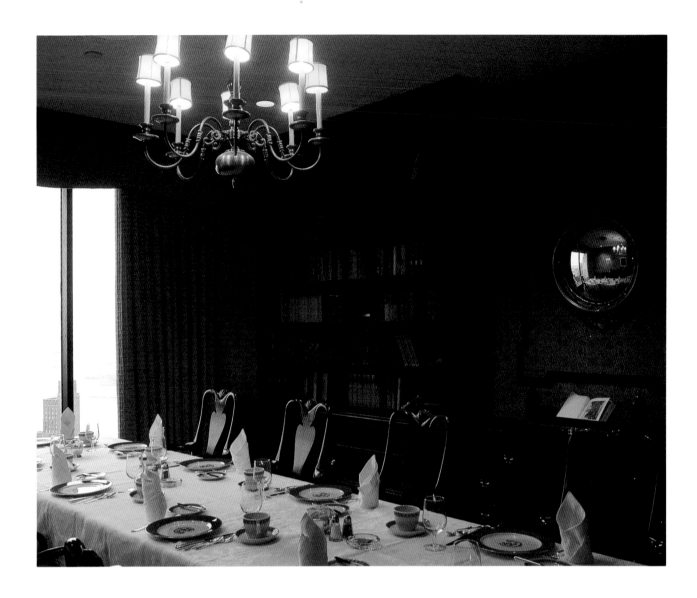

The City Midday Club

One of Wall Street's oldest and loveliest clubs is the City Midday Club. It was founded in 1901 "to maintain and operate a luncheon club, library, reading room and other accommodations for the use and convenience of its members."

The early luncheon menus were reflective of the leisurely pace of the time and featured well over one hundred selections. There were twelve varieties of steak, five lamb and mutton-chop choices, plus lamb kidneys and lamb hash (each prepared in three ways—plain, poached with an egg or gratin), a variety of game, cheese (fifteen kinds), fruit and dessert. The average entree price was sixty-five cents. By the 1930s, the number of selections had been greatly reduced, and yet the average price of the entrees was still under a dollar.

Originally headquartered at 25 Broad Street in the Broad Exchange Building, the club relocated to a charming English Tudor-style clubhouse at 23 South William Street in 1945. It remained there until 1967, when it moved to more expansive quarters on the top floors of the new building at 140 Broadway, where it is today. The club's rooms are decorated in the Federal style, and they have magnificent harbor views (possibly the best in the area because they do not require the long trek to the top of Windows on the World). Ladies were admitted as members in the mid-1970s, and shortly thereafter they were also permitted in the Main Bar and Grill for lunch. The Drug & Chemical Club of New York, founded in 1894, was merged into the City Midday Club in January 1986.

New York Marriott World Trade Center

This was the first downtown hotel. Designed by Skidmore, Owings & Merrill, its graceful bow front structure offers a pleasing contrast to the tall towers it nestles beside. It opened in 1981, nine years after the twin towers were completed and is thus Three World Trade Center. The hotel was recently newly renovated. It boasts the largest amount of meeting space in lower Manhattan—26,000 square feet, including a Grand Ballroom that can accommodate 1,000. Upstairs, above the three story atrium and Greenhouse Café, with its glass ceiling looking up at the twin towers, are over eight hundred guest suites. Some of them are duplexes. On top of that is the rooftop Health Club, the largest of any hotel in Manhattan, which includes relaxing massage therapy, intensive exercise, a running track and a swimming pool. The hotel is connected to the World Trade Center complex which is an extra plus.

CHRIS LITTLE

Windows on the World

(Above) The boldly reconceived Windows on the World restaurant on the 107th floor of One World Trade Center reopened in June 1996, following a $25 million renovation that has transformed it into a dramatic setting for dining, entertainment and private occasions. The "new" Windows is situated on two luxurious acres in the sky and offers the most extraordinary views of the city—in fact, it is not unusual to look *down* on helicopters and airplanes, a sight that even the best-traveled individual is unable to ignore.

Delmonico's

(Opposite) The most famous name in dining since 1827, Delmonico's has had several homes over the years. The original restaurant was at Union Square. The downtown branch has been in the Wall Street area for well over a hundred years; the building it presently occupies at 56 Beaver Street was built in 1891.

The Whitehall Club

(Above) This famous club was established in 1910 primarily for executives in the shipping industry. It was the first large fraternity of shipping executives from around the world. The founders of the Whitehall Club included John D. Rockefeller, Jr. (who frequently played squash there since the Downtown Athletic Club next door had not yet been built), plus the heads of United States Lines and other shipping companies.

The club was located at 17 Battery Place in the Whitehall Building, which was built in two stages, 1904 and 1909-10. Prior to the completion of the Equitable Building, this was the largest building in New York. The club installed a fireplace with a chimney flue pushed up through the top floor to the roof. It had a gymnasium plus handball and squash courts. Its commanding views of New York harbor were unequaled.

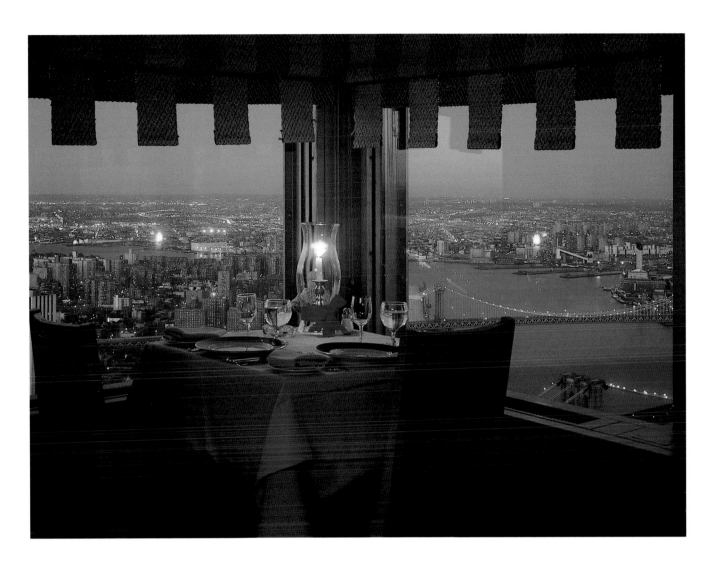

The Wall Street Club

(Above and opposite, below) The Luncheon Club of Wall
Street opened on March 2, 1931. Among the original gov-
ernors were some of Wall Street's most prominent names
including: Cleveland E. Dodge, Edward C. Lynch,
Hunter S. Marston, George L. Ohrstrom, Edward Allen
Pierce, and Elihu Root, Jr.

The club was dedicated to the propositions that "for a
man of affairs, the importance of perfect lunching facili-
ties amid ideal surroundings with good food, well served,
cannot be underestimated, and that the business man
should have available luncheon facilities under comfort-
able and attractive conditions, contributing to his relax-
ation, his health, and his energy." Neither women nor
men under the age of 21 were admitted except on
Saturdays. The club occupied the 26th and 27th floors of
the financial district's most prestigious building: 40 Wall
Street. The club was planned architecturally as a spacious
institution with every distinction which could be obtained:
high ceilings so it had a maximum of light and sunshine,
air and quiet plus panoramic vistas from its many win-

dows. On the 26th floor were the main dining room
lounge and glass-enclosed sun terrace, on the 27th floor
were 11 private dining rooms, capable of seating parties
up to 80, and still another open-air terrace restaurant
shaded by colored awnings and surrounded by shrubs.

In January 1937 the club's name was officially changed
to "The Wall Street Club." Despite the loyalty it demon-
strated in the purchase of war bonds in 1943, the club
received a letter of complaint from Mayor La Guardia
because it was serving butter to its members.

On May 1, 1962, the Wall Street Club moved into its
new facilities on the fifty-ninth floor of One Chase
Manhattan Plaza. The waiting list grew so long that a
notice was sent out to advise prospects that the club
would not be able to elect new members for a period of
time. Eight years later, in October of 1972, it was decided
that women should be elected as members. During ensu-
ing years the club prospered but then saw its membership
decline as firms relocated to midtown. The club has
unfortunately now closed its operations.

Wall Streeters Celebrate the Night Off

(*Above, right*) Harry's at Hanover Square has been an institution since 1972. Roebling's (*below, right*) and Flutie's (*opposite*) at the South Street Seaport are newer institutions. The Ambrose Lightship and Water Street's office buildings can be seen outside Flutie's, whose window also reflects the lights and the faces of a couple dining next to us. Note the curved shiplike bulkhead above the couple.

The Ambrose Lightship went into service in 1907 to guide vessels into the channel leading to New York's harbor. Its namesake, John Ambrose (1838-1899), fought for over forty years to obtain congressional endorsement for his plan to widen the channel into New York. He finally succeeded, cutting the distance into port by six miles and enabling the largest vessels to enter it, thereby assuring New York's position as the leading port city in the world.

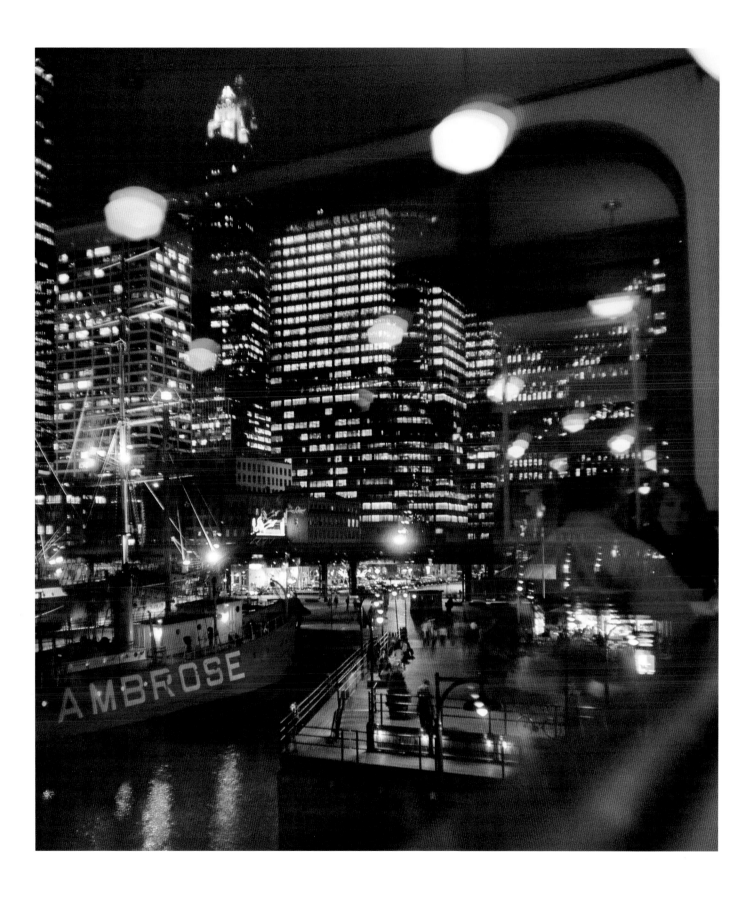

The Water Street Skyline from Pier Seventeen of the South Street Seaport

This section of the financial district resembles Sixth Avenue more than anything else. It all began with the building at the far left in the photograph, Fifty-five Water Street (1972). When it opened, it contained 3.68 million square feet of office space and was then the world's largest private office building. Next to this are One Financial Square (1987), until recently the headquarters of Thomson, McKinnon, Inc.; Seventy-seven Water Street (1970), designed by Emery Roth & Sons, who have brought us more waterfront structures, including Fifty-five Water Street, than any other firm; and One-twenty Wall Street (1930), a building with a powerful, wedding-cake silhouette. This was an unusually remote location for such a large building at the time, but the nearby Second and Third Avenue Elevated on Pearl Street helped.

Next appears the large octagonal-shaped Continental Center at 180 Maiden Lane. The lovely Wall Street Plaza building is next, built in 1973 and designed by I.M. Pei —one of the area's most successful designs. Behind Wall Street Plaza are J.P. Morgan's distinctive mastaba-topped office (1988) and the Art Deco American International Building (1932). The National Westminster Bank (1983) is next, followed by One Seaport Plaza (1983) headquarters of Prudential-Bache Securities Inc. and Lloyds Bank International.

Manhattan is like a poem. A poem compresses much in a small space and adds music, thus heightening its meaning. The city is like poetry: it compresses all life, all races and breeds, into a small island and adds music and the accompaniment of internal engines. . . .

New York is nothing like Paris; it is nothing like London; and it is not Spokane multiplied by sixty, or Detroit multiplied by four. It is by all odds the loftiest of cities.

E. B. White, (1949)
Here is New York

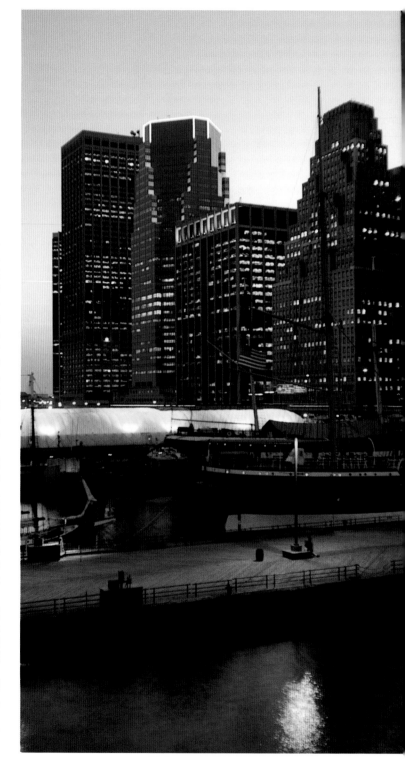

South Street Seaport

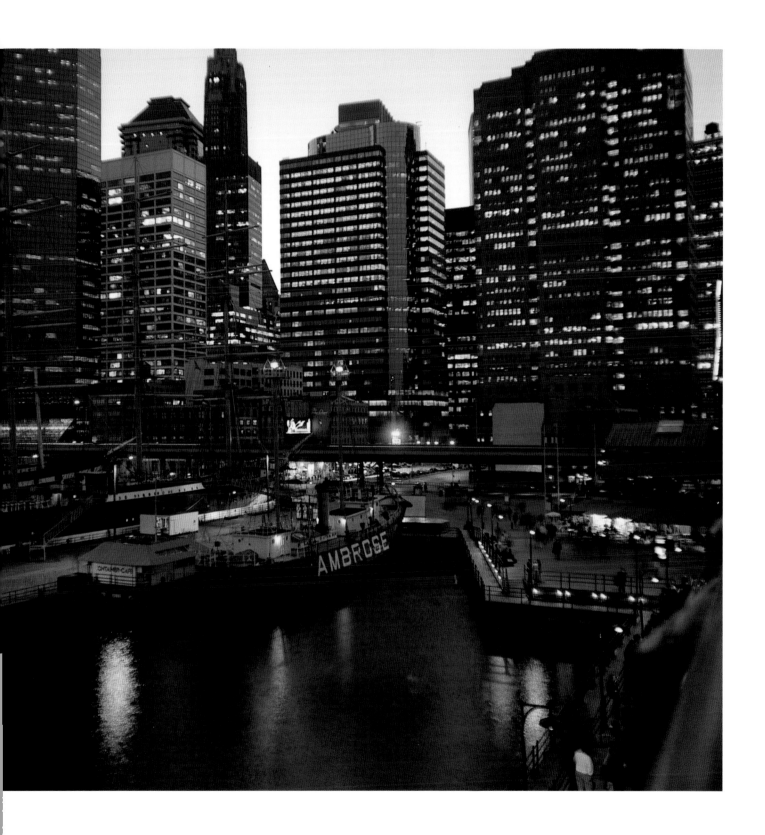

The City of Ships

(*Above*) Sloppy Louie's and Sweet's have been popular sea-food restaurants since the 1930s. In fact, prior to the opening of the South Street Seaport's Fulton Market Building in 1983, they were the only such restaurants in the area and thus have a longstanding following. Sweet's has the added distinction of being one of Thomas Edison's "first day" customers for electricity, and the only customer still doing business in the building it occupied at Two Fulton Street when the first electric customers in New York were hooked up in 1882.

(*Opposite*) The bowsprit of the *Peking* thrusts its way over the pier and practically touches the overhead FDR Drive. The *Peking* and her neighbor, the *Wavertree*, are among the South Street Seaport's principal attractions. The *Peking* was built in Hamburg in 1911. This majestic four-masted, steel-hulled ship was brought to the seaport in 1975.

The Pier Seventeen Pavilion is the Rouse Company's newest addition to the Seaport (1984). It is gigantic, playful, and a tasteful reminder of the more vernacular structures that once populated the waterfront area.

Christmas at Pier Seventeen

At Christmas, the pier is decorated with trees and lamp-post garlands. No matter how cold the weather, the waterfront always draws a crowd, as it has for two hundred years.

Stretching across the horizon is Brooklyn Heights, with its piers in the foreground and famous promenade above that. For many years the Brooklyn ferry plied this route, from Fulton Street to Fulton Street. It was immortalized by Walt Whitman, who proclaimed that views such as the one above were the "best, most effective medicine my soul has yet partaken."

South Street Seaport

(*Above*) The museum was established in 1967 through efforts of Peter Stanford. It took the first of several steps that have preserved an enclave of low-rise structures around Fulton Street (many of which date to the early 1800s). The transfer of air-rights to office buildings to the south, the purchase of Schermerhorn Row by the State of New York in 1974, and the creation of a successful festival marketplace by the Rouse Company have combined to assure a successful future for this important part of New York's past.

Without the accumulation of air-rights covering a number of blocks and their transferral to lots southward, the expansion of the Wall Street area could have quickly overwhelmed the museum area with high-rise office structures. Today, the South Street area is designated a historic district by the Landmarks Preservation Commission.

(*Opposite, top*) Late afternoon browsers pore over the offerings of the Strand Book Store, located in one of the South Street Seaport's counting houses. This structure, like its neighbor the A.A. Low Building, was probably built around 1850. In the background is the familiar *Peking*, one of the last great four-masted ships, built in Hamburg in 1911.

(*Opposite, bottom*) Holiday shoppers engaging in an old favorite pastime: browsing at Abercrombie & Fitch. Generations of children have played the games and fantasized African safaris at the old Madison Avenue store. Today the Seaport has its own version, presently the only one in New York.

The Yankee Clipper Restaurant

(*Above*) This restaurant is located at 170-176 John Street in a building completed in 1840 and designed by Town & Davis (who designed the Federal Hall National Memorial across from the New York Stock Exchange). It was originally a counting house for a successful commission merchant, Hickson Field.

The all-granite facade is rare in New York, where use of this material was often restricted to the ground floor. The utilitarian nature of the building is emphasized by the lack of ornamental decoration. The Field Building is constructed where Borling Slip once lay, filled in around 1835. The building later became a famous ship chandlery—Baker, Carver & Morrell.

Water Street, at the Seaport

(*Opposite*) The Seaport Museum's gallery is located at No. 215, a Greek Revival structure built in 1868 (note the pediment on the top and the four tiers of columns). The row of lower structures at Nos. 207-211 Water Street were built from 1835 to 1836. They house Bowne & Co., the city's oldest stationery and printing shop, the Seaport Museum's Model Shop, and its Book & Chart Store. These structures were carefully restored in 1983, opening at the same time as the Fulton Market Building around the corner.

Bowne & Co. was founded in 1775 and is now a major financial printer, located at 345 Hudson Street. The printing shop at the Seaport is a recreation of the original.

The South Street Seaport and Schermerhorn Row

The red brick buildings on the right were built between 1811 and 1812 for Peter Schermerhorn, a prosperous merchant and ship owner. They were called counting houses, with loading or storage space below and counting rooms upstairs. The high-pitched Georgian slate roofs contained hoisting mechanisms for lifting heavy cargo, and the un-

usually tall chimneys were built according to city regulations to prevent fires. These six structures were built on landfill-water lots that were 600 feet from the existing shoreline.

By 1814, the Brooklyn Ferry was landing at Peter Schermerhorn's wharf. The increase in traffic resulted in

the opening of shops, a large market, and, in 1835, the Fulton Fish Market. This area was designated a New York City landmark in 1968 and a national landmark in 1972.

In the left of the photograph are the Bogardus Building, a modified reconstruction of an earlier cast-iron warehouse, and the Fulton Market Building—both opened in 1983.

The Christmas tree is called a "Friendship Tree" and was a gift from the province of New Brunswick, Canada, to the children of New York. The Canadians also thoughtfully donated the tree at the edge of Bowling Green that appears on pages 16 and 17 of this book.

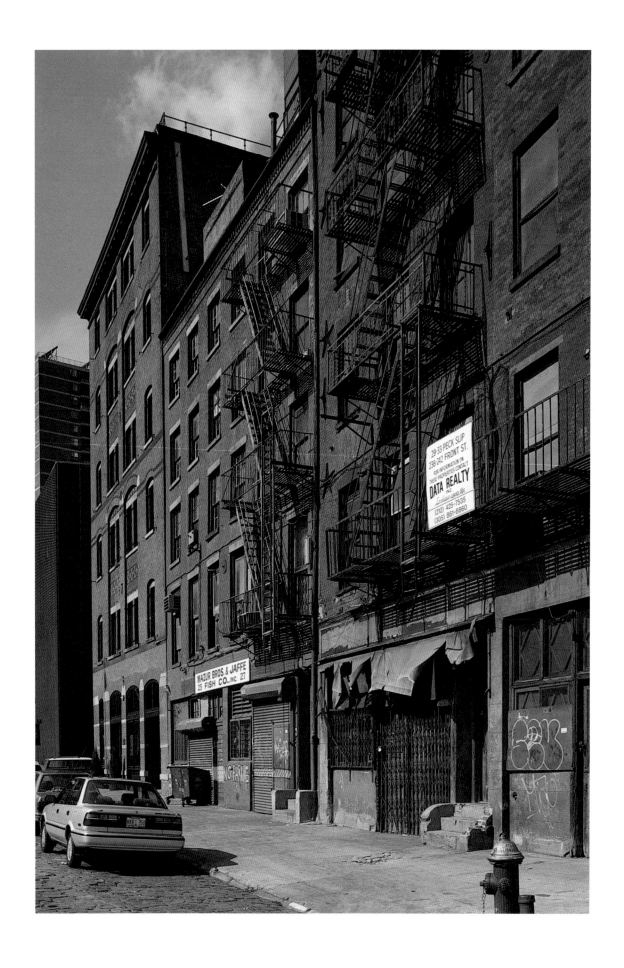

Peck Slip

(*Opposite*) This view of Peck Slip between Water and Pearl Streets shows what the lofts and warehouses dating from the mid-nineteenth century looked like before the Seaport began its restoration program.

Peck Slip is named for Benjamin Peck, who had an active ship-fitting business here in the mid-1700s. The actual slip was created in 1755. In 1763 he built the Peck Slip Market at this location, one of the many predecessors of the Fulton Market.

Consolidated Edison Company

(*Above*) On the south side of a Consolidated Edison electrical substation is Richard Haas' mural, painted in 1975 to enable a modern utility building to blend in with its historic neighbors. A view of the Brooklyn Bridge appears through the arcade, with the real bridge looming in the background.

Thomas Edison located his first electric generating station near here at 255 Pearl Street in 1882. In fact, it was the first commercial generating system for incandescent service in the country. He selected this area because the financial community was nearby (the first lights were turned on at 23 Wall Street), as were the newspapers.

Holiday Lights

The masts of the *Peking* (*above*) and the *Ambrose* Lightship (*opposite*) are decorated with Christmas trees for the holidays. The *Ambrose* (1907) was the South Street Seaport Museum's first acquisition, donated by the Coast Guard in 1967 after completing service at the entrance to New York Harbor. The *Peking* (1911) was brought to the museum in 1975, after service as a cargo ship between South Africa and Germany and later, renamed the *Arethusa*, as a training ship for British sailors. It is one of the last sailing ships built for commercial purposes.

The Christmas trees, lights, spars, and masts are a wonderful summary of the gentlest side of a Wall Street Christmas.

Wall Street, South Street

Many a rapid fortune has been made in this street, and many a no less rapid ruin. Some of these very merchants whom you see hanging about here now have locked up money in their strong-boxes, like the man in the Arabian Nights, and opening them again, have found but withered leaves. Below, here by the water-side, where the bowsprits of ships stretch across the footway, and almost thrust themselves into the windows, lie the noble American vessels which have made their packet service the finest in the world.

They have brought hither the foreigners who abound in all the streets; not, perhaps that there are more here than in other commercial cities; but elsewhere they have particular haunts, and you must find them out; here they pervade the town.

Charles Dickens
American Notes, 1842

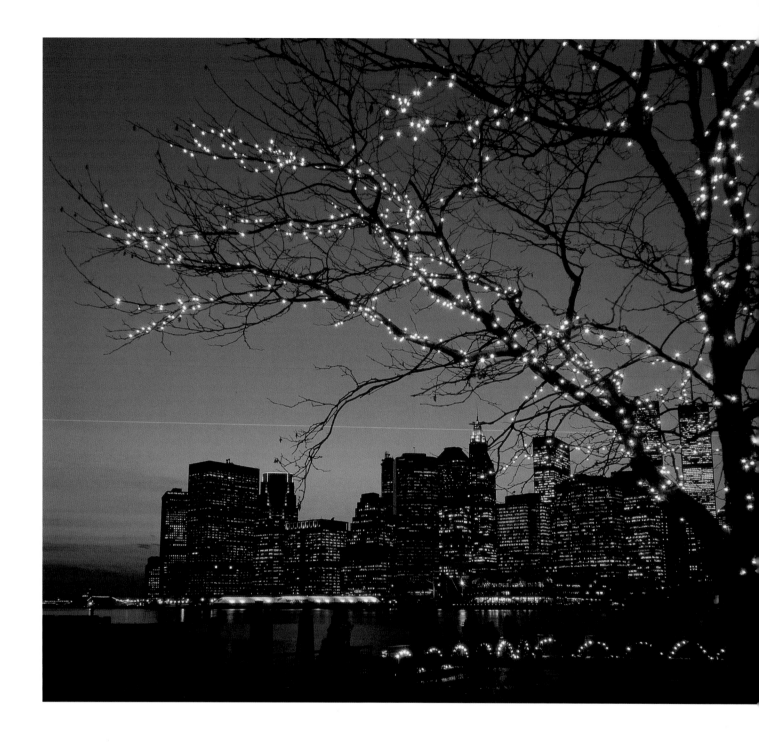

Wall Street from the River Café

Through the holiday lights of this famous restaurant appears the skyline of office and firms that comprise the subject of this book: Wall Street. Whether seen from the Brooklyn Heights Promenade, Governors Island, or the Staten Island Ferry, it is a seascape second to none. For some, it is a collection of buildings, new and old, strung together with irregular streets. For many, it is more than that: a place to make one's livelihood and also one where fortunes are made and lost.

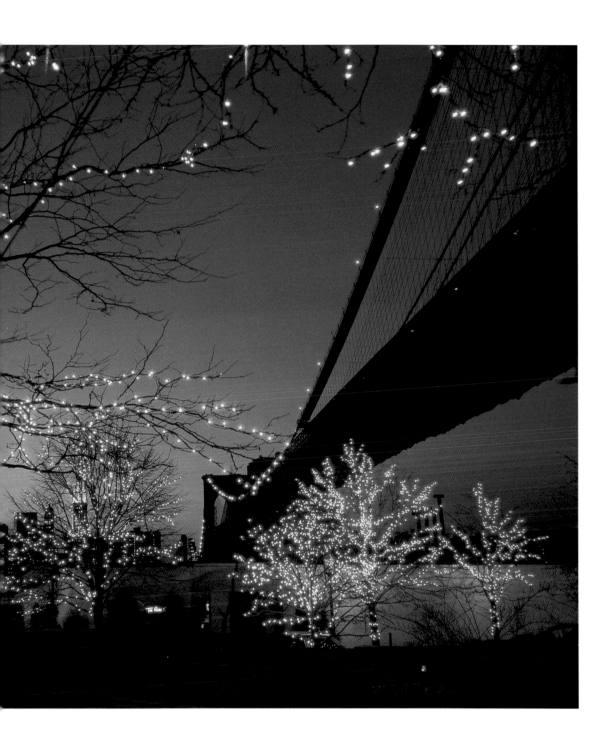

INDEX